Harry L. Snavely

THIS IS PHOTOGRAPHY

This is

Photography

ITS MEANS AND ENDS

BY

THOMAS H. MILLER

Supervisor of Employee Photographic Training
Eastman Kodak Company

AND

WYATT BRUMMITT

Writer and Editor
Eastman Kodak Company

GARDEN CITY PUBLISHING CO., INC.

GARDEN CITY, NEW YORK

TO BEGIN WITH..

PHOTOGRAPHY seems so simple. In fact, it is completely simple if you require nothing more of it than casual pleasure and snapshots.

Many of us, naturally, aren't content to stop there. We want to know *why* and *how*.

The moment we become curious, we become vulnerable. We ask questions. And the answers may floor us with their complexity, their strange language, and—above all—their implications of a vast and hitherto unsuspected world of photographic technicalities. Some of us hurriedly retire from photography at this point. But others of us pull ourselves together, breathe deep, and ask, "Now let's have that again, please, and slowly this time."

"This Is Photography" is not a primer. It assumes that you know enough about photography to know that it is not utterly simple. On the other hand, it does not pretend to be a technical encyclopedia.

The *means* of photography are in themselves so absorbing that the *ends* —the pictures we want to produce—are sometimes overshadowed. Naturally, any such book as this must talk about processes and equipment; but the *ends* of photography are our primary concern—in short, better photographs.

With many of the chapters there are experiments. You'll get something out of the mere reading of them, more out of performing them, and still more out of doing them with variations which your own interests may suggest.

Whether used for study or simply read for the enjoyment there may be in it, the ultimate aim of "This Is Photography" is to make you feel at home in photography.

You can be sure of this: Out of your increasing photographic understanding and skill will come a lot of deep personal satisfactions—satisfactions far beyond any you might know were you content to accept photography as the simple thing it seems to be.

T. H. M.
W. B.

CONTENTS

prints can be made from almost any reasonably fair negative. It takes only the "know how."

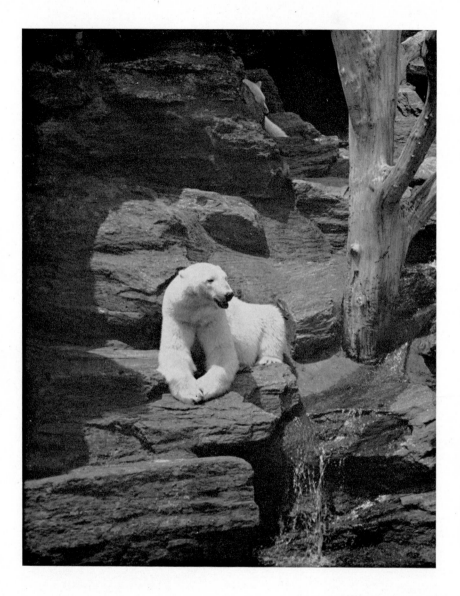

. . . as Johnny saw it

You and Your Camera

STARTING right now, practically every word within these covers concerns *pictures* and the photographic means of producing them. Under the circumstances, it seems fairly reasonable that we decide, at the start, what a picture is.

Well, the cavemen drew pictures on the walls of their caves. Michelangelo painted pictures in the Sistine Chapel, Griffith lined up a million or so snapshots on a movie film to picture *The Birth of a Nation*, and Johnny Whoozis made a Brownie snap of a polar bear at the zoo last Saturday.

In each case, the picture served as a more or less vivid form of communication. With his wall-scrawlings the caveman told his friends and descendants something of contemporary natural history as he saw it; with his frescoes Michelangelo told the world something of his religion; and with his snapshot Johnny tells all who will pause and behold that he saw a bear at the zoo the other day.

But there's more than mere communication involved. Even Johnny's polar bear snapshot is more than a mere factual record. It is not the same as a printed sign saying, "Bear:" It is the bear *as Johnny saw it*. And its success as a picture depends on the point of view Johnny selected, on the kind of light there was, on the angle of the light, and on the degree to which the finished print puts the emphasis on the bear.

But of all those factors, none is as vital as the personal factor summed up in the phrase, "*as Johnny saw it*." Putting it more directly, you are the most important part of any camera you will ever use. Despite the fact that photography is a scientific affair based on a fascinating lot of physics, chemistry, and mechanics, the real satisfactions of photography depend on your eyes, your imagination, and your mastery of photographic processes.

Photography is an intimate, intensely personal thing. Your use of it expresses you, characterizes you as certainly as does your handwriting, your manner of speech, or the friends you choose.

That's why millions find such deep pleasure in photography; we are all at our best when we are responding to an inner hunch to create, to build. Some people satisfy this urge by writing, some by cabinet work, some by making music, some by painting, some by tinkering with the car, and so on. In photography many different creative skills are involved, from a discerning, picture-wise way of looking at things to a mastery of the tricks of enlarging. And it's fun all the way.

But, no matter how involved you may become with the technique of photography, keep in mind the central fact that every bit of technique has only one real function—to give you, ultimately, a photograph which will be a permanent record of something you saw, something you looked at and enjoyed in your own, individual way.

In other words, don't mistake *means* for *ends*. That is the fatal mistake of the misguided gadgeteer who is always sure he'll make a picture *someday*—when he gets another gadget. Someday never comes.

YOUR EYE AND YOUR CAMERA

In most respects, a camera is a pretty good imitation of the human eye. Your camera may be a battered veteran, a survival from earlier, more reckless days; or it may be a shiny new creation, equipped with the latest and best in lens, shutter, and all the gadgets so dear to the hearts of many. But, old or new, simple or complex, it is still a mechanical approximation of an eye.

Here are simple diagrams of an eye and camera. The eye is, essentially,

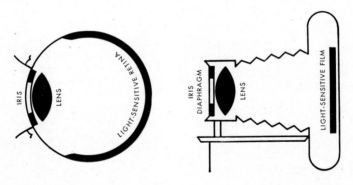

a little enclosed chamber with a lens at one end and a light-sensitive area at the other. The lens gathers rays of light from the scene at which the eye is looking, and transmits those rays, nicely organized, back to the sensitive area. By a complex system of nerve reactions the image, formed by the rays of light on the retina of the eye, is wire-photoed to the brain.

In a camera, much the same business goes on. The glass lens is like the eye's lens. Instead of the retina, there's a light-sensitive film or plate, on which the image is recorded. When the film is developed—a fascinating bit of chemical sleight-of-hand—the image is there for you to see and to use in making one or thousands of prints.

Naturally, this is a sketchy outline of the photographic miracle, but it should suffice to stress the point that an eye and a camera are very similar.

But there are extremely important *dis*similarities. And an appreciation of them is the beginning of wisdom, as far as photography is concerned.

First, never forget that the camera is, after all, only a mechanism—devoid of sense or imagination. It may cost a thousand dollars, but it is just as dumb as a fistfull of mud. It is more dependent on you than a brand new baby on its doting mother. Your camera can "see" only as you allow it to see; it cannot take matters into its own hands and balk at attempting something that's inane or impossible. It is your unquestioning, totally submissive slave. So the responsibility is entirely yours.

Second, there's the fact that, in seeing, you use a kind of visual short-hand, whereas your patient camera takes everything within its ken in laborious, literal longhand. For example, you see a friend on the street. On the basis of a quick glance which possibly includes a scanning of his face, his expression, and the way he walks, your mind completes the picture. "Good old George," your mind says, "George, who has a nose he busted playing tackle for dear old Siwash; George, who still owes me five

The camera "sees" indiscriminately . . . the eye sees selectively.

bucks; George, who has a dancer tattooed on his right arm; George, who drives a Buick . . ." and so on.

But your camera, being dumb, goes at George in a strictly impersonal, objective way. It pays as much attention to the wrinkle at the hem of George's coat as it does to George's amiable eyes.

You can sense something of the camera's point of view when you find yourself, overnight, in a totally strange place. You see details you never bother to observe at home; at home, things are so familiar that you take them for granted, merely checking now and then on some particular detail. The camera is always a stranger; it takes nothing for granted.

It appears, then, that the most important thing about your camera is not its similarity to your eye, but its dependence on you, on your appreciation of the visible world, on your ability to pick out scenes which your camera can convert into good pictures. It's trite but, in the manner of most trite things, true that a box camera in the hands of a good photographer will produce pictures far superior to those made with the best camera in the world operated by someone with neither imagination nor skill.

So, develop your own sense of seeing. Look at things. A casual glance isn't enough. Get the habit of scanning a scene, appreciating its qualities. For, unless you do enjoy what you see, unless you get an honest bounce out of the beauties, the ironies, the design of the visible world, you can't expect your camera to give you any but lack-lustre pictures. If you delight in seeing, there's a grand chance that you'll make really fine pictures.

Then, backing up your ability really to *see* with a sound appreciation of the technique of photography, you will make the fine pictures which, today, may seem beyond your reach.

Look about you. You'll find pictures where you least expect them.

Which Camera?

"I AM ABOUT to buy a camera. Which one do you advise?"

This question is Old Faithful. It never fails. In letters to camera makers, in conversations with camera counter clerks, and with anyone else suspected of harboring photographic information, it is bound to emerge, sooner or later. And the askers ask in good faith; for there are hundreds of cameras on the market, and to select one from the many may be bewildering.

But, as it stands, it's a question that cannot be specifically answered. Before an answer can even be approximated, a number of counter-questions must be asked. To wit:

What do you want to do with photography?

What do you expect photography to do for you?

Amuse you? Support you?

Do you want snapshots for an album? Or do you plan to make a lot of little negatives, of which a few are to be glorified into exhibition prints?

Do you plan to do your own developing, etc?

Do you require a pocket-sized camera?

Do you want to be able to make extreme close-ups?

Architectural subjects?

Do you want a lot of adjustments and controls, or do you want them minimized?

And, ahem, how much money do you plan to spend?

In basic principle all cameras are much alike, whether they cost two or two hundred dollars. Then why the "spread" in prices?

There are three prime points on which cameras differ. The first is the lens, which is usually the most costly single component of any camera.

13

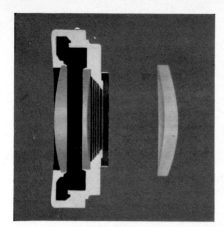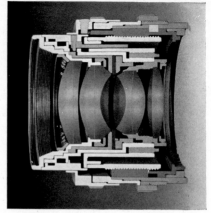

A "simple" and a complex lens; one costs little, the other much.

A good small lens made of a single piece of glass, ground and polished to conform to a simple formula, can be turned out easily and in quantity. But a fine lens is an achievement, involving many carefully made and assembled elements. It may, alone, cost hundreds of dollars.

Then There's the Shutter

In the average inexpensive camera the shutter is a simple flap, swung back and forth across the aperture by a wire spring. It has only one speed. A second general type of shutter, is the complex spring-winding shutter, with a precision gear train capable of giving a series of reasonably exact different timings, including, in some cases, a fascinating one-second exposure, a seemingly long second full of gentle whirring noises. This type is usually mounted between the elements of the lens; if the workmanship is good, it is worthy of the finest camera. The third type is that of the focal plane shutter—a shutter located in the back of the camera, as close as possible to the focal plane where the film is. Focal plane shutters work in a manner similar to window blinds. For the exposure, a slitted curtain is drawn across the focal plane. By varying the width of the slit and the tension of the spring mechanism, a wide variety of exposure times can be obtained.

High shutter speeds are not essential unless your first concern is stopping rapid action. However, high speeds do overcome the hazard of camera motion during the exposure. The more you wish to enlarge your picture, the more important this becomes.

Third among the major points on which cameras differ is the view finder. On inexpensive cameras it may not be absolutely accurate; but it does show you a view which conforms approximately with the actual field embraced by the camera. Usually, there's no harm done by this

14

slight discrepancy. But for precise work an accurate view finder is essential, and an accurate view finder is an optical instrument. It runs into money. There are direct-vision view finders, with and without lenses; there are wire frame finders for fast, not-too-exact work; there are reflex finders using either the camera lens itself or a similar lens to project an image of the view, periscope fashion, up to a hooded ground glass. Then there is the straight lens-to-ground-glass arrangement, where the image is seen directly as focused by the lens.

Now, let's look at the different general kinds of cameras to see what they have to offer. First, and dearest to the hearts of our childhood is:

The Box Camera

And we'll tolerate no condescension, if you please. For the box camera, in its simplicity, in its remarkable capability, achieves greatness. It demolishes picture-making technicalities by minimizing need for concern over the niceties of photographic science; the niceties are there, but the snapshooter is serenely unaware of them. Offhand, it is impossible to think of any everyday parallel to the box camera; no other single bit of equipment combines so much creative zest with so little fuss.

The box camera is basic, and it is complete, as far as it goes. It consists of a small light-tight box with a lens and shutter at one end, and film at the other. Controls are reduced to the perfect minimum. The one shutter speed is usually something between 1/25 and 1/50 second. There is one lens aperture. There is no focus to bother with. You merely load, aim, fire.

True, some box cameras incorporate means by which you can take time exposures, or vary the lens aperture slightly, but these features are relatively unimportant, for the glory of the box camera is its simplicity.

Box cameras make remarkably good pictures. Being fixed-aperture, fixed focus, fixed-speed cameras, however, they cannot be expected to master every photographic situation. Extreme close-ups, action shots, precision shots requiring maximum lens corrections, shots in bad light— all such work is beyond the proper sphere of box cameras.

The lenses in box cameras aren't intended for making pictures under adverse lighting conditions or for extreme enlargement. They are simple little affairs, made of good quality glass and finished to considerable precision. Still, when you consider that the retail sale price of the average box camera is somewhere in the neighborhood of three dollars, it's hardly reasonable to expect the lens to be a masterpiece.

15

The box camera is ideal for youngsters and for other photographic beginners, no matter what their age. Since it keeps the emphasis on photographic ends rather than means, it is valuable to those who are tentatively feeling their way toward the mastery of photography. Indeed, it is a good thing even for experts to revert to box cameras once in a while. The experience tends to restore their sense of proportion—the sense which comes closest to that other invaluable but indefinable sense, the sense of humor.

So, do not underrate the box camera. Use it. Enjoy it. And, outgrow it!

The Folding Camera

Because there are so many different cameras within this category, we could wish for a more specific type name. But, outside of trade names, there is none available.

The simplest, most inexpensive folding camera is nothing in the world but a box camera with an accordion-pleated bellows replacing the box. It costs somewhat more because the construction is trickier, but lens, shutter, and view finder are quite the same. Picture sizes vary from about $1\frac{5}{8}$ x $2\frac{1}{4}$ inches to $3\frac{1}{4}$ x $5\frac{1}{2}$ inches.

From there on up the price scale, the folding camera involves increasingly elaborate variations on the basic theme. Lenses get better, focusing adjustments appear, shutters increase in complexity and precision but remain in the camera front, and view finders become more accurate.

At the top of the folding camera bracket are those with fast, well-corrected lenses which permit both black-and-white and color snapshots even under adverse light conditions. Their shutter speeds of 1/400 can stop most action. One of these, the Kodak Monitor, also has a device linked with the film winding and shutter setting mechanisms to prevent unintentional double exposures. You may outgrow such a camera, but you'll not do so quickly. In fact, you probably will spend a good long time fully realizing its potentialities.

The Miniature (35-mm.) Camera

Some caustic die-hards insist that the miniature isn't a camera; it is, they say, a cult. It is true that a lot of fanatical nonsense has been perpetrated in the name of "mini" photography, but anything capable of arousing such ardent, almost passionate partisanship (and opposition) must have something.

16

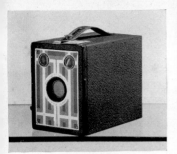

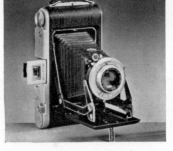

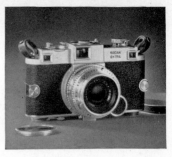

Box Brownie Folding Kodak Precision Miniature

The miniature has plenty.

Generically, the miniature is an offspring of the motion-picture industry, for it was designed to make use of the relatively inexpensive and good 35-mm. film manufactured for professional motion-picture work. On this basis, design proceeded. As the work went on, other advantages began to appear. In a compact little camera, a roll of film with room for 36 negatives, each 24 by 36-mm. (or 1 by 1½ inches) could be loaded. By using a small, short-focus lens, depth of field at any aperture was excellent. Even with fast lenses, lenses rated at $f/2$ or thereabouts, depth of field remained excellent.

So the small camera with the relatively fast lens appeared. And because its early converts used it primarily in news work, and obtained remarkable, unposed pictures of celebrities, it became known as the "candid" camera. And that "tag" nearly proved fatal to the miniature, for people soon grew disgusted with the vulgarity, the lack of good taste which flourished in the name of candid photography.

The miniature was rescued from the doom toward which it was headed by the discovery, on the part of serious workers, that it had many really useful and important possibilities. Given precision camera construction and intelligent darkroom work, miniature photography had a lot to offer. The miniature camera could be fitted with accessory lenses for wide-angle or telephoto shots, thereby giving its operator an immense optical change of pace and control. It could be used for serious portraiture as well as news; it could cover sports easily and compactly; it could be used under otherwise "impossible" conditions.

The miniature got its start abroad, but American adaptations and developments have improved vastly on the original. Today you can purchase a miniature for a very few dollars, or you can spend hundreds without any effort whatever. But be careful about the inexpensive miniature. Remember that the smaller the camera, the greater the need for precision. Similarly, we do not advise buying the most expensive miniature without

a good deal of serious forethought. A few month's experience with a medium-priced miniature will tell you whether or not you're a born miniaturist, and will be a help if and when you go all-out for the little camera.

One of the definite advantages of the miniature lies in the fact that many excellent films have been provided expressly for it. All types of black-and-white film of exceptional quality are made in the miniature size, films that are tops in speed, in fineness of grain, and in all the other qualities. And full-color Kodachrome Film was early made available for miniaturists.

In the wake of the miniature has come a whole new development of the photographic industry devoted to supplying almost innumerable accessories. It is not at all unusual for a miniaturist, whose initial interest may have been aroused by the convenient size of the camera, to require a roomy case for extra lenses, special film magazines, range finders, filters, and so on. It's a paradoxical situation, but justifiable; for a good miniature, with its many accessories, expertly handled, can be made to encompass an extreme variety of photographic work.

There is, of course, a range of cameras and capacities within the miniature field—an even wider range than in any other group. It should be stressed and repeated that the deluxe, high-precision miniature is not a camera for the casual snapshooter or for the beginner. The proper use of such a camera is based on equally precise photographic technique.

"Big" Miniature Cameras

Few photographers agree on the upper size limit of the miniature camera. Some say the 35-mm. film is the automatic delimitation. Others expand the limits to a negative size of 1⅝ x 2¼ inches, or to 2¼ x 2¼ inches or to 2¼ x 3¼ inches. It seems that 2¼ x 3¼ is certainly the maximum, but rather than put too much emphasis on size alone, the other miniature characteristics should be taken into consideration. Thus, a Brownie of the 2¼ x 3¼ format is simply a little camera, not a miniature; for it lacks the precision, the controllability, and the wide versatility of a true miniature.

In this group of small, precision cameras, affording negatives larger than those made on 35-mm. film, there are today several excellent cameras. Most of them are designed for roll film—often for 620 film—and are well-suited for color work with Kodacolor. A few of them take, or can be

Camera Capabilities

It is impossible—or inadvisable, at any rate—to establish arbitrary limits for the capability of any camera, no matter how simple. But here is a highly condensed classification of camera capabilities in terms of standard lens and shutter equipment. No accessories are assumed. Naturally, the finer cameras embrace all the abilities of humbler equipment.

Simple, fixed-focus cameras for average snapshots.

f/6.3 lens, 1/200 shutter—snaps by Photofloods, moderate action.

f/4.5 lens and 1/400 shutter—many stage shots, most sports.

"Ultra" lens and shutter—poorly lighted or high speed shots.

cameras. In fact, there are now Brownies with built-in flash equipment. Synchronizers for simultaneously opening the shutter and firing flash bulbs are available as accessories for practically any camera. Flash technique is an interesting special phase of photography, about which there'll be comment in the chapters dealing with interior photography and action.

View and Studio Cameras

The time-honored spectacle of a bulky camera on a tripod, with a man behind it, half hidden under a black cloth, is the trade mark of all view and studio cameras. They are intended for serious, deliberate work, and, as such, are often recommended for students in photography.

The view camera differs from other cameras in that it can be adapted easily for use with a wide variety of lenses, in its great bellows extension, in the fact that the ground glass is its only view finder, and in its adjustments which permit correction or distortion of perspective. Usually, the lens is stopped way down for maximum depth and detail, and the shutter time often runs into several seconds or even minutes. It loads with either sheet film or plates.

It is entirely possible to use a 4 x 5-inch view camera as a hand camera, but tripod operation is far better and easier. Recent improvements in view camera design and construction have added a new interest to this type of equipment. It is not impossible that there will be a swing to the view camera as a kind of reaction from the intense popularity of the miniature. Certainly the view camera gives its user the absolute maximum in control and flexibility. You can buy a good one, without lens, for about sixty dollars; if you're interested, you might try out an inexpensive second-hand one. There's no better photographic "trainer."

Studio cameras are essentially big view cameras. In most cases, they load with 8 x 10-inch film or plates, although an 11 x 14-inch camera is not unusual. Some studio cameras are mounted on elaborate supports, with as many gadgets to twist and whirl as you'd find on an anti-aircraft gun. There are dozens of special-purpose cameras, such as those used in photoengraving, but they fall well beyond the scope of our present concern.

Once you have a reasonably good camera, concentrate on it. Study it. Read all that its makers have written about it. If your camera is a really good one, it can serve you faithfully for many years and, in its potential capability, continue to inspire and lead you on.

Camera Capabilities

Simple, fixed-focus cameras for average snapshots.

f/6.3 lens, 1/200 shutter—snaps by Photofloods, moderate action.

It is impossible—or inadvisable, at any rate—to establish arbitrary limits for the capability of any camera, no matter how simple. But here is a highly condensed classification of camera capabilities in terms of standard lens and shutter equipment. No accessories are assumed. Naturally, the finer cameras embrace all the abilities of humbler equipment.

f/4.5 lens and 1/400 shutter—many stage shots, most sports.

"Ultra" lens and shutter—poorly lighted or high speed shots.

adapted for, film packs or sheet film. There can hardly be doubt about the added picture quality afforded by the larger negative size, assuming, of course, that the precision characteristics of the true miniature are maintained.

One of the most notable additions to the precision miniature type in the 2¼ x 3¼ negative size is the Kodak Medalist. It resembles smaller miniatures and is a combination of small camera precision with the advantages of larger film sizes. It can use roll film, film pack, sheet film, and plates.

Another camera of interest in this field is the Miniature Speed Graphic, a focal plane camera of the newspaper type for which many useful accessories are available. Both these cameras are tops in their class and well worth their cost, if the user needs what they have to offer.

Press Cameras

For almost a generation the press photographer was invariably presented as a go-getting individual armed with a formidable instrument called a Graflex. Later, some deserted the Graflex in favor of the more compact Speed Graphic Camera. Today, many newsmen use a miniature part of the time, but the aroma of the press still clings to cameras of the Graflex and Graphic type.

With good reason, too. The Graflex, for example, is a husky camera capable of anything from portraits for the society page to action shots in the murk of a water front fire. It is equipped with a focal plane shutter with speeds up to 1/1000 of a second, and a lens seldom, if ever, faster than $f/3.5$, ($f/4.5$ is average). Viewing and focusing are done by means of a reflex finder. The taking lens projects the image it "sees" onto a mirror which in turn reflects it upward where it can be seen, right side up, on a glass surrounded by a protective hood. When the exposure lever is pressed, the reflex mirror springs up out of the way and, instantaneously, the slit in the focal plane shutter whips down in front of the film.

The Speed Graphic camera retains the focal plane shutter, but omits the reflex viewing and focusing. If there's time for it, viewing and focusing can be done on a ground glass in the back of the camera. Otherwise, focus is determined either by racking out the lens in accordance with your best guess at the distance or by means of a range finder incorporated in the camera. Usually Graphic-type cameras have a between-the-lens

shutter in addition to the focal plane shutter as a matter of convenience in making slow snaps or time exposures. Too, the currently universal use of flash synchronizers in press work appears to favor the between-the-lens shutter, although synchronizers for focal plane shutters are now available and reliable.

The synchronized Photoflash, by the way, is not limited to press

A big miniature, the Medalist

A reflex camera, the Graflex

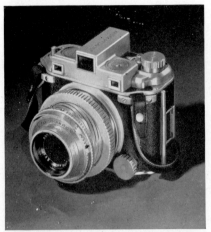

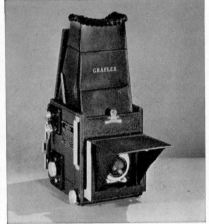

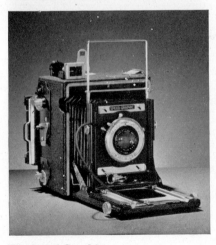

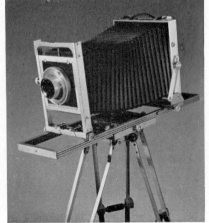

The Speed Graphic

A studio "view" camera

cameras. In fact, there are now Brownies with built-in flash equipment. Synchronizers for simultaneously opening the shutter and firing flash bulbs are available as accessories for practically any camera. Flash technique is an interesting special phase of photography, about which there'll be comment in the chapters dealing with interior photography and action.

View and Studio Cameras

The time-honored spectacle of a bulky camera on a tripod, with a man behind it, half hidden under a black cloth, is the trade mark of all view and studio cameras. They are intended for serious, deliberate work, and, as such, are often recommended for students in photography.

The view camera differs from other cameras in that it can be adapted easily for use with a wide variety of lenses, in its great bellows extension, in the fact that the ground glass is its only view finder, and in its adjustments which permit correction or distortion of perspective. Usually, the lens is stopped way down for maximum depth and detail, and the shutter time often runs into several seconds or even minutes. It loads with either sheet film or plates.

It is entirely possible to use a 4 x 5-inch view camera as a hand camera, but tripod operation is far better and easier. Recent improvements in view camera design and construction have added a new interest to this type of equipment. It is not impossible that there will be a swing to the view camera as a kind of reaction from the intense popularity of the miniature. Certainly the view camera gives its user the absolute maximum in control and flexibility. You can buy a good one, without lens, for about sixty dollars; if you're interested, you might try out an inexpensive second-hand one. There's no better photographic "trainer."

Studio cameras are essentially big view cameras. In most cases, they load with 8 x 10-inch film or plates, although an 11 x 14-inch camera is not unusual. Some studio cameras are mounted on elaborate supports, with as many gadgets to twist and whirl as you'd find on an anti-aircraft gun. There are dozens of special-purpose cameras, such as those used in photoengraving, but they fall well beyond the scope of our present concern.

Once you have a reasonably good camera, concentrate on it. Study it. Read all that its makers have written about it. If your camera is a really good one, it can serve you faithfully for many years and, in its potential capability, continue to inspire and lead you on.

Lenses

No LIGHT—NO PICTURE. This is a photographic fundamental which we sometimes forget. We tend to become preoccupied with new processes, new fast films, and new, faster lenses. Very naturally, we feel that light doesn't matter and that the day will soon come when we can make pictures in complete darkness. That day is infinitely remote, however, for without light of some sort (light which may even be invisible, as far as our eyes are concerned) there can be no photograph.

Since light, then, is the basis, the without-which-nothing of photography, it seems reasonable to consider the nature of it, and the way it behaves.

Light is one of a large group of energy-types, all of which travel radially from their points of origin, in waves. For the simplest form of radial wave action, consult your nearest swimming pool. Drop a pebble into the middle of it, and watch the waves spread, in expanding circles, until they reach the edge of the pool. But waves of this type are slow and clumsy compared to waves on which, for example, sound is carried through the air. And sound waves are slow compared to the waves on which radio impulses are carried. Light waves travel at the same speed as those of radio impulses, but they have a different wave-length classification.

It is in this difference of wave length that light achieves its personality, its visibility. Radio wave lengths, for example, are long, measured from the crest of one wave to the crest of the next. The ordinary broadcast wave lengths run from 545 meters to about 187 meters long, with special short wave transmissions traveling on waves as short as 10 centimeters, or about 4 inches.

But light waves are vastly shorter, beginning at .00008 cm. with the deepest visible red light and winding up at .00004 cm. for the point where

violet merges into ultraviolet. Of even shorter lengths than ultraviolet waves are the X-rays, the Gamma Rays, and radiation associated with Cosmic Rays.

SHORT WAVELENGTHS				I CM.	LONG WAVELENGTHS	
COSMIC RAYS	GAMMA RAYS	X-RAYS	ULTRA-VIOLET RAYS	INFRA RED OR HEAT RAYS	HERTZIAN WAVES	WAVES USED IN RADIO BROADCASTING

VISIBLE LIGHT

In the whole spectrum of radiation, visible light occupies a very thin section. And it will undoubtedly become relatively thinner as we learn more and more about ultra-long and ultra-short waves. But thin as that slice is, it is all-important.

Because light and radio waves have a family resemblance, you can think of your camera as a kind of receiver—an optical radio set designed to capture and reproduce light rays. But there's no need to complicate photography by elaborating on this parallelism; it is in the special qualities of light, in its own peculiar behavior, that photographers are interested.

Here Are Five Basic Generalities About Light:

1. (Light waves travel in straight lines;) they travel in an infinite number of straight lines radiating out from any specific point of origin.

2. (Light can be deflected or reflected, as by a mirror.) And the rule of Physics I, that "the angle of reflection equals the angle of incidence," holds comfortingly true.

3. Light can be bent (refracted) and sent off on a new path by a prism, a fact relied on in designing lenses.

4. Light can be absorbed. A piece of black felt, for example, absorbs most and reflects a minimum of light, whereas a shiny white surface reflects a maximum, absorbing only a little light.

5. Light can be systematically filtered, so that some of its component qualities are absorbed and the rest passed on, unaltered.

Photography makes use of all of these characteristics. For example, photography is concerned—just as our eyes are concerned—primarily with light which has been reflected (No. 2 in the list) and absorbed in varying degrees (No. 4). We are seldom interested either in looking

at or picturing a light *source* such as the sun or an arc-lamp; our concern is with the light from that source which has been reflected by an object or a scene. On the degree to which an object reflects and absorbs light depends its visibility. In complete darkness you cannot see a sheet of white paper held in your hands. It's invisible, for there is no light for it to reflect. Turn on a light, and the paper instantly becomes visible, reflecting light generously, with just enough absorption to give you a good idea of its texture. Photography, like the sense of sight, is almost exclusively concerned with light which has been reflected, refracted, absorbed and otherwise affected.

Nowhere, however, is the application of these fundamentals more interesting than in the lens—the lens which is the most important single component of your camera.

It's important but not, oddly enough, wholly indispensable. We *could* struggle along without lenses, but it would be a fearful struggle and photography as we know it today simply would not exist.

Pictures Through a Pinhole

Ever hear of a pinhole camera? It's a little box, very much like a Brownie camera in shape, but it has no lens in the front of it. Instead, there's a fine, clean pinhole. With such a camera it is entirely possible to make pictures. Here's how. With a piece of film in place inside the back of the camera, the little box is placed on a tripod, aimed at any subject which will stand still for a while, and the pinhole uncovered. An exposure of several minutes is usually required. During those moments this is what goes on.

Waves of light "broadcast" from, for example, a pair of automobile headlights, enter that pinhole and, continuing in straight lines, go on back to the light-sensitive film. Almost an infinite number of rays from these lamps strike the front of the camera, but all are excluded except one from each point in the source. These admitted rays cross one another while passing through the pinhole. Thus, rays from the right are imaged on the left side of the film and vice versa, and the image is inverted.

At the end of a fairly long exposure, possibly several minutes, the camera is closed and the film developed. You'll have an image—a pretty good image, too. It won't be as sharp as a good snapshot, but it won't be too bad.

The trouble, of course, is that you need to let more light into the

25

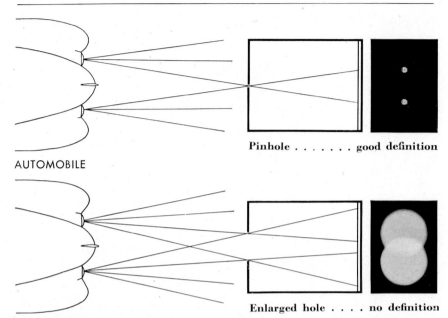

Pinhole good definition

AUTOMOBILE

Enlarged hole no definition

camera and thereby cut down the exposure time. If, however, you enlarge the pinhole to permit more light to enter, you further decrease your sharpness because you get a little cone of light from every point in the scene. The cones from neighboring points overlap, and you get a really first-class blur. The illustrations above compare the possible and impossible of pinhole photography.

The pinhole camera is a pleasant little scientific novelty, but it simply will not suffice for modern photography. A lens is needed to admit more light and to control it.

The specific characteristic relied on in designing a lens is that light is bent or *refracted* as it passes from air to glass, or glass to air. An extreme close-up view of refraction may serve to clarify its significance.

Here an enlarged light ray traveling in air approaches glass, where it is

destined to be slowed down because glass is more dense than air. Because the ray is approaching the glass at an angle, one side of it will strike sooner than the other, hence will be slowed down while the other side continues unimpeded for a while. This uneven "pull" on the ray changes its direction. It's much like an automobile with faulty brakes. When the brakes grab hold on one side before the other, the car swerves to the side first slowed down.

Now, once the light ray is wholly in the glass, it continues on a new straight line course through the new medium. When the light emerges from the other side, when, as it were, the brakes are released, light automatically speeds up to its usual rate of air travel, 186,000 miles per second. One side of the wave front, because it is released first, gets ahead and pulls the whole ray around into the new direction.

By changing the slants of the glass surfaces, the side of the ray emerging first, the side exerting "pull" on the ray, may be controlled. Light passing through a prism, then, would run as indicated below.

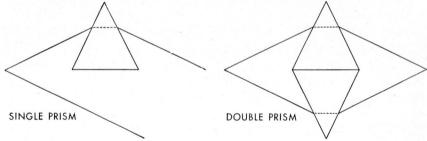

SINGLE PRISM DOUBLE PRISM

But now take two prisms and put them base to base. And look what happens. Along comes a second ray of light from the same point entering the lower prism. The bending action of the prism sends those light rays on so that they again come together.

Now, having gone that far, take the next obvious step. Get a lens maker to make, in a single piece of glass, a complete circle of prisms, all base to base. And the combination of a practically infinite number of prisms, all ground to a scientific nicety, gives a vastly greater convergence of light rays from any one point. If there's a film at that meeting place, we gain by the impact of much more light than we had in the pinhole camera, which could accommodate only one ray from any one point. Obviously, then, we need no long exposure, as with the pinhole camera; for we are blessed with vastly more light falling onto our film.

27

That's a tremendous step ahead, but it doesn't quite solve the whole problem.

The very fact that a lens is accurately made so that it bends light in a very definite, predetermined way introduces a new problem—the problem of focus. As long as the subject being photographed is at a certain, specific distance, and so long as the lens-to-film distance coincides with the plane in which the lens brings light rays together, all is well. But when either of those distances is changed, trouble arises.

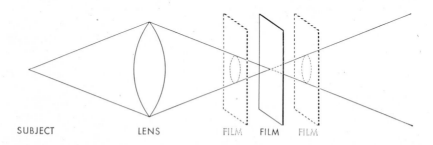

SUBJECT LENS FILM FILM FILM

Here's what happens when the lens-to-film distance is changed. Light rays from any point in the pictured scene are converged, by the action of the lens, so that they approach the film in a cone-shaped formation. Obviously, if the rays encounter the film in front of or beyond the place where they all come to a point, the resulting image will be a circle—a cross-section of the cone-shaped formation. This circle is called, in photography, the *circle of confusion*, and a better, more down-to-earth name would be hard to find. For, when the rays from millions of points in a pictured scene are imaged on the film not as points but as little over-lapping circles, confusion is what you get.

Much the same situation arises when the lens-to-subject distance is changed while the lens-film distance remains unaltered. For the angle between the paths of a ray of light as it enters and leaves a lens is practically the same, no matter what the distance may be between the source of that ray and the lens.

The lens, in a physical sense, acts as a sort of pivot or fulcrum for the complete, subject-to-focal-point travel of the ray. Therefore, the closer the subject, the farther back the point of convergence; and the farther the subject, the nearer the converging point.

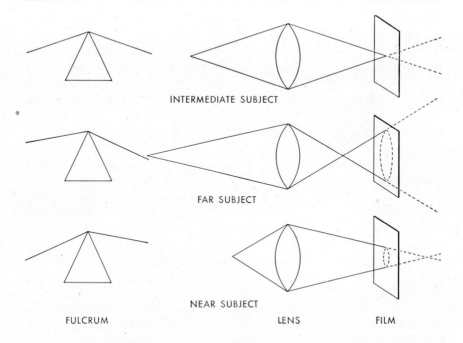

INTERMEDIATE SUBJECT

FAR SUBJECT

NEAR SUBJECT

FULCRUM LENS FILM

Obviously, then, if the film is placed at the converging point for rays from one subject distance, as in the top sketch, objects at considerably greater or shorter distances will be imaged as circles of confusion instead of points.

Box cameras have small lenses and produce their best results when used to picture objects about 15 feet away. In manufacture, the lens-to-film distance in the box is adjusted for pictures at this distance. Obviously, points imaged on the film from other distances should appear as circles of confusion. And they do, but the circles are so tiny that the average user of this type of camera doesn't mind. They are tiny because the lens is so small that there is very little difference in the angles of light striking the lens from points 15, 25, 50, or 100 feet from the camera.

With large-lens cameras, this fixed adjustment is impossible. If a camera with a large lens were focused for pictures at 15 feet, attempts to picture objects at 50 feet would be utter failures.

Therefore some means has had to be devised to make the lens-to-film distance variable, so light rays from any specific distance can be con-

29

verged on the film as points, not as circles of confusion. This, in short, is what is meant by *focusing a camera*. On a track or screw threads, you move the lens in or out for the sole purpose of adjusting the lens-film relationship to meet the requirements of your picture.

For close-ups you need maximum lens-to-film distance; for shots of distant objects, beyond a hundred feet or so, the lens-film distance is considerably less. Thus, by mounting the lens so that it can be moved, a solution to the problem of accurate focus is provided.

The Modern Lens Is a Masterpiece of Precision

Important research carried on during the past few years has produced a means of eliminating flare and of actually increasing the light-transmitting properties of glass. It involves the treating of interior air-glass surfaces with a chemical. Naturally, it has started scientists off on new researches which will undoubtedly produce other refinements before long. The fine modern lens is a masterpiece of precision, but there is every indication that the lens of tomorrow, or the day after, will be a still finer thing.

By the way, if you've grown up with the old inferiority-complex notion that American-made lenses aren't as good as lenses made abroad, you'd better get rid of it. It simply isn't true. And important advances in the chemistry of glass making have recently been announced in this country. The Eastman Kodak Company has a radically new optical glass of a rare-element type. It is made from compounds of tantalum, tungsten, and lanthanum, and contains little or no silica, the basic component of other optical glasses. It is distinguished by its very high refractive index (light-bending power) and by low dispersion (spreading of the individual colors). Most of the advances in lens making have been made possible by the application of new kinds of glass, often differing only in a small degree from previous types. It may be expected therefore that this entirely new kind of glass will lead to the production of lenses superior to any known before.

A LENS FOR YOUR CAMERA

The business of fitting a lens to a camera is not at all haphazard. It must be done with considerable care; otherwise the result could be grotesque— as grotesque as a light car fitted with a submarine Diesel engine.

The two major characteristics of a lens, the characteristics which give

the photographer the fundamental facts he must have before he starts to use a lens, are its focal length and its *f*-rating.

Focal Length (F) is almost a self-defining phrase. It means, simply, the distance from the lens to the plane (called the focal plane) where approaching parallel rays of light are brought to a point by the lens, so that a sharp image is formed.

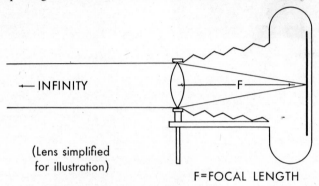

← INFINITY

(Lens simplified
for illustration)

F=FOCAL LENGTH

Since all rays of light approaching a lens from a point at infinity are parallel, the focal length is the distance of the image from the lens when the subject is at infinity. Even though focused on a close-up subject or completely removed from the camera, the lens' focal length never changes, for it is a result of the fundamental design to which the lens was ground.

A camera is generally fitted with a lens having a focal length roughly equal to the diagonal of the film to be used in that camera. The diagonal of a 2¼ x 3¼ film is slightly less than 4 inches; hence, most 2¼ x 3¼ cameras are equipped with 4-inch lenses. Some cameras are sold without lenses. In such cases, selection of the right lenses becomes a responsibility of the purchaser. So, remember the "rule of the diagonal."

Perspective

A word about perspective—the apparent relation between objects, as to position and distance, as seen from any given viewpoint. Lenses of differing focal lengths give you the same perspective but, because they vary in the area they cover, they create a different effect. The longer the focal length of a lens, the narrower its field of view. Yet if you enlarge a negative made with a short focus lens and limit its field of view to that of the

31

of your lens, but much more often you can do better by working at a considerably smaller lens opening.

The major difficulty with a wide-open, high-speed lens is the shallowness of its *depth of field*. "Shallow depth of field" sounds a little odd, of course, but *depth of field* is a specific, measurable quality and it can be either deep or shallow, depending on circumstances which you can con-

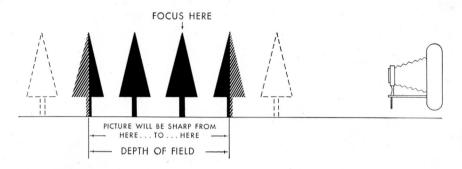

FOCUS HERE

PICTURE WILL BE SHARP FROM HERE...TO...HERE

DEPTH OF FIELD

trol. The depth of field is the distance between the points nearest to and farthest from the camera that appears in sharp focus.

A glance at the sketches below will probably illumine this subject more effectively than words. But at worst, it's not a tough matter. Simply think back to those cones of converging light rays mentioned in the

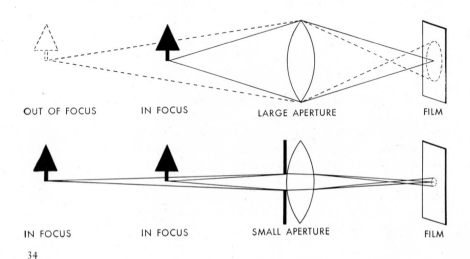

OUT OF FOCUS IN FOCUS LARGE APERTURE FILM

IN FOCUS IN FOCUS SMALL APERTURE FILM

paragraphs on *focus*. When the lens aperture is relatively large, the angle between the converging rays from any point is large. Naturally, then, the circle of confusion becomes larger very quickly, fore and aft of the focal point. Because this is equally true for rays from all other distances, objects in front of or beyond that object quickly fall out of focus. In other words, the *depth of field* is shallow. But when you stop down your lens to, say, *f*/22 your converging cones are very slender, and the circles of confusion remain small for objects that are a considerable distance on either side of the one focused upon. Thus you obtain great *depth of field.*

It should be noted again that an extremely small circle of confusion does not produce a noticeable blur or out-of-focus effect. The eye may not even distinguish between a minimum circle and a point. It is within these limits of negligible circles of confusion that depth of field is calculated. What constitutes a maximum allowable circle of confusion is a matter which must be determined on the basis of the kind of work a camera may regularly be called on to do and the conditions under which the pictures so made are apt to be viewed. Obviously the finer detail to be reproduced, the smaller the tolerable limits of the circles of confusion. The allowable limit is really a function of the focal length. In calculating depth of field tables, the circle of confusion is arbitrarily established at 1/1000 of the focal length. Thus for a 5-inch lens the circle of confusion should not exceed 1/200 inch, for a 2-inch lens 1/500, and for a 10-inch lens it can be as large as 1/100. Thus when pictures made with these different focal length lenses are printed to the same image size, the depth in all is equal.

Determining Depth

Some cameras have *depth of field* indicators—little dials by means of which you can determine the extent of the fore-and-aft sharpness in any picture you contemplate making. As you study such a dial you will discover a very interesting phenomenon: *depth of field* tends to decrease rapidly as you close in on a subject. For example, in using a good modern lens in an average size camera you'll note that when you focus on a subject 25 feet away, your depth of field at *f*/4.5 is from about 21 to 37 feet, and at *f*/16 from about 13 feet to infinity. But when you focus on a subject only 6 feet away, the depth of field at *f*/4.5 is only from 5¾ feet to 6½ feet, and at *f*/16 it is still only from 5 feet to about 7¾.

The reason for this interesting state of things will be found in another

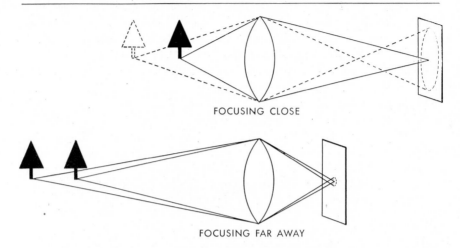

FOCUSING CLOSE

FOCUSING FAR AWAY

consideration of circles of confusion—and in careful viewing of the sketches. Since the images of more distant objects all fall into about the same plane, the depth of field for distant subjects is considerable. However, close-up subjects, even though very close together, are imaged in quite separate planes; hence, they cannot be simultaneously focused. The closer the subjects get to the lens, the greater the separation of their images—and the less the resulting depth of field.

Depth of field, then, depends upon four items. They are here listed, together with their effects when the other factors are held constant.

1. *Focal length*. The shorter the focal length the greater the depth of field. Miniature cameras have short focal length lenses and therefore greater depth of field. Relatively and geometrically, there is no difference between a long and a short focal length lens; the difference which accounts for the greater depth of field is simply one of the actual, measurable size of the lens opening. Thus a 4-inch lens has to be set at $f/8$ to give a geometric depth equal to that of a 2-inch lens set at $f/4$.

2. *The f-number*. The larger the f-number (smaller the opening) the greater the depth of field.

3. *The distance focused upon*. The farther the subject is from the lens the more will be in focus in front of and behind the subject.

4. *The circle of confusion*. The larger the circle of confusion to be tolerated before the picture is pronounced as unsharp—the greater the depth of field.

Putting three of the "depth" factors into mathematical combination, the *hyperfocal distance* can be calculated. The hyperfocal distance is the point nearest the camera which can be considered *in focus* when the lens is focused at infinity.

$$\text{Hyperfocal distance} = \frac{\text{Focal length multiplied by itself}}{f\text{-number x the circle of confusion x 12}}$$
$$\text{(to convert the answer into feet)}$$

or in formula

$$HF = \frac{F^2}{f \text{ x c.c. x } 12}$$

Using this new concept you can then calculate the near and far points of sharp focus for any distance setting.

$$\text{Near Point} = \frac{\text{Hyperfocal distance x distance focused upon (d)}}{HF + (d - \text{Focal length})}$$

$$\text{Far Point} = \frac{HF \text{ x d}}{HF - (d - F)}$$

$$\text{Depth of Field} = \text{Far Point} - \text{Near Point}$$

Example

What is the depth of field when using a camera with a 6-inch lens at $f/8$ focused at 10 feet and assuming a tolerable circle of confusion (c.c.) of 1/200?

$$HF = \frac{F^2}{f \text{ x c.c. x } 12}$$

$$HF = \frac{36}{8 \text{ x } \frac{1}{200} \text{ x } 12} = \frac{36}{\frac{96}{200}} = 36 \text{ x } \frac{200}{96} = 75 \text{ feet}$$

$$\text{N.P.} = \frac{75 \text{ x } 10}{75 + (10 - .5)} = \frac{750}{75 + 9.5} = 9 \text{ feet}$$

$$\text{F.P.} = \frac{75 \text{ x } 10}{75 - (10 - .5)} = \frac{750}{65.5} = 11.5 \text{ feet}$$

$$\text{Depth of Field} = \text{Far Point} - \text{Near Point}$$

$$\text{Depth of Field} = 11.5 - 9 = 2.5 \text{ feet}$$

There's an interesting side light on this business of depth of field. Many amateurs grow up in photography with the definite notion that a small lens aperture produces finer detail not merely over a deep field but even on the subject focused upon. If there was a billboard to be photographed at 50 feet, they religiously stopped down after focusing exactly for 50 feet. The truth of the matter is that stopping down gains little or nothing under those circumstances. If the focus is exact, you get the same definition in photographing a flat subject (perpendicular to the axis of the lens) no matter what aperture you use. This generality, like most, is

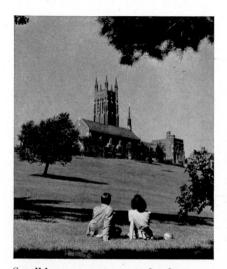 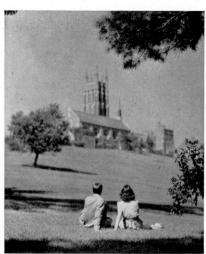

Small lens aperture, great depth Large aperture, less depth

Unwanted background eliminated by use of wide aperture

subject to some limitations, for there is variation in lenses; some have what might be called *optimum* apertures, apertures at which they work best. The theoretically perfect lens provides best definition at full aperture; in practise, the better the lens, the greater the optimum aperture. Only experience will give you a full understanding of your lens.

Depth of Field Experiment

Object:
To determine the effect of lens aperture and subject distance on depth of field, and to compare results under practical picture-making conditions with mathematically computed depth.

Equipment:
A focusing camera (preferably 2¼ x 3¼ or larger) on which the lens aperture data is marked.

Procedure:
PART 1

Photograph a distant (infinity focus) subject, first with a small lens aperture, then with a large lens aperture, adjusting exposure time for correct exposure. Repeat procedure for a subject less than 10 feet distant. If possible, include both foreground and background objects. These will help show the effect of aperture size and subject distance on depth.

Mount the finished prints together on a notebook page for comparison.

PART 2

Calculate the depth of field for your camera when used with the lens wide open and focused on an object 6 feet away. Now make a picture under these conditions and from a contact print, viewed at about 12 inches, estimate the near and far points. The illustration below suggests a subject particularly suitable for this part of the experiment, as the distances can be easily and accurately measured.

Compare the computed figures with those of your observation.

Questions:
1. What factors affect depth of field and what is the nature of their effect?
2. If your observations do not agree with your calculations, might one of these factors account for the difference, (a) incorrect focus in making your picture (b) your liberal or critical observation of the sharpness (c) improper print viewing distance?

Be Camera-Wise

THERE ARE good and bad camera habits, just as there are good and bad driving habits. And the good habits return large dividends, in terms of better pictures and greater personal satisfaction. Good habits, photographically speaking, are based on common sense and scientific facts. Photographs begin, for the most part, as intensely personal things—as ideas. Good photographs are accomplished through the application of established procedures. You can't buck these procedures very long or very successfully. It's a losing fight.

There's endless scope for ideas, inspiration, daring, and originality in photography as an art; it is when photography, the science, is called on as the medium for the art that "rules of the road" become essential.

It doesn't much matter what your basic attitude toward photography may be. For example, you may naturally tend to dream up a picture before you start out to make it. In that case you probably spend considerable time and effort to set the stage, to get models, and select locations before you unlimber your equipment. Your camera will be fairly large, and you'll use a tripod and a set of judiciously selected accessories. On the other hand, you may prefer to get your fun out of picturing spontaneous, unexpected, unrehearsed activity. Your little camera, hung about your neck, comes into play with a swish—and then when the flurry is over, it's forgotten. In either case, your success depends on your deep-seated photographic habits.

The good driver knows his car, knows the "feel" of it, knows when the going is easy or tough, knows what is possible, and what is not. Similarly, the good photographer knows his camera. He knows what it will and will not do; and he knows very accurately when he is pushing his luck. This business of knowing your camera is primarily a matter of experience, but it can be accelerated by a few hours of quiet study with

the unloaded camera. Put it through its paces, get the feel of the various controls.

The better you know your camera, the better care you will give it. Here are a few suggestions for camera housekeeping. Consider them carefully.

The modern camera is a well-made, nicely adjusted mechanism. In average use, it is sturdy enough to go for a year or so without a major overhaul. But it cannot be expected to go on and on, indefinitely. A good camera, like a good watch, deserves respectful care. The wise photographer sees that proper care is administered; it's good picture insurance as well as common sense and economy.

For overhauls involving internal mechanism—the shutter, the iris diaphragm, and other mechanisms—only experts are qualified. Tinkering is definitely out.

But general camera housekeeping can be, and should be, done by the camera owner.

Camera Housekeeping

The most vulnerable part of your camera is its lens. It is precisely made, according to an exact formula; in most cases it is a combination of several glass elements, some of which are cemented together with a resin which is affected by prolonged exposure to light and by heat. So, the first rule of camera husbandry is to keep the lens clean and to protect it from needless harm.

Cleaning a lens is definitely not done by breathing humidly thereon as a prelude to brisk wiping with the nearest handkerchief. If the lens is so thickly coated with dust and grease that some sort of solvent is needed, use a drop or two of a lens cleaning fluid such as Kodak Lens Cleaner or similar solutions supplied by reputable manufacturers of optical goods. Then, wipe it carefully and lightly, with a piece of soft lens cleaning paper or a bit of lintless, clean linen. A soiled cloth may have dust in it which can easily scratch the carefully polished lens surface.

Most of the grease found on dirty lenses comes from fingers; it is an excellent idea, therefore, never to touch the glass surface. The chances of getting dust and grit on a lens are better during periods of camera inactivity than during actual picture making. If your lens doesn't fold back into the camera body where it is covered, keep your camera in its case or in a drawer where it will be well protected.

A flagrant—almost pictorial—case of lens flare.

Dust sometimes seeps into the interior of a camera, too, so make it a habit to keep the inner face of the lens and the inner surfaces of the camera itself as clean as possible. Free dust inside a camera is attracted to the smooth, faintly sticky surface of film—and dust on film means tiny black specks on your finished pictures.

Some photographers feel that a camera case is a bit of needless ostentation. They are sadly mistaken, for a case not only helps to keep a camera clean, but protects it from casual bumps and injuries. And cameras do need that protection. One of the easiest bad habits to acquire is that of stowing a camera in the glove compartment of an automobile. It is, true enough, a handy place for it, but it's a dangerous place too; for in summer it gets very hot in there, so hot that both film and lens can be seriously affected.

Among the good habits to cultivate, then, are camera cleanliness and protection from shocks and heat. To those add such other simple, common sense habits as these:

1. Load film only in subdued light, never in direct sunlight. The backing paper and packing provide excellent protection for films; with reasonable care all danger of light fog can be eliminated.

2. When the camera is idle, keep it in a dry, clean place.

3. All mechanical tensions should be relaxed during inactive periods. The shutter should not be left cocked. If you happen to own a focal plane camera of the Graflex type, be sure to cut the spring tension down

to zero when you put the camera away after use. Otherwise the spring tends to lose its strength and the shutter speeds will become unreliable.

4. If the youngsters in your home must have a camera to play with, get them an inexpensive box camera. Don't permit careless or mischievous hands to get at *your* camera, for bumps and dents do it definite harm. And marks from small, warm fingers can raise hob with any lens.

5. Have your camera inspected regularly—about once a year. Such an inspection should include a check for light leaks in the bellows and internal dirt in the lens. Too, the functioning of diaphragm and shutter should be tested, along with the means by which film is kept firmly flat in its proper place. Such an inspection need not be expensive nor time-consuming.

So much for camera care. Now about habits of camera use. Assume you are about to start off with your camera, with known or hoped-for picture opportunities ahead.

What kind of film is in your camera? If it has been a week or so since its last outing, you may have forgotten what type of film you loaded last time. And you've misplaced the empty carton. Of course, if you're using sheet film, you can identify the film, in a darkroom, by its notching code. But all that is a lot of trouble. So why not make it a habit to put a little tab of Scotch Tape on your camera or film septum when you load it? On that tab you can indicate the kind of film and the date. Thus your uncertainties are dissipated.

Another thing. If the camera is still loaded, was the film advanced after the last exposure? Once the question is raised, you're likely to get panicky and move to the next frame or film, just to play safe. More often than not, that means a wasted film. So spike that question and its attendant panic by establishing a rigid habit as to film winding. Two things favor winding the film after each exposure. For one, you are better prepared for a sudden picture opportunity. Then too, most people find it more natural to change the film *after* making the exposure. It's like spacing after a word when you're typing. There's an uncouth couplet that may amuse you and help in your habit formation. It runs,

> *You're out on a limb*
> *When you don't wind that "flim."*

Now to get on with preparations. How about extra film? There's seldom need to carry many extras, but ordinary reasonableness suggests one extra roll, or pack, or sheaf of film holders. At any rate, don't expose

yourself to the tragedy of reaching the pictorial climax of your expedition—with all your film shot.

Make it a habit to carry along no more than the one or two filters which the weather and the type of pictures you hope to make call for. And, if you haven't learned how to make good pictures without filters, leave the filters at home.

Don't Shoot Until—

When it comes to actual picture-making habits, here's one that is so simple, so logical that it's easy to forget. *Use your view finder.* Your eyes and mind may be dazzled by some widespread view, but your camera simply isn't interested in anything beyond the confines of that rectangle of space shown in the finder. If yours is a direct view finder, with separate front and back sights, hold it close enough to your eye to enable you to see the inner frame of the forward sight. You may be able to do this with eyeglasses on, or you may have to take them off, depending on your vision and the type of glasses you wear.

Most view finders are designed so that their fields of view match those of the camera lenses at average snapshot ranges. However, with close-up subjects, the respective fields of view tend to separate because the lens and view finder are generally placed several inches apart. This discrepancy between the fields embraced by view finder and lens is what photographers refer to in speaking of *parallax*. To correct for it the camera must be pointed slightly toward the view finder side. The experiment following this chapter will aid you in determining the extent to which you will have to compensate for parallax.

If you've come to know your camera as well as you should, you'll

"Scalped" subjects are the commonest results of unconsidered parallax.

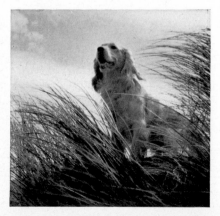

realize a small fact which many overlook. In all cameras whose lenses are equipped with iris diaphragms, it is entirely possible to set the lenses at points *between* the marked *f*-numbers. Thus, if you feel that *f*/5.6 is a shade too much and *f*/8 a bit on the tight side, there's nothing to prevent you from setting the lens between those two points, at about *f*/7, which is probably not a marked stop on your lens. This is not necessary in black-and-white photography, but may be in color work.

The same type of practice is not suggested for shutter speeds. Better shutters have a stepped speed cam; hence you'd better stick to the indicated speeds.

Getting the Range

Now about safe and sane camera focusing. The basic rule is: For distances of less than 25 feet, your focus setting must be accurate; distances less than 6 feet require a tape measure, unless you are working at a very small aperture; for distances of 50 or 75 feet, your permissible error is fairly large; and for distances of 100 feet or more, set the lens at infinity.

Closely related to the focusing problem is the phenomenon of depth of field—or the extent to which your lens gives you sharp detail fore and aft of the point on which you focus. In most average work you probably want as much depth of field as possible—and you get it by using the smallest lens diaphragm opening consistent with adequate exposure. Sometimes, however, in making a close-up you may wish to obscure an undesirable background; you do it by using the maximum lens aperture. The optical laws governing depth of field were briefed in the chapter on lenses.

This business of depth of field explains why accurate focus is so important for close-ups and medium shots. Outdoors, where light is plentiful, you can gain a little leeway by closing down, but indoors, where the light is usually only fair, you are forced to be accurate—really accurate.

If you have a range finder on your camera or as part of your equipment, use it as a means of checking your own distance judgment and not as a crutch on which you are helplessly dependent. If you have no range finder, you can check your estimates by walking them off. The average healthy adult walks along at the rate of five feet to two steps; thus you can check a distance by walking it, casually counting by fives at each second step.

Next to inaccurate focus for close-ups, the commonest source of

45

trouble for most amateurs is camera shake—a movement of the camera, as the shutter is tripped, which results in loss of precise detail throughout the picture. Two preventives are respectfully offered. First, learn to handle your camera so that the shutter is worked by one finger, trigger fashion, while the other fingers and all of the other hand work together to hold the camera steady. Stand firmly, legs apart; give the camera support not only with your hands, but with your body; if you're using an eye-level finder, snuggle the camera up against your cheek bone. The second preventive is to use sufficient shutter speed. Even with average care with miniatures you'll need 1/100 and, for most folding Kodaks, 1/50.

Photography is a year 'round proposition and good habits are always in season. However, there is one additional point you should keep in mind during cold weather. Camera, lens, and film steam up when you take them from the cold into a warm room, but not when taken from warm to cold. Shutters may slow down, too, at low temperatures. So when you go on winter hikes, ski trips, and such, keep your camera under your coat or jacket, close to your body, removing it just in time to make your picture. When you take it into the house, allow time for the condensation to dry before you make any pictures.

The lens in any good camera is more versatile than you may suspect. You may be a long time in discovering its many aptitudes. And supplementary processes, especially enlarging, can make up for some of your lens' admitted inabilities. But, even so, the time will probably come when you need to make close-ups—portraits, copies of drawings or manuscripts, and similar close-range jobs—which your equipment, as it is, may not be able to handle. In that event, you can use a supplementary lens—a simple little affair that slips over the camera lens. There are several Kodak supplementary lenses—a portrait attachment for use with simpler cameras, and the Kodak Portra lenses, 1+, 2+, and 3+. To bring far objects closer, there's another series of supplementary lenses, the Kodak Telek 1−, 2−, and 3−, which need ground-glass focusing. Such supplementary lenses, properly used, can be among your most valuable accessories.

Speaking of accessories, there are so many of them, and they are all so interesting that the temptation is to load up with them. At the start, fight off that temptation. Later on, when you know exactly what you and your camera can do all by yourselves, you may discover that the appropriate gadgets really can help. But don't be impatient. Remember that

a good camera, well used, will produce consistently better results than a mediocre camera cluttered up with extras.

Finally, don't count on luck. Luck is notoriously unreliable; the only certainty about it is that it will desert you when you need it most. If you know what you want to do, and how to do it, you can dismiss luck forever. And good riddance.

Parallax Experiment

Object:

To determine the degree to which a direct view finder departs from the camera view when used for composing close-up pictures.

Equipment:

A camera with a ground glass focusing back and a direct eye-level view finder having no parallax correction. A tripod.

Procedure:

Set the camera up on a tripod ready to make two exposures of a subject six feet from the camera. For the first of these, use the ground glass back for centering the subject on the film. For the second, use the direct view finder. Move the camera up to four feet from the subject and take two more pictures, one centered by ground glass, one by the direct finder.

If you have a portrait attachment, slip that onto the lens. Make two exposures with the pictures centered as above.

Mount the prints for each distance side by side and decide just what allowances you must make for parallax when using the direct view finder for subjects close to the camera.

Question:

Why does the degree of parallax correction needed differ from one camera and finder to another?

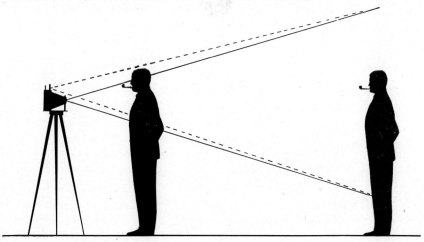

Camera Motion Experiment

Object:

To determine how fast the shutter speed must be to eliminate blurred images resulting from motion of the camera when hand-held.

Equipment:

A camera with adjustable shutter speeds.

Procedure:

Focus the camera on a subject composed of many right angle, sharp lines. The side of a house at a distance of 30 feet from the camera is excellent for the purpose. Hold the camera at waist or eye level. Make exposures at all marked shutter speeds, including a short "bulb" exposure and a time exposure of about 2 seconds. Adjust the diaphragm (f-number) in each instance to obtain correct exposure.

After development and printing, examine the prints with a magnifying glass. It will be readily noticeable that, as the shutter speed was increased, the lines became sharper and more clean cut. You may discover that 1/5 second gave you a sharper picture than 1/25. Put that down to sheer luck. Such accidents happen, but they are the exceptions which prove the rule that slow shutter speeds demand camera support.

From a study of the pictures you will readily determine the point, in the range of exposure speeds, at which it is safe to hand-hold a camera; for slower speeds, obviously, a tripod is indicated.

The effects of camera motion may not be apparent in small prints, but enlarged details thereof tell the story. Shutter speed, left, 1/25; right, 1/100. Moral: for hand held shots avoid slow shutter speeds.

Films

To REPEAT, the most important part of any camera is the person who uses it; and a close runner-up is the camera's lens. But no camera, no matter how excellently lensed or how artfully handled, really amounts to much until there's a light-sensitive film in place within it, ready to record the image the lens permits it to "see" at the behest of the photographer

Oh sure—film. Film's the stuff you buy at your photographic dealer's. It comes in rolls or packs or sheets; you shove it into the camera and you're all set. Anybody knows what film is. There's no reason at all why people should regard film with any more respect than is accorded electric light bulbs or radios or newspapers or any of a hundred other commonplace modern miracles.

However, old timers cannot achieve that same casualness about today's film. They know how tough it used to be in the old days when they had to prepare their own plates for all their pictures. It was a tricky business, usually carried out under difficult conditions. For field work, a whole wagonload of equipment was necessary; a light-tight tent was one of the vital items. The plates were almost invariably glass, heavy, hard to handle, and very easy to break. To get the light-sensitive coating on smoothly was, even in the home studio, a combination of skill and luck.

Yet, the pioneer photographers not only succeeded in making plates, they made good plates and very good pictures. Possibly one reason why they made such good pictures is the fact that so much prayer, proficiency, and perspiration went into the preparation of each single plate. Every exposure *had* to be right. They simply couldn't afford hit-or-miss photography.

It is not suggested that today's neat, lightweight, convenient photographic film be revered merely because our uncles and grandfathers had

to achieve its prototype in the hard way. But it is suggested that film be respected for itself alone and for its remarkable capabilities.

Every photographer, at an early point in his career, succumbs to the temptation to look at a piece of undeveloped film in full light. But there is no outward clue in the innocent looking thing to its almost magical potentialities. Ordinary film consists of a support of flexible, transparent material on which there is a smooth, cream-yellow coating. You can easily scratch this coating or wash it off with hot water. On the back of the film is a dye, perhaps blue, green, or red. But all such casual investigations mean nothing. For the miraculous virtues of film are totally invisible.

The Emulsion

Film achieves its photographic usefulness because it carries, suspended in that yellowish coating, millions of microscopic crystals of silver bromide. And silver bromide is light-sensitive; it registers its encounter with light by turning black later on, during the process of development. On that central fact depends the whole structure of photography—the science, the art, the "useful citizen," and the hobby that is photography.

The making of modern film is one of the most scrupulously controlled processes in industry. Maximum cleanliness is vital in every step, and many of those steps have to be taken in darkness. Temperatures have to be maintained at precise levels; relative humidity must be constant; the thickness of the supports and of the coatings must be uniform—and so on throughout the whole manufacturing process.

While a number of portrait and commercial photographers still prefer glass plates (made not by themselves, but by the same skilled technicians who make film), the preponderance of today's negatives are made on a flexible base of cellulose acetate or cellulose nitrate.

The Support

This film support is, in itself, insensitive to light. Its purpose is to provide a transparent, firm, yet adequately flexible and chemically stable base for the film emulsion. In the manufacture of film support, cotton is first treated with either acetic or nitric acid and then dissolved in chemicals, of which ether and wood alcohol are the major constituents. The result looks like a clear, thick syrup, affectionately known in the industry as "dope." It is, of course, highly volatile.

Huge, highly polished metal cylinders about 4 feet wide and 20 feet

in diameter revolve slowly as dope is fed evenly onto them. In the course of less than one revolution enough of the solvents are driven off by heat and the dope has gained adequate body to permit its removal from the drums. It then wends its way through monstrous, continuously operating machines where it is fully dried and wound onto great rolls to await its life work as a support for the emulsion.

The supports for roll films and film packs are relatively thin; miniature films and motion picture films are thicker; sheet films generally are the thickest.

Film Manufacture

The making of emulsions (the light-sensitive coatings) is another story, which begins with silver. At Kodak Park where the Eastman Kodak Company makes its film, more than six tons of bar silver are used in an average week. Add the silver tonnage consumed in other photographic concerns and you have a very impressive lot of silver, all dedicated to the making of pictures.

To get back to our story . . . the bars of silver are dissolved in nitric acid, with silver nitrate as the result. Crystals of silver nitrate are formed as the water in the solution evaporates. Then the crystals are washed and purified.

Meantime, gelatin (chemically superior to the kind you buy at the corner store) has been prepared for its function as a vehicle for the light-sensitive emulsion. It is warmed to a syrupy consistency, and silver nitrate and potassium bromide added to it. At this stage, operations must be carried on in almost complete darkness, for the silver and the bromide combine to form light-sensitive silver bromide crystals. The potassium and nitrate unite as potassium nitrate, which is removed from the gelatin by washing. Thus, the crystals of silver bromide are left alone in the embrace of the gelatin. Photographically speaking, this is the emulsion.

Emulsion coating of the transparent film support requires that the emulsion be warmed to a liquid state, and kept at a precise temperature and a constant level in a large trough. From rolls, the film support loops down into the trough and picks up a "skin" of the emulsion. From there the film and its coating travel over a series of chilled drums designed to effect controlled cooling and uniform setting of the emulsion. Next, the coated support passes through long drying tunnels, after which it is wound onto huge rolls.

51

Applied much as are emulsions, the brightly dyed gelatin coating on the back of the film acts to absorb intense light which penetrates the emulsion and support during exposure. If not absorbed, these light rays may reflect from the back of the support or film holder, scatter and create a halo effect around bright points in the image. You've seen this halo in pictures of street lights at night. Because of its function, the light absorbing dye is called an *antihalation backing*. The color is completely removed during development, so as not to interfere with the printing or enlarging.

Here is a cross-section drawing of a typical modern film. It is precision-manufactured, according to an exact formula. Old timers never dared dream of such a thing.

After coating, the film is cut, prepared for use in rolls, packs, or sheets, packaged and made ready for shipment.

The manufacturing process here outlined applies to ordinary, black-and-white film. In the production of color films and special purpose films, many complications and variations are encountered. But, basically, the making of the film you use is much as we have described it.

WHY SO MANY KINDS OF FILM?

In any gathering of picture makers, there is much talk of film. Everyone seems to have his own favorite; obscure trade names are spoken glibly. And you hear knowing references to the "characteristic curve" of this or that film; its speed rating is discussed in terms of several systems; its most intimate qualities are flaunted for general admiration, amazement, or disapproval.

And that is all as it should be. Still, it is possible for the ardent hobbyist to become so preoccupied with these technical details that he never really settles down to picture making; he flits from film to film, seeking some miraculous combination that will automatically give him top speed,

minimum grain, brilliance, full color sensitivity, and an exhibition print from every exposure. Obviously, there is no such golden mean. Modern film offers excellences and virtues undreamed of a generation ago, but the responsibility for good pictures still rests, as it always has and always will, with the individual photographer, his ability to see, his understanding of his camera, the intelligent use of whatever film he selects, and his command of fundamental photographic technique.

FILM'S FOUR BASIC CHARACTERISTICS

Films have these general qualities—color sensitivity, speed, graininess, and contrast. As these characteristics vary, the potentialities of the films vary.

Color Sensitivity

On color sensitivity depends the classification of the film as blue sensitive ("ordinary" or "regular"), orthochromatic, or panchromatic. (We are concerned here, of course, exclusively with the color responses of black-and-white or monochrome film. Color films and color photography are to be treated separately, later on.)

An important distinction between the sensitivity of black-and-white film and that of the human eye is that the film "sees" in terms of *brightness* only, while the eye discerns both *color and brightness*. Thus, while any film is capable of rendering a color and a shade of gray as identical tones; the eye knows better. It is in the selection of a film which will give the desired relation of brightnesses that the photographer must exercise both skill and judgment.

Silver bromide is ordinarily sensitive only to ultraviolet and blue light. However, the addition of certain sensitizing agents to the emulsion during manufacture renders the silver salts sensitive to other colors as well. The colors and the degrees to which the films are made sensitive to them depend upon the particular agents added.

Classed according to color sensitivity, there are three main groups or types of film; each has its own specific usefulness.

Blue-sensitive (ordinary or regular) film is sensitive to ultraviolet and blue only. Also, it is usually high in contrast, a fact which makes it well suited for copying black-and-white line drawings and manuscripts. Where color interpretation is unimportant, it makes an excellent film for commercial studio use.

Orthochromatic ("ortho") film responds to ultraviolet, to blue and

53

green. Such film finds wide usefulness in average snapshot making and in night photography by Photoflash.) It is used widely by professional portrait photographers in making pictures of men, for it reproduces faces with full contrast and character. Ortho film is used commercially when its particular color rendition is desired. Its insensitivity to red means that it can be developed under a red light in the darkroom, a factor contributing to its popularity among those amateurs who do their own developing and printing.

(*Panchromatic* ("pan") film, because it "sees" ultraviolet, blue, green, and red, gives the widest color response and the most natural-looking interpretation of colors in tones of the black-and-white scale.)

Kodak panchromatic films are arbitrarily sub-typed A, B, and C in order of their increasing sensitivity to the longer (red) wave lengths of light.

Type A was the first panchromatic emulsion and was only slightly red sensitive. It is now obsolete.

Type B panchromatic film, slightly more red sensitive, has approximately the same brightness response as the human eye, except in the ultraviolet; it therefore interprets subject brightness about as we do. Where accurate color rendition is important, Type B panchromatic film is best suited, and its smooth rendition of skin tones makes it ideal for close-up portraits of women and children. In view of these several characteristics, Type B films are among the most popular modern emulsions.

Type C panchromatic film has maximum red sensitivity, hence highest speed in tungsten light, a fact which makes it tops for snapshots indoors at night. When used outdoors, this extreme red sensitivity means relatively less blue sensitivity and therefore pictures having good contrast between skies and clouds.

Ortho (left) and pan film differ in interpreting identical subjects.

Film Speed

Now about the second basic film quality, that of *speed*. This is, we are frequently reminded, the age of speed. Just as frequently, though less cheerfully, we are required to face the fact that speed involves sacrifices. Film speed is no shining exception to the rule.

Speed, in the film sense, is simply sensitivity. Greater speed means that good pictures can be made with less light. With less speed, more light is needed. It depends on manufacturing processes, including greater or less "cooking" or digesting of the emulsion prior to the coating. In general, the longer the cooking period, the larger the grains of silver bromide— and the larger those grains, the greater their sensitivity. In the last few years, films have been doubled and trebled in speed, with the result that, today, some of the most common snapshot films have a higher speed than specialized films could boast of, a dozen years ago. But the greater graininess of high speed films involves serious drawbacks.

Graininess

Graininess is usually not sensed in small prints, but when large-scale enlargements are made, it becomes all too visible, presenting a mottled appearance, especially in large, uniform, middle-toned areas.

Makers of film have made important advances in minimizing this graininess, both in manufacture and in evolving "fine grain" development processes; however, greater speed still means more graininess.

20X enlargements made from fine- and coarse-grain negatives.

Contrast

Contrast, the fourth important film characteristic, is the ability of the film to distinglish between closely related tones in the brightness scale. While the manufacturer controls it at the time the emulsion is prepared, this built-in contrast can be increased or decreased in film development and in printing. However, the wise photographer selects his film with its inherent contrast in mind.

High contrast films are used in copying line drawings, newspaper print, manuscripts or documents where maximum brightness differentiation is essential. In such cases maximum contrast is required, as only black-and-white tones are finally desired.

Lower contrasts in different degrees are desirable in most other forms of photography, such as snapshots and portraits.

There are other film characteristics or qualities which the well-rounded photographer understands, appreciates, and capitalizes. The characteristic curve, latitude, gamma, and resolving power—all these bits of camera-fan jargon—are meaningful and important, but specific discussion of them is postponed to the chapter, "Sensitometry."

THE LATENT IMAGE

Most mysterious and fascinating of all photographic phenomena is that of the latent image—the invisible image carried and retained in the film between the moment of exposure and the beginning of development. There have been innumerable instances of latent images lasting many years. Some exposures made at the time of the San Francisco fire in 1908 remained in a camera until 1937; on development they turned out creditably. An even more striking instance was discovered when the remains of the Andree polar expedition, which had set out in 1897, were found in 1930 in the far north. The men of the expedition had perished early in their explorations but the equipment was intact, including loaded cameras. When the films were developed, entirely usable images appeared. While perfect conditions for preservation of the film were, by accident, maintained in this instance, the persistence of the latent image under any ordinary conditions is a remarkable thing.

Exactly what the latent image is, no one knows with certainty. There are several theories. One of them maintains—on the basis of considerable evidence—that the latent image consists of a sub-microscopic silver speck on the silver bromide grain which renders the exposed grain developable.

Choosing Your Film

YOUR SUBJECT	KODAK ROLL AND PACK FILM	KODAK MINIATURE FILM	KODAK SHEET FILM
People, outdoors	VERICHROME	PANATOMIC-X	ORTHO-X
Close-ups of women	PLUS-X	PLUS-X	SUPER-XX OR PORTRAIT PAN
Interiors with existing light	SUPER-XX	SUPER-XX	TRI-X
Flash shots	VERICHROME	PAN-X	ORTHO-X
General landscapes and cloud pictures	PLUS-X	PAN-X	SUPER-XX
Copying line drawings High contrast work	PLUS-X WITH FULL DEVELOPMENT	MICROFILE	CONTRAST PROCESS (ORTHO OR PAN)

Fortunately for all of us, however, we know all we need to know in order to create a latent image and to develop it into a definite, visible, and usable one.

Making a Photographic Emulsion

Materials Required:

1. GELATIN. A good photographic grade gelatin can be purchased from leading photographic supply houses in 1 lb. lots. While not a photographic grade, gelatin suitable for the experiment can be purchased from the Chemical Sales Division, Eastman Kodak Company, Rochester, N. Y., in 100 gram lots for about 55c.

2. POTASSIUM BROMIDE Available at any
3. POTASSIUM IODIDE large photo-
4. SILVER NITRATE graphic store.

5. GLASS. Any high grade thin glass will be satisfactory.

Proceed as Follows:

1. Dissolve 10 grams of gelatin in 360 cc. warm water. A stirring paddle of hardwood should be used; avoid resinous woods.

2. Add 32 grams potassium bromide and 0.8 grams potassium iodide and dissolve. Raise the temperature to 55° Centigrade (131°F.) and maintain it there.

 So far the work may be done in white light, but all subsequent steps must be carried out under the ruby light of the darkroom.

3. Dissolve 40 grams of silver nitrate in 400 cc. water. Add this to the potassium bromide solution at the rate of 20 cc. every half minute for ten minutes. Stir constantly.

4. Hold the temperature at 55° Centigrade for 10 minutes to allow ripen-ing, then let the temperature drop slowly.

5. Add 40 grams gelatin to set the emulsion. Keep the mixture cool until it has set thoroughly. This requires from 3 to 4 hours.

6. Shred the emulsion by forcing it through cheesecloth. Onto the shreds pour 3 liters (approximately 3 quarts) of water, leave 2½ minutes, pour off 2 liters, and add 2 liters more. Repeat five times. This washes out the excess potassium bromide, potassium iodide and potassium nitrate.

7. Heat for 15 minutes at 55° Centigrade for further ripening. Slowly cool to 40° Centigrade (104°F.).

8. Pour 4 cc. of the emulsion onto a clean 3¼x4¼-inch glass plate, spread to form a uniform coat, place on a level chilled metal plate until the emulsion sets, and is dry. The plate is now ready for use.

The Exposure:

Outdoors in bright sunlight an exposure at f/8 and 1/25 second will be approximately correct. For development, use any of the active, fast-working film developers. See formulas in the following chapter.

Questions:

1. Have you made a regular, orthochromatic, or a panchromatic emulsion?

2. List the relative advantages and disadvantages of glass plates and the flexible types of film support.

Developing Film

You've "TAKEN" your picture. The latent image, wrapped in mysterious invisibility, lies in the film. To make that latent image come to life, you take the next step. You develop it. You do this by placing the film in a chemical solution called, oddly enough, the developer. After a few moments you remove the film from the developer, rinse it in water, and put it into another solution called the fixing bath. After another few minutes you switch on the light, and peer anxiously at the result.

There's your image, but it's strangely different from the subject. It's a negative; that which was white in the scene you "took" is now black, the blacks are clear transparency. Everything in the black-and-white scale is reversed. It's a little disconcerting. To get the positive print, a picture you can look at and enjoy, you make a contact exposure on photographic paper. And the image you get on paper is a *negative of the negative*. Obviously, two negatives make a positive. That's your picture.

This is a good negative **and this a good print**

Shadow and highlight detail, recorded in the negative, are preserved in the print

If your first encounter with the development of film prompts you to mutter something about "black magic," even the most literal minded, most technical enthusiasts will pardon you. For there is certainly something of magic in the process; and it is more than likely to be carried out in darkness. But "black magic" carries an unpleasant connotation; in that respect the phrase is wholly inappropriate.

Like most other forms of magic, development turns out to be remarkably simple. All it takes is a little understanding.

Specifically, what happens in the process of development? Physically, of course, the latent image is made visible. Chemically, the developer attacks the exposed grains of silver bromide, reducing them to metallic silver and a form of bromine. The metallic silver is deposited on the film support. The bromine is liberated, eventually to go down the sink.

Undoubtedly, the way to clarify all this is to get some practical experience. So consider, now, ways and means thereto.

THE DARKROOM AND EQUIPMENT

The darkroom and equipment for developing need not be elaborate. Any room from which *all* outside light can be excluded will serve. Many a photographic career started in a "blacked-out" kitchen, bathroom, fruit cellar, or a space under the basement stairs. How dark is dark enough? Try this little test. Turn out all lights; wait three or four minutes until your eyes become accustomed to the darkness. Then, if you can't see a sheet of plain white paper on the workbench in front of you—it's dark enough. To have a darkroom in the basement is the fond ambition of most enthusiasts. There all materials can be stored, and facilities for developing and printing kept readily accessible.

Only the following items of equipment are essential in film development and print making:

1. Four clean enamel or glass trays, approximately five by seven inches in size.
2. An accurate thermometer.
3. A graduate or liquid measure.
4. Bottles for storing solutions.
5. A safelight.
6. A printing frame or box (to be described in the next chapter).

Small kits of such equipment are available at low cost. These kits may also include the chemicals necessary in the process.

Inasmuch as the film is light-sensitive until the processing is nearly complete, it is necessary to develop the images under subdued light of a controlled color and brightness. As mentioned earlier, films of the "chrome" type, Kodak Verichrome for example, are insensitive to red light and therefore can be developed under a ruby colored *safelight*. Some ordinary red electric bulbs are satisfactory, but should not be relied upon as entirely safe unless supplied specifically for the job. Otherwise, test them. Note the experiment at the end of this chapter. If light other than red strikes the "chrome" type film during development, a general veiling or *fog* over the entire surface of the film results. The Wratten Series 2, (deep red) safelight slide, used with a 10-watt bulb at a distance of four feet from the film will be entirely safe. A good safelight is good insurance. Panchromatic films, fully sensitive to all colors, are developed in total darkness.

THE DEVELOPER

If you are a beginner you will find it best to go to your local photographic dealer to obtain developer. There you will find packets, cans, and bottles of ready-mixed chemicals on sale, and in almost any quantity desired. For use, these chemicals need only be dissolved in water according to printed instructions on the labels. Once you start using packaged developers, you probably will stick by them for good. You'll find that, in addition to being easy to mix, they are economical, clean, and space- and time-saving. Most important, there's no chance for variation from one batch of solution to the next.

If you prefer to mix your own solutions, you may wish to use the following formula which is exceptionally good for film development.

KODAK DK-60a DEVELOPER

	Avoirdupois	Metric
Water, about 125°F. (50°C.)	96 ounces	750 cc.
Elon .	145 grains	2.5 grams
Kodak Sodium Sulfite, desiccated . 6 oz.	290 grains	50.0 grams
Kodak Hydroquinone	145 grains	2.5 grams
Kodalk 2 oz.	290 grains	20.0 grams
Kodak Potassium Bromide	29 grains	0.5 gram
Water to make	1 gallon	1.0 liter

Dissolve chemicals in the order given.

Average development time for deep tank about seven minutes at 68°F. (20°C.).

See instruction sheets packed with materials for development times.

As you become more experienced you will want to try several different developers and determine for yourself which one best fits your needs. You'll find many different ones listed in the various Kodak Data Books and the Kodak Reference Handbook on sale at Kodak dealers.

What the Developer Does

The process of developing invisible images into visible ones requires three quite distinct steps.

1. Softening and swelling of the gelatin so that the solution can get at the exposed crystals of silver bromide.
2. The dissociation of the silver and bromine.
3. The exposed silver bromide crystals are transformed into tangles of extruded silver, commonly called the developed "grains."

Naturally, no one chemical can accomplish this whole task. So a developer contains many chemicals and, because the chemical quantities can be varied with varying results, there are hundreds of formulas. Essentially, though, they contain the same ingredients.

1. A SOLVENT, water. Chemical reactions of the nature of film development require solutions. Obviously dry chemicals could never accomplish even the first stage, the softening.

2. A REDUCER whose task it is to do the actual breaking up of the exposed silver salts. Elon is one. When used alone in a formula Elon produces images rapidly but they are low in contrast. The action of Elon is little affected by slight changes in the temperature of the developer.

Hydroquinone is another reducing agent. Its images generally are slow to appear, but have good contrast. Elon and hydroquinone are frequently combined and the best properties of each utilized in compounding a developer which works fairly rapidly, gives good brilliance, and is only moderately affected by temperature changes.

Pyro or pyrogallic acid, distilled from gall nuts imported from China, was not so many years ago in wide use, but has largely been replaced by these newer and more efficient reducers. Pyro oxidizes rapidly and turns brown, staining hands, negatives, or anything it contacts. This same stain is deposited upon the film almost in proportion to the amount of silver deposited. Much silver means lots of stain; a little silver a little stain. Thus negatives developed in pyro gain added printing contrast.

3. AN ACTIVATOR. To function properly, most reducers require that the solution be alkaline rather than acid or neutral. Sodium carbonate,

borax, or Kodalk supply this extra energy to the reducer. In addition, the alkali softens the gelatin more rapidly than plain water and thereby assists in the physical diffusion of the developer through the film.

Sodium carbonate has long been most commonly used, but it has some drawbacks. Notable of these is the formation of carbon dioxide gas as the film, with warm developer in and on it, is carried into the fixing bath containing acetic acid. The emulsion is soft from the warm carbonate and unable to resist the pressure of the tiny bubbles of carbon dioxide which form within the emulsion. As the bubbles break they pit the emulsion surface.

Kodalk, originally introduced as an activator for developers that might have to be used at excessively high temperatures, causes no volatile gas formation even at 80°F. It is now being used in many everyday developers for both amateur and professional photofinishers.

Borax, less active, is used with semi-fine grain formulas.

4. A PRESERVATIVE. Reducing agents are greedy for oxygen. If they get it they "rust" themselves away until they become photographically inactive and deposit rust-colored stains on the film. They take oxygen from both air and water. The inclusion of sodium sulfite in the solution preserves the reducer by retarding the oxidation or "rusting;" the formation of the colored compounds that stain film is thereby prevented. When large amounts of sulfite are used, it tends to dissolve part of the silver, making for finer-grain images.

5. A RESTRAINER. While suitable developing agents will work only on exposed silver grains, even the best developing agent may reduce some of those not exposed. Thus a general veil of gray—"fog"—is deposited on the film surface. Potassium bromide, the restrainer, makes the developer more selective, makes it harder for any unexposed grains to get themselves developed. It *prevents fog*.

Why Follow Recommendations?

With each formula goes a recommendation for the proper development time and temperature. These are more than suggestions. They are the results of scientific experiments and are backed up by many practical tests. If you follow them, you're almost certain of good results. Occasionally, of course, there's reason to change from the recommended technique, but this should be done cautiously and deliberately.

Start out by following instructions, not just one time, but consistently.

You probably will need to make no adjustments. But if you find that your picture-making system (which includes camera, printer, enlarger, etc.) gives negatives that require a contrasty printing paper, such as No. 4, increase the development time slightly. With any developer, an increase in time over normal increases the contrast. Conversely, you can lower your contrast by shortening the time. Keep the temperature constant, at 68°F.

High developer temperatures cause undue softening and swelling of the emulsion, making it readily susceptible to finger marks and scratches.

Then, too, remember that if sodium carbonate is used in the developing solution, there is a tendency for carbon dioxide gas to form within the emulsion as, soaked with developer, it is dipped into subsequent acid baths. An emulsion unduly softened during development at a high temperature cannot resist the force of these tiny carbon dioxide bubbles. On the other hand, the soft, warm, newly developed emulsion may try to shrink back to its original state too rapidly in subsequent cold baths. This results in a crackled appearance called *reticulation*. Get in the habit right now of keeping all your solutions at the same temperature.

An increase in either time or temperature is accompanied by additional graininess and a rise in the fog level. In fact, anything which increases the general activity of a solution adds to the contrast, softness of the emulsion, graininess, and fog.

Agitation

Films *must* be given good agitation throughout processing. In development, by-products of the reduction are formed, for example, sodium bromide. These are heavy and settle down on the films in trays or cling to films hanging vertically. A development restraining coating thus covers the emulsion and a fresh supply of developer is unable to get through to the emulsion. These by-products often collect in spots; grouped at random over the surface of the film, they retard development unevenly. The result is a mottled appearance. Good agitation gives good contrast, as it increases greatly the effectiveness of the solutions. Agitation, therefore, is a specific and important part of the development process. Usually it need involve nothing more than a gentle rocking of the tank for a few seconds every minute or two during the development period. Tray development usually involves ample agitation in the course of routine handling of the film.

of your lens, but much more often you can do better by working at a considerably smaller lens opening.

The major difficulty with a wide-open, high-speed lens is the shallowness of its *depth of field*. "Shallow depth of field" sounds a little odd, of course, but *depth of field* is a specific, measurable quality and it can be either deep or shallow, depending on circumstances which you can con-

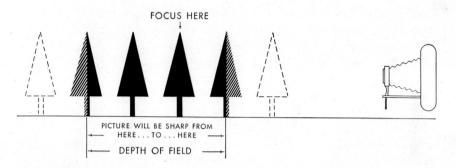

FOCUS HERE

PICTURE WILL BE SHARP FROM
HERE...TO...HERE

DEPTH OF FIELD

trol. The depth of field is the distance between the points nearest to and farthest from the camera that appears in sharp focus.

A glance at the sketches below will probably illumine this subject more effectively than words. But at worst, it's not a tough matter. Simply think back to those cones of converging light rays mentioned in the

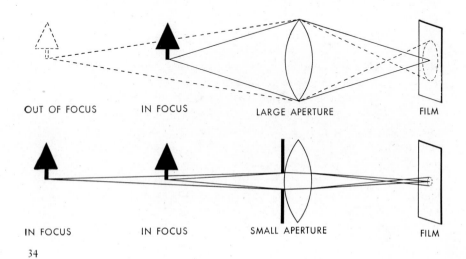

OUT OF FOCUS IN FOCUS LARGE APERTURE FILM

IN FOCUS IN FOCUS SMALL APERTURE FILM

provides a common standard for exposure calculations, with all cameras and under all conditions.

There has been a lot of quite needless worry about $f/$, due, in part, to the fact that it looks vaguely like one of those abstract symbols so dear to the hearts of higher mathematicians. Here is the simple truth. The symbol f stands for focal length; the diagonal bar indicates a fraction, and the numeral beyond the bar gives you that fraction. An $f/8$ lens is one whose widest effective aperture has a diameter which measures ⅛ of its focal length. Obviously, an $f/4$ lens of the same focal length has an effective lens diameter twice as great as that of an $f/8$ lens. If the diameter is twice as great, the area is four times as great at $f/4$ as $f/8$; therefore, to achieve identical exposures only ¼ the time is required at $f/4$ as at $f/8$. In photographic language $f/4$ is "faster," and by four times.

It is important to look on this f business in an amiable way. With f as an unmysterious factor, you can make a lot of headway toward the understanding of photography, for f is important not only in the making of ordinary pictures but also in the use of special lenses, in enlarging, in the projection of slides, and in every operation involving a lens of any kind.

One of the things about f-*numbers* which tends to confuse is the fact that the smaller the number the "faster" is the lens. If you keep in mind the idea that an f-*number* is a fraction, the mystery subsides; ½ is greater than ¼, ¼ is greater than ⅛, ⅛ is greater than $\frac{1}{16}$, and so on.

Practically every good camera lens has an iris diaphragm built into it— an ingenious little mechanism of overlapping metal leaves by means of which the effective aperture of the lens can be varied. And, as the aperture is cut down, various stages in the process are marked so that you know exactly the f-ratio of each position. An $f/4$ lens, for example, is usually marked so that progressive *stopping down* can be fixed exactly at points where the f-ratio is 5.6, 8, 11, 16, 22, or 32. Those particular ratios are arbitrarily chosen because they give you a fairly precise mutual relationship. Closing the diaphragm from one f-number to the next larger in the following series: $f/1.0$, 1.4, 2.0, 2.8, 4.0, 5.6, 8, 11, 16, 22, 32, 45, 64, reduces the intensity of the light falling on the film by one half.

But now—what's the idea in stopping down a lens? If you have a good $f/4$ lens shouldn't you be happy about it and use it all the time? Well, you have 80 or more horsepower in the average modern car. How often do you call on all those horses to *give* for all they're worth?

With lenses it's much like that. Sometimes you need the full aperture

Exaggeration, by means of short and long focal length lenses.

longer focus lens, the pictures appear to have the same perspective. Thus, when using a camera with interchangeable lenses, you will find that the longer focal length lenses tend to shorten distances and dimensions in the direction in which the camera is pointed. Shorter focus lenses exaggerate distances and dimensions making near-by objects appear disproportionately large. For these reasons, the normal focal length is always best unless the desirable properties of the other lenses are needed. The short focal length lenses give you wide angles of view which are useful when photographing in cramped quarters, while long local length lenses enable you to make full-frame pictures of small objects at considerable distances.

The second major basis on which a lens is rated is that of its *f-number*—f/8 for example. It is a scientific way of stating a relationship which exists between the lens' opening and its focal length—and on this relationship depends the intensity of the light falling onto the film. Such a system

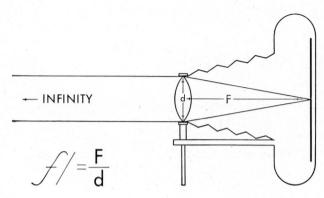

← INFINITY

$$f/ = \frac{F}{d}$$

the photographer the fundamental facts he must have before he starts to use a lens, are its focal length and its f-rating.

Focal Length (F) is almost a self-defining phrase. It means, simply, the distance from the lens to the plane (called the focal plane) where approaching parallel rays of light are brought to a point by the lens, so that a sharp image is formed.

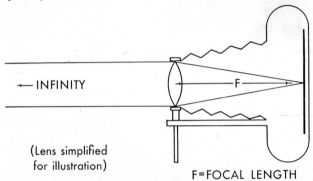

— INFINITY

F

(Lens simplified for illustration)

F=FOCAL LENGTH

Since all rays of light approaching a lens from a point at infinity are parallel, the focal length is the distance of the image from the lens when the subject is at infinity. Even though focused on a close-up subject or completely removed from the camera, the lens' focal length never changes, for it is a result of the fundamental design to which the lens was ground.

A camera is generally fitted with a lens having a focal length roughly equal to the diagonal of the film to be used in that camera. The diagonal of a 2¼ x 3¼ film is slightly less than 4 inches; hence, most 2¼ x 3¼ cameras are equipped with 4-inch lenses. Some cameras are sold without lenses. In such cases, selection of the right lenses becomes a responsibility of the purchaser. So, remember the "rule of the diagonal."

Perspective

A word about perspective—the apparent relation between objects, as to position and distance, as seen from any given viewpoint. Lenses of differing focal lengths give you the same perspective but, because they vary in the area they cover, they create a different effect. The longer the focal length of a lens, the narrower its field of view. Yet if you enlarge a negative made with a short focus lens and limit its field of view to that of the

But "developing" alone, even though properly done, does not complete the development process. After the film has been bathed in the developer, it carries metallic silver where light originally struck it, plus the still light-sensitive emulsion where no light struck it.

So, before it is safe to turn on the white room lights it is necessary to rinse the developer from the film with fresh water and then to bathe it in what is called a *fixing bath*. The fixing bath dissolves the unexposed and undeveloped crystals from the film, leaving an image of metallic silver on the clear support.

FIXING BATHS

There are three types of fixing baths. The principal ingredients are water and sodium thiosulphate, traditionally called "hypo." The hypo does the fixing, although in some baths other chemicals are added.

1. NON-HARDENING FIXER. It is used infrequently and then for special processes such as color printing, and for prints to be hand-colored. A 25% to 35% solution of hypo fixes most rapidly. Adding more hypo does not speed up the rate of fixation. Sodium bisulfite is generally added to non-hardening fixing baths to neutralize the alkali of the developer, and sodium sulfite is included to prevent sulphurization.

2. ACID HARDENING FIXER. In addition to hypo and sulfite, acetic acid and a hardening agent such as potassium alum or potassium chrome alum are included. The acid neutralizes the alkalinity of the developer and stops its action. Alum hardens the gelatin originally softened by the water and carbonate of the developing solution. Sodium sulfite serves as a preservative and also prevents the sulphurization of the hypo due to the presence of acetic acid and alum. It is by far the most widely used type of fixing bath today.

3. ULTRA-RAPID FIXER. Since ordinary hypo baths are of the most efficient concentration, faster working baths require other forms of hypo. Because of the instability of these forms as dry chemicals, they are supplied in concentrated solution. They completely fix film in three minutes, and paper in 1½ minutes. Slightly more expensive than other forms, rapid fixers are used principally by news photographers and others to whom speed is essential.

Like developer, fixing baths can be purchased in package form and dissolved in water for use. If you prefer to mix your own hypo, here's a standard formula which lists the chemicals and amounts for one quart of

fixing bath, to be used without further dilution. Dissolve the chemicals in the order of their listing.

KODAK F-5 FIXING BATH
For Films and Papers

	Avoirdupois	Metric
Water, about 125°F. (50°C.)	20 ounces	600 cc.
Kodak Sodium Thiosulfate (Hypo)	8 ounces	240.0 grams
Kodak Sodium Sulfite, desiccated.	½ ounce	15.0 grams
*Kodak Acetic Acid (28% pure)	1½ fluid oz	48.0 cc.
**Kodak Boric Acid, crystals.	¼ ounce	7.5 grams
Kodak Potassium Alum.	½ ounce	15.0 grams
Cold water to make.	32 ounces	1.0 liter

*To make 28% acetic acid from glacial acetic acid, dilute three parts of glacial acetic acid with eight parts of water.
**Crystalline boric acid should be used as specified. Powdered boric acid dissolves only with great difficulty, and its use should be avoided.

Films or plates should be fixed properly in 10 minutes (cleared in 5 minutes) in a freshly prepared bath. The bath need not be discarded until the fixing time (twice the time to clear) becomes excessive, that is, over 20 minutes. One quart of the above formula will satisfactorily fix the equivalent of 40 to 50—5 x 7-inch films, provided the films are rinsed in water between development and fixation.

DEVELOPING YOUR FILM

Fortunately for all of us, the mechanics of film development are infinitely simpler than the many reactions that take place while the films are immersed in the various solutions. There are two general methods for developing films, known respectively as the *tray method* and the *tank method*.

The Tray Method

1. Is principally for the beginner, but
2. Should be a part of everyone's photographic technique; you never know when or where you're going to be called on to develop a roll of film without benefit of your usual "accessories."
3. Is suited more to "ortho" film development. You need the safelight to see what you're doing. But, again, be prepared to do a roll of "pan" in total darkness if need be.
4. Is not advisable when the development time is longer than 10 minutes.
5. Is one for you to know and outgrow.

The Tank Method

1. Is economical. You will spill and splatter less; therefore it
2. Is cleaner to use, too.
3. It means cleaner negatives. There's no need for touching films until they're ready for drying.
4. Makes it easier to control your solution temperature.
5. Prevents any toxic chemicals from getting onto your hands.
6. Requires no darkroom when a day-loading type tank is used.

First, here's how to develop your roll films via the tray method.

Arrange three trays side by side in a sink or on a covered table or bench. The tray on the left is most convenient for the developer, the center for a rinse water, and one on the right for the fixing bath.

After you have poured the chemicals into the trays ready for use and turned off all but the safelights, remove the film from the paper roll or container which has served as its protection from unwanted light. Depending upon the type of camera used ·in making the exposure, you will encounter one of four types of film packing. Each type requires a slightly different handling during development.

1. ROLL FILM. Roll film is a strip of sensitive film backed by an attached paper strip which excludes light while the film is being loaded into, and removed from the camera. The film is attached to the protective paper only at the end first pulled through the camera. In the darkroom, before developing, remove the paper and unroll the film.

It is advisable to rinse the film in clear water before development. This lessens its tendency to curl and buckle, and makes uniform development much easier. Hold the long film strip at both ends, emulsion side down, and loop or dip it into the water. (Films curl slightly toward the emulsion side, the dull surface on the inner side of the roll.) The film will then be in a "U" shape, with only the bottom of the "U" immersed in the water. In order that all parts of the film can be equally wetted, the film is drawn through the water by a smooth seesaw action of right and left hands.

After rinsing the film in this manner for one minute, lift it out, turn it over emulsion side up and run it through the developer for the required time. The looping action must be sufficient for complete immersion of both ends in their turn.

After the development time, which may be from 5 to 10 minutes, depending upon the film and formula used, lift the film loop to the rinse

bath tray where clear water will remove the developing chemicals from the surface of the film.

Fix the film by immersing it in the fixing bath in the third tray. At this point the opalescent coating which was not blackened during development will be dissolved from the film surface. During fixation, the film image will not only be made photographically permanent, but the alum in the "hypo" will harden the emulsion enough to prevent scratches or abrasion marks during ordinary handling of the finished negatives.

As the film is first placed in the hypo, the rinsing action should be continued. This will insure that all parts of the film are fixed evenly. If the available tray is large enough and the quantity of hypo used is sufficient to cover the film, the strip may be carefully folded back and forth across the long dimension of the tray and allowed to soak in that position for the greater part of the fixation time. About every two minutes move the film about in the tray to give it the benefits of uniform fixation.

It is difficult to tell you just how long the film must be in the hypo before it is 100% safe to turn on the room lights. There is really no point in turning on the white room lights before the film has been "cleared" of the yellowish emulsion, for not until it is clear will you be able to tell whether or not the negative fulfills your hopes. Fresh hypo completely fixes film in ten minutes, about half of which time is required for clearing. With adequate safelight protection, you can determine when your film is clear by inspection; double the clearing time for full fixation.

After fixation, wash the film for at least thirty minutes in running water to remove all chemicals used in processing. If these are allowed to remain

Primitive, but it works **The modern, convenient way**

on the film, stains or image fading will result. One of the three trays can be used for washing. A larger washing tray is an advantage, however, as the film can circulate with the motion of the running water, and will not need to be rinsed by hand at such frequent intervals.

Now, about tank development. The tank for developing roll film includes a reel onto which the dry, undeveloped film is wound. The reel and film are inserted into the tank itself and the lid fastened in place. All further treatment takes place within the tank, as small pouring holes in the lid permit the easy addition and removal of the developer, rinse water and fixing bath. To keep fresh developer at the surface of the film, the tank must be occasionally turned upside down and then righted or rocked back and forth to provide ample agitation. This provides a less active rate of development than the continual rinse of tray development, so the time must be increased about 20% over the time for the tray method. The film may be washed by running a stream of water into the reel, either in the tank or a tray.

2. MINIATURE FILMS. The very nature of miniature photography makes tank development the only answer. You're almost always dealing with pan film, hence development in total darkness is required; too, handling of the film has its dangers, for dust spots or abrasion marks will be magnified later on in the course of enlarging. The premium, therefore, is on negative cleanliness.

Finally, of course, it just isn't convenient to loop five feet of narrow film back and forth through a small tray. It leads to comedy, consternation, constriction, and catastrophe.

3. THE FILM PACK. To remove the exposed sheets from the pack for development, the metal cap is removed, the back of the pack opened, and the paper-backed film lifted out—all in darkness, or safelight, of course. For tray development, the paper backing and the film should be separated from one another. Films can be developed individually in the tray, if kept well under the surface of the developer and properly agitated by rocking the tray. This method, however, requires too much time for a pack of 12 sheets; you will find it better to develop the 12 sheet films simultaneously, or to do two batches of 6 each.

In developing a full pack in the same tray, extreme care is required. Films must be handled only by the very edges. Moist fingers touching the surface of the film cause finger prints which cannot be corrected by any convenient means later in the process.

The tank's a "must" for miniature film and for sheet film in quantity

With twelve sheets of film in the same tray, two methods of agitation or rinsing are advisable. Either the tray should be rocked continuously, or the films should be constantly and smoothly changed in the tray from bottom to top to avoid any possibility of them sticking together.

Films from the pack may be rinsed and fixed in the same manner as they are developed.

Washing of film pack films is somewhat easier than the washing of roll film, as their size permits more motion within the tray, thus lessening the need for manual rinsing.

Developing tanks, similar to those used in the processing of roll film, are helpful in processing packs, because twelve sheets may be developed simultaneously and the danger of finger marks largely avoided. An inner cage provides a separate compartment for each sheet of film. After the cage is loaded with the exposed film, placed in the tank, and the lid screwed on, the room lights can safely be turned on for the development period.

4. SHEET FILM. Sheet films are used primarily by advanced amateur and professional photographers. Somewhat thicker than either the pack or roll film, this type is easy to handle and convenient when only one or two pictures are to be made on a particular assignment. The tray method of development is best suited to amateur processing of sheet film. The steps in the procedure are much like the steps in the developing of film packs by the tray method.

Professional photographers slip the film sheets into grooved hanger

racks. The racks are lowered into large tanks or individual compartments for developer, rinse water and fixing bath, in order. Such a system permits the processing of several times as many films daily as would ever be possible with tray development.

DRYING THE FILM

For drying, the film should be hung in a place where the air circulates freely, for without this circulation the drying time is unduly long. Before removing the film from the wash water, swab it with cotton. This will remove any sandy or gritty particles that may have filtered through your water pipes. After the film is lifted from the washing tray, and the excess water allowed to drip from it, the strip or sheet is hung from a line much the same as Monday's laundry. Several clips or pins are available for this purpose, one of the most satisfactory being the common spring clothes pin.

At this point you will notice that many small droplets of water are on the film surfaces. If not removed, these will spot the film, due to uneven shrinkage of the swollen, water-soaked emulsion as it dries. To remove this excess water, the films are slowly wiped down with a dampened cloth chamois, or sponge, immediately after removal from the washing tray.

Soft viscose sponges are used by many photographers for wiping films. These have only one disadvantage—and that a serious one. Grit particles are apt to become embedded in the sponges, and may later come to the surface to scratch another film. Laundering easily cleans the cloths and chamois, removes the dirt, grit and chemicals that might be absorbed by them, and makes them completely safe for repeated use. But sponges can't be laundered quite so successfully.

A slow, gentle wiping of both film surfaces from top to bottom is most effective. If the action is too rapid, the water drops are not absorbed. The time for complete drying will vary with different conditions of humidity and air circulation.

When dry, the films are removed from the clips, the roll-film strip cut into single picture sections, and the negatives filed in an appropriately identified envelope or folder. The wise beginner starts a film file with his first roll. Divisions may be made according to the date of exposure or subject matter. Complete data regarding both exposure and processing should be written on the filing envelopes. Thus you build up a usable backlog of technical data.

71

Safelight Test

Object:

To determine the length of time that film or paper can be exposed to a darkroom safelight without a harmful fog resulting, on development.

Equipment:

Developing and printing facilities. The safelight or safelights you use in your darkroom.

Procedure:

Arrange the safelight you intend using for film development at the usual distance above your working space. Turn off all lights, including the safelight. Place a small piece of film on the table, with the emulsion side facing the safelight and with one end covered with black paper. Turn on the safelight. After one minute, cover an additional narrow strip across one end of the test film with the black paper. After each successive minute, for fifteen minutes, cover an additional strip of the sensitive film by sliding the black paper over its surface.

After this exposure, develop in total darkness, fix, wash, and dry this test in customary fashion.

If the test strip of film shows fogging, the safety time for your safelight-film combination equals the time of exposure just shorter than the one producing a detectable fog.

Repeat this procedure, using any safelight and film or paper combination. The safety factor is determined in the same manner.

Question:

Would a dark blue safelight be suitable for use while developing?

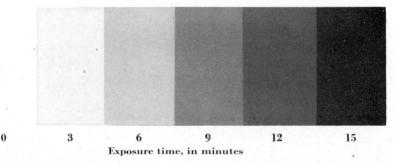

| 0 | 3 | 6 | 9 | 12 | 15 |

Exposure time, in minutes

Safelight test strip, on Kodabromide F-2, at 3 feet from a Wratten 0A Safelight, used with a 10-watt bulb.

Because this test imposed extreme conditions, it constitutes a reliable guide to the safe handling of sensitive materials. In actual darkroom practice, film or paper is seldom exposed directly to the safelight for any considerable period. During tray development when exposure to safelight is apt to be most direct, the material is somewhat less sensitive, hence less likely to fog.

Agitation Test

Object:
To compare the effects of agitating and not agitating films during the course of development.

Equipment:
A camera for exposing two sheets of film. Developing trays.

Procedure:
Properly expose two identical sheets of film. Develop one alone in a tray, rocking the tray continuously, as development proceeds, for the recommended time. In developing the second sheet, simply slip it into the developer and leave it there unagitated and for the same length of time as the first negative.

When fixed, washed, and dried, print the two negatives simultaneously onto the same sheet of paper. Use a paper, exposure time, etc., which give the best obtainable print for the properly developed negative. As an alternative, the two negatives may be cut down the center and opposite halves of each joined together to make a single print. While it is sometimes possible to correct during printing for low contrast caused by lack of agitation, there are no means for correcting unevenness, mottle and spottiness that also invariably arise from lack of agitation.

Mount these prints in a conspicuous place as constant reminders of the importance of agitation.

Questions:
1. What effect does agitation have on negative density? Contrast?
2. What function does agitation play in development?

Developed without agitation **and with continuous agitation**

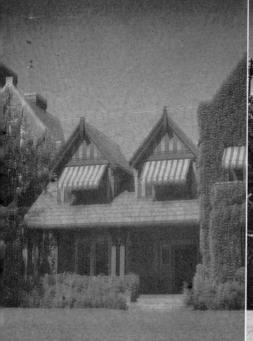

Time of Development Experiment _____

Object:

To determine the effect of development time on the contrast of a negative, and to demonstrate how Elon and hydroquinone differ as developing agents, both in the rate of image growth and resulting contrast.

Equipment:

A camera for making film pack or sheet film exposures. A tripod will be helpful. Facilities for developing films and making prints.

Procedure:

Select a subject with a wide range of brightnesses. Expose 24 correctly timed negatives. Develop 8 of these in Kodak formula DK60a, one for each of the following times: ½, 1, 3, 7, 11, 15, 25, and 60 minutes all at 68°F. Fix, wash, and dry them.

Prepare a small quantity of DK60a, omitting hydroquinone. Bring to 68°F., and develop 8 films in that; one for each of the times indicated above. The quantity of solution required will depend upon the size of the tray or tank used. Fix, wash, and dry.

Prepare another quantity of developer, using the DK60a formula but omitting the Elon. Bring to 68°F., and develop 8 films for the same times as above. Fix, wash, and dry.

Keep the negatives separated by groups, and as soon as they are dry, mark them with identifying numbers.

Make the best possible print from the negative developed 7 minutes in the regular Kodak DK60a. Using that same grade of paper, make prints from all negatives developed for this experiment. In so doing, expose each sheet of paper just long enough so that the dark shadows of the subject match in all prints. Fix, wash, and dry the prints.

For study, arrange the prints in sequence, in three rows with the corresponding times of development in the same vertical column. Mount on a card or notebook sheet for keeping.

Questions:

1. Which works faster, Elon or hydroquinone?
2. What would logically be the principal reducing agent in a developer used for reproducing line drawings of high contrast?
3. How does the time of development affect the contrast of a correctly exposed negative? What happens to the detail in the bright portions of the subject with overdevelopment?
4. What is the function of the alkali in the developer?
5. What effect does the age of the developer have on development?
6. What is fog? How long does the development time have to be before the fog is especially noticeable?
7. What effect does fog have on the picture?

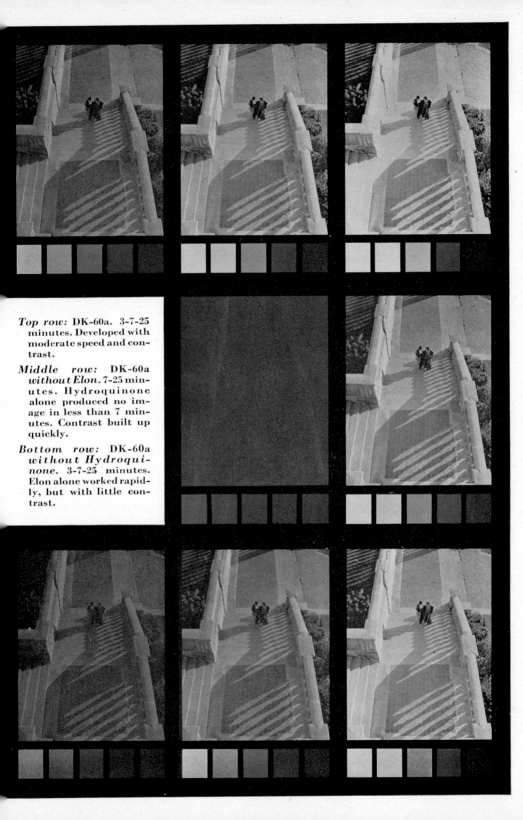

Top row: DK-60a. 3-7-25 minutes. Developed with moderate speed and contrast.

Middle row: DK-60a *without Elon.* 7-25 minutes. Hydroquinone alone produced no image in less than 7 minutes. Contrast built up quickly.

Bottom row: DK-60a *without Hydroquinone.* 3-7-25 minutes. Elon alone worked rapidly, but with little contrast.

Temperature of Development Experiment _____

Object:

To determine the effect of the temperature of a developer on its action and the degrees to which temperature changes affect Elon and hydroquinone.

Equipment:

A camera for making film pack or sheet film exposures. A tripod will be helpful. Facilities for developing films and making prints.

Procedure:

Expose 9 identical negatives of a subject such as a doorway, landscape, or street scene with a wide range of brightnesses. Develop one negative under each of these 9 conditions.

1. Kodak DK-60a7 minutes 68°F.
2. DK-60a7 minutes 58°F.
3. DK-60a7 minutes 78°F.
4. DK-60a formula with hydroquinone omitted15 minutes 68°F.
5. DK-60a formula with hydroquinone omitted15 minutes 58°F.
6. DK-60a formula with hydroquinone omitted15 minutes 78°F.
7. DK-60a formula with Elon omitted25 minutes 68°F.
8. DK-60a formula with Elon omitted25 minutes 58°F.
9. DK-60a formula with Elon omitted25 minutes 78°F.

Fix, wash, and dry.

Make the best print possible from negative number 1. Using the same grade of paper, print all other negatives, matching the blacks of the shadows in each case with the number 1 negative.

Arrange the dried prints in order and mount on a card or notebook sheet for study.

Questions:

1. How does a temperature change affect the reducing action of hydroquinone? Elon?

2. What are the properties of Kodalk?

3. What is the recommended temperature for fixing baths?

4. How does temperature affect the rate of fixing?

5. How does temperature affect the rate of washing?

6. What is reticulation?

Illustrations (right)

Top row: DK-60a, 7 minutes,58°F.,68°F., 78°F.

Middle row: DK-60a, no Elon; 15 minutes, 58°F., 68°F., 78°F.

Bottom row: DK-60a, no Hydroquinone, 25 minutes, 58°F., 68°F., 78°F.

Photographic Paper and Printing

WITH FILM development complete, you have on your hands one or more negatives—supple, dark, useless-looking things. Hold one up to the light. The image you see there is the reverse of the subject you took; blacks are white, whites are black. All very interesting but, as a picture, it simply doesn't make sense.

To achieve a positive, real-looking image on paper, another process is necessary—the process of photographic printing.

Photographic printing is simply a process of passing light through a negative so that it forms a corresponding image in the sensitive emulsion of a photographic paper. When the emulsion side of the negative is in uniform contact with the emulsion side of the paper, the image passed to the paper is exactly the same size as that of the negative. A print so made is called a *contact print*. It has the advantage of perfect "synchronization;" being in contact with the negative, it picks up its every detail automatically. Prints made by projection—enlargements and reductions—must depend on the precision of the optical system of the projector and on the sometimes fallible focusing ability of the operator. Hence, contact prints automatically achieve a sharpness which only real precision attains in projection prints. But there are advantages in projection printing, too, as may appear a little later on.

PRINTING BY CONTACT

The process of printing consists of four basic steps:
1. Exposure
2. Development
3. Fixing
4. Washing

The first two are fascinating, so fascinating that many amateurs tend to

overlook the last two, not realizing—or forgetting—that inadequate fixing and washing mean impermanent prints.

Preliminaries to printing include darkening your workroom, setting up the necessary trays, preparing solutions, etc., so that once you are under-way with your evening's printing, you can proceed without interruption.

First, how dark need the darkroom be? Not as dark as for film develop-ment. Paper emulsions are relatively slow and sensitive only to blue light, hence a fairly high level of illumination is permissible, so long as the light present does not contain blue. Window shades should be drawn at night to exclude direct rays from street lights, neighboring houses or passing cars. If you have a regular darkroom lamp, use the Wratten Series OO or OA safelight with a 10-watt bulb. Some orange and ruby colored bulbs are safe but should be carefully tested before you expose any quantity of your printing paper to them. (See "Safelight Test," page 72.)

Trays and Chemicals

Three trays are placed side by side in the sink or on a covered table. The left-hand tray, for convenience, is used for the developer, the center one for a chemical rinse, called a stop bath, and the one on the right for the fixing bath.

Because of the differences between film and paper emulsions, the proc-essing chemicals vary, although it is entirely possible to use some devel-opers, such as Universal Developer, for both film and paper. To save time, developers that work more rapidly are generally used for paper prints. As previously suggested, prepared chemicals may be purchased in powder or concentrated form and dissolved in water for use. You'll find the small packets of developer convenient if you make an occasional small batch of prints. D-72 in larger quantities is convenient if you work more fre- 79

Packaged chemicals for convenience and accuracy

Arrange your trays like this

quently and make a greater number of prints. Following is the formula for Kodak D-72, if you care to mix your own solutions from bulk chemicals:

KODAK D-72 DEVELOPER
Stock Solution

	Avoirdupois		Metric
Water, about 125°F. (50°C.)	16	ounces	500 cc.
Elon .	45	grains	3.1 grams
Kodak Sodium Sulfite, desiccated. . .	1½	ounces	45.0 grams
Kodak Hydroquinone.	175	grains	12.0 grams
Kodak Sodium Carbonate, desiccated. .	2¼	ounces	67.5 grams
Kodak Potassium Bromide.	27	grains	1.9 grams
Water to make.	32	ounces	1.0 liter

Dissolve chemicals in the order given.

For papers, dilute 1 to 2 and develop about 60 seconds at 68°F.

This formula can also be used for films and plates. See recommendations listed on instruction sheets packed with materials.

The acid stop bath for the center tray is prepared by diluting 1½ ounces of 28% acetic acid with water to make 32 ounces. Its purpose is two-fold. First, it neutralizes the alkali in the developer carried over on prints, thereby putting an abrupt stop to development and preventing uneven markings or development streaks. It also prolongs the life of the fixing bath by preventing the developer alkali from being carried into the hypo by the prints.

In the third tray is the fixing bath. You can use the same fixing bath for prints as for films if you use the formula suggested in the chapter on "Developing Film."

Make some provision for washing your prints in running water after they're fixed.

The Printing Frame and Printing Box

There are two standard means by which contact print exposures are made —the *printing frame* and the *printing box*. You'll need one or the other.

The printing frame is very much like a small picture frame, except that it is far sturdier and the back is easily removable. Too, the back is equipped with spring steel clips which assure a firm, squeezing pressure, so that paper and film are held in sure contact between the glass front of the frame and the stiff, felted back.

In practice—and in safely subdued light—the printing frame is placed,

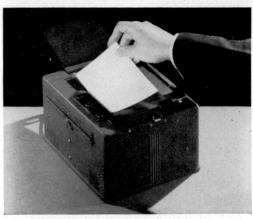

The printing frame is simple and adequate But a printing box is more efficient

glass side down, on the work table, and the spring clamps turned so that the back can be lifted out. Then the film is laid on the glass, *emulsion side up*. (That's the dull-surfaced side.) Over it goes the paper, *emulsion side down*. (Photographic paper tends to curl toward the emulsion side.) Then the back is put on, the clamps tightened, and all is ready for the exposure to white light.

Make certain that all other unused printing paper is safely covered. For the printing exposure, the frame is held, glass side foremost, about a foot from an ordinary 40-watt electric light, and the light turned on for a few seconds. After the bright light is turned off and the exposed paper removed from the frame, it is ready for development.

The printing-frame is a make-shift. It works, but it's not the most convenient arrangement in the world. Since it requires an open light, it means covering all sensitive materials between exposures. And, unless you're careful to have the frame in exactly the same position relative to the light for every exposure, you have no sound basis for comparing results on successive exposures. It is quite easily possible to build a simple apparatus so that light and printing frame are always at one set distance, but if you go to that trouble, you might just as well go a little farther and enjoy the greater benefits of a printing box.

A printing box, whether you buy, build, or borrow it, is simply a box with the necessary light inside of it. The top is covered by a piece of strong, clear glass, over which a pressure pad, made of two pieces of felt-covered wood or metal, hinged together, clamps down. The negative to be printed is placed on the glass, emulsion up, with the paper over it. When the pad comes down, negative and paper are in perfect contact.

In the ready-made boxes, the clamping down of the pressure pad

81

switches on the lamps. In addition to the lights used for making the exposure, good printers also contain a small ruby lamp which remains lighted throughout the working time of the box. Its purpose is simply to facilitate positioning of the film, the adjustment of the marginal masks for white borders, and the placement of the paper over film and masks.

The printing box is so convenient, so quick, that you'll lose interest in printing frames after your first printing box experience. For one thing, the box is lighttight during the exposure; hence, you are spared that panicking worry about "did I or didn't I cover up that paper before I switched this light on?"

Printing Exposures

It is physically and scientifically possible to work out an automatic or an arbitrary exposure guide for contact printing. But, for most of us, there's no necessity for any such setup. For, with a little experience, it is a relatively easy matter to determine the right exposure. If you are profligate with paper, the trial-and-error system will serve. If you are both economical and efficient, you'll cut a single sheet of paper into four or five narrow strips and expose each strip for a precise time, varying your exposures in some such order as 4 seconds, 8 seconds, 16 seconds. Mark the respective exposure times on the back of the strips, in pencil, so that after normal development, you can compare the results.

82

Four test strips will usually give you the key to the right exposure. With more experience, you'll need fewer tests

1 Second 2 Seconds 4 Seconds 10 Seconds

Here and now get into the habit of exposing for proper appearance when the print is developed according to the recommended time and temperature. It is impossible to get the best that's in your negative if you try to compensate for all printing errors by either shortening or forcing development.

If one of your test strips looks right, make your full-sized print accordingly; if not, make another test for a longer, shorter, or "in between" time as indicated by your first results. With experience, you'll learn to estimate the proper exposure for different types of negatives with fair accuracy and a minimum of waste paper.

Development

Slip the exposed paper neatly and quickly into the developer. Be sure that all of the paper gets under quickly, so that development will be even and uniform. In a few seconds—as you rock the tray gently—you'll see the image begin to come up, the strongest blacks first, then the middle tones and, finally, the highlights. If the exposure is normal, the print should appear to be complete in about 45 seconds. Give it an extra 10 or 15 seconds for the sake of full-bodied, rich tones and full contrasts. Too, the dim light tends to make the print seem dark, so be wary about yanking the print from the developer too soon.

With development complete, the print is slipped into the center tray for a chemical rinse in the stop bath and, after five seconds or so, shifted over into the hypo.

Prints made on a single-weight paper, such as Azo and Velox, will be fixed sufficiently in twenty minutes, provided they receive good agitation in the fixing bath during that period. Not only should the tray be rocked back and forth every minute or two, but the prints themselves should be rotated in the tray, so none of them becomes firmly matted to another. If a heavy, double weight paper is used, even more agitation is in order during fixation.

But—you don't have to wait until the prints are fully fixed to turn on the white room lights for a real inspection of your work. Two or three minutes in the hypo should be sufficient to preclude fogging.

Is the Print a Good One?

Take a good long look at the finished print. Does it have the richness, the full range of tones it should have? If it does; all is well. If it doesn't,

there are two immediately possible remedies. One, a different exposure. For example, a longer exposure will correct for over-all lightness and lack of depth or darkness. Longer than normal development will do little more than invite over-all fog and staining. If the print is too black, try a shorter exposure. If the print is gray, lacks brilliance, sparkle and snap, consider the second possible remedy—a paper of a *different contrast*.

In the description of the printing process reference to the "contrast grade" of paper used has so far deliberately been omitted.

In an ideal world, in which all subjects and exposures would be perfect and all photographers ditto, there would be need for only one grade of paper, for all negatives would print on normal paper. Fortunately, the world is not that dull. Light values vary, shutter speeds vary, judgment sometimes misses, and even darkroom control has been known to slip up. Hence, there are many negatives that are not normal. Yet they may be made to produce beautiful and useful prints. This amiable situation is brought about through the use of papers which help to compensate for the negatives' shortcomings. Thus, a too contrasty negative is printed on a "soft" contrast grade of paper, while a low-contrast negative may be forced to stand and deliver a usable print by printing it on high-contrast paper. Simple, isn't it?

Contrast grades usually run from 0 to 5; normal contrast paper is a No. 2 or No. 3. Numbers 4 and 5 are contrasty papers, whereas numbers 1 and 0 are, respectively, soft and softer. For the average amateur's purposes, a supply of 1, 2, and 4 should serve to meet most requirements. Naturally, a larger supply of 2 should be carried, for the relatively normal negative, it is to be hoped, will predominate. The extreme grades of paper are, like life preservers or parachutes, handy to have around in a crisis, but are not to be used as a steady diet.

Azo and Velox are two outstanding contact printing papers used both by professionals and amateurs. Both are supplied in varying surfaces and a full range of contrasts. Velox is noted for its uniformity of tone throughout all contrast grades, a fact which makes it popular among photo-finishers.

Washing and Drying Prints

Assuming that you've made amends for any printing difficulties, and that you are reasonably satisfied with the prints in your hypo tray, let's finish the process. Prints, like films, must be carefully washed after fixation. In

fact, prints need even more thorough washing, for paper absorbs more of the chemical solutions than does film. Those chemicals have to be washed out.

Laboratory tests show that even small quantities of hypo, if allowed to remain in the paper, will tend to produce faded images. To overcome this, several chemical "hypo eliminators" have been devised. However, fresh water can be relied on to do the job properly, if you're patient about it. About an hour's wash in running water, or twelve changes of water—five minutes each—should suffice. If long time permanence is wanted, use the hypo eliminator, Kodak HE-1 *after* washing.

After the fixing bath has been removed from the prints, and the excess wash water allowed to drip from them, they may be laid down on flat photo blotters or a clean water-absorbing cloth, or may be rolled in a blotter roll for drying. The tendency of prints to curl on drying will in no way harm them, as they may be easily stretched flat by pulling them gently over the smooth edge of a table or bench.

In order to produce prints with a high gloss surface like those frequently supplied by photofinishers, it is necessary to glaze or "ferrotype" them after washing. This is a process of rolling the wet prints, emulsion side down, onto a highly polished "ferrotype tin," where they remain until dry. Not all papers ferrotype properly. Those designated for the purpose, Azo F and Velox F, carry an overcoating of clear gelatin which, when rolled onto the highly polished tin, assumes a similar surface on drying. As the prints dry, they peel away from the tin easily.

PRINTING IS AN ART

Possibly "craft" is a better word than "art," but the point is that an experienced printer utilizes many tricks and devices to achieve his ends.

Thus, to *hold back* a portion of a negative so that the rest of it has an extra opportunity to register, he sometimes interposes tissue paper between the printing light and the part of the negative to be *held back*. Many printing boxes are equipped with panes of clear glass, below the diffusing glass, the purpose of which is to serve as shelves for tissue. This process is known by the pleasantly vivid name of *dodging*. Thus, the "artful dodger," of whom you may have heard, may have been simply a skilled and ingenious photographic printer.

You may have noticed some workers trying to accelerate development by rubbing their finger tips vigorously over the part of the print that

seems slow in coming up. Heat, of course, speeds up all chemical reactions and, in this case, the heat of the fingers might hurry development in one particular area. This procedure, however, is not advisable; for, while heat accelerates development, it also accelerates staining due to over-oxidizing of the developer.

Sometimes printers even resort to extreme measures of this type: they'll yank the partially developed print from the developer, douse it in fresh, cold water to arrest development, and then go over the balky areas with a finger or a bit of cotton dipped in developer. If they get the desired result, the print then goes back into the bath for complete development.

And so it goes.

Such devices, interesting as they may be, again belong in the life-saver or parachute class. It's simply good sense to aim at the production of the best possible prints by orthodox methods. And that implies good negatives to begin with.

PAPER EMULSIONS

If you think the modern photographic industry provides a large variety of film emulsions, take a look at the paper situation.

In the first place, there are three basic types of paper—slow emulsions for contact prints, fast emulsions for easy enlarging, and an in-between type which can be used for both contact and projection printing. These types are known, respectively, as chloride, bromide, and chloro-bromide papers.

Speed in papers is not comparable to film speed. There's no real need for it; in fact, the advantage is all the other way 'round; for the slower emulsions used with paper permit a far greater degree of control during exposure.

Within each of the three general paper types there are dozens of subtypes distinguished by the character of the surface—matte, semi-matte, lustre, glossy—or by the paper tint—natural, white, cream, ivory,—or by the "warmth" of the emulsion (blue-blacks are cold, brownish blacks are warm). These characteristics in Kodak papers are denoted by a letter, F, G, R, E, etc. Then, for these sub-types there are the different contrast grades, 0, 1, 2, 3, 4, 5. And, in many instances, different grades are available in both single and double weight.

When you stop to consider the multiplicity of these paper types and the scores of sizes in which most of them are available, it's plain to see

that there are headaches in stocking and selling photographic papers.

There are styles or fashions in papers, just as in dogs or books. One year the photographers may develop a mass fondness for hard-as-nails glossy prints; and the next may find a special demand for novelty surfaces. The intelligent photographer will try to avoid fads and to select his papers on the basis of the individual picture to be printed and on the purpose for which it is intended. For commercial work, with reproduction by photoengraving involved, it's best to use full contrast and a glossy finish. For pictures to be seen at first hand, a less commercial finish is desirable.

It is only by actual experience and experiment that you will discover which papers best meet your requirements.

PHOTOGRAPHIC PAPER

In the course of making a print, you may find yourself suddenly impressed with the fact that you're dunking a piece of paper into chemical solutions and much plain water—and that the paper remains paper.

You can't do that with ordinary paper. Drop a piece of newspaper into water. In a matter of seconds it has lost its strength, its color, and its usefulness. The same thing happens to almost all the other forms of paper when subjected to water. But photographic paper, the paper on which a photograph is ultimately realized for all the world to see and to admire, is made of much sterner stuff. It has to be. For it undergoes an ordeal by water that would leave ordinary papers limp and unlovely.

Photographic paper is not only tough; it is very much purer than the driven snow. Again, it has to be. If it contained traces of iron, copper, or other chemical impurities, they might easily be the ruination of the photographic emulsion-coating. Too, they could easily stir up trouble during the chemical reactions involved in development.

Before the light-sensitive emulsion is coated on the paper (by a process very similar to that used in film coating), the paper has first to be seasoned for a time and then to be coated with a milky white substance called baryta (barium sulphate and gelatin). Baryta, which is chemically inert, fills the surface pores of the paper and provides a smoothly uniform surface as a foundation for the photographic emulsion. It keeps the emulsion from soaking into the fibres of the paper, with inevitably uneven results. The consistency of the baryta is the major factor in the establishment of the matte (dull) or gloss finish of the paper.

87

Paper Contrast Experiment _____

Object:

To illustrate the characteristics of the different contrast grades of contact printing paper.

Equipment:

Facilities for printing. An average negative, one making a good print on a normal contrast grade of paper.

Procedure:

Using the selected negative, make the best obtainable print on all contrast grades of a standard contact printing paper, such as Azo or Velox. The printing time will vary with the contrast grade, so keep a record of those times.

You will profit by repeating this procedure, using a negative low in contrast, or flat, and then a contrasty negative, or one printing best on a low contrast paper.

Mount in order on a card or notebook sheet for comparisons.

Questions:

1. What is wrong in highlights, shadows, etc., in each print that appears in your estimation to be off in contrast?
2. How do the speeds of the different paper grades compare?

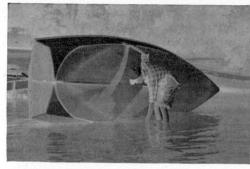

Average contrast negative

Low contrast paper is too soft

Normal contrast paper, good print

High contrast paper, harsh highlights, empty shadows

Low contrast negative

High contrast negative

Low contrast paper is extremely flat

Low contrast paper makes a good print

Normal contrast paper, still too flat

Normal contrast paper, too contrasty

High contrast paper makes a good print

High contrast paper, extreme contrast

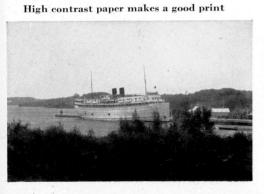

Washing Test

Object:

To determine whether or not films or prints are reasonably free from hypo and sufficiently washed to prevent fading of images.

Procedure:

Mix 250 cc. of hypo test solution (Kodak HT-1a) as follows:

Distilled water 180 cc.
Potassium permanganate.. 3 grams
Sodium Hydroxide
 (caustic soda) 6 grams
Add enough distilled water
 to make 250 cc. of solution

To Test Films for Completeness of Washing:

1. Dilute 2 drops of the above solution with 250 cc. of pure water.
2. Lift an eight-exposure roll of No. 116 film or the equivalent (about 80 square inches) from the wash and allow the excess water to drip into the diluted test solution. If hypo is present, the solution will change from violet to orange or yellow. If no hypo is present no change in color will result.

To Test Papers for Completeness of Washing:

1. Dilute 2 drops of solution HT-1a with 125 cc. of pure water. Use 15 cc. of this in a glass for your test.
2. Take about 120 square inches of prints (for example, 10 prints from No. 116 negatives) from the wash and let the excess water drip into the test solution. If hypo is present, the solution will turn yellow then lose its color, if no hypo is present, no color change will take place.

Both films and papers should be washed until the wash water from them does not change the color of the test solution.

To Insure Accuracy of the Test:

Add a sample of tap water equal to the volume of water from the films or paper, to a sample of the fresh test solution. If there is no color change, the tap water you are using for washing is free from certain chemicals which might otherwise render your washing test inaccurate. If there is a slight change in the color of the violet test solution upon addition of the tap water, the tap water test should be run alongside the wash water tests. Comparisons of the two test solution colors will then indicate freedom from hypo when both tap and wash water give equal color changes.

Enlarging

THERE'S A THRILL to enlarging. The very fact that you're able to produce a big, framable picture from a negative that may be as small as a postage stamp is, in itself, exciting. Bigness always is.

But there's more to enlarging than the mere "blowing up" of an image. The control you exercise in making an enlargement is so extensive that you can almost create new pictures from your old negatives. It is eternally true that the expert photographer sees his finished picture in the view finder of his camera; after the exposure each succeeding step in the photographic process serves merely to carry him straight to the realization of that picture. But we are not all so expert. If we find a means by which some of our shortcomings can be remedied, we embrace it. Enlarging is such a means.

Far more important, however, is the fact that enlarging is a method of glorifying pictures—of translating them into terms which carry far more force than those of album-sized snapshots. By skillfully enlarging an image you bring it somehow closer to reality, or the illusion of reality. And that illusion is one of the important intangibles in any art form.

One factor contributing to this illusion is that you generally view enlargements from a distance which enables you to see the correct perspective in the picture. To see the same perspective in a contact print you must hold it only a few inches from your eyes—and that, naturally, you seldom do.

Enlarging, as intimated in Chapter 7, is simply a form of photographic printing. It differs from contact printing in that the negative image is projected, much as a lantern slide is projected. The image is focused onto a sheet of light-sensitive enlarging paper which is subsequently developed.

The enlarging apparatus is, essentially, a camera in reverse. Instead of receiving an image, it projects one. There's a strong light source, the rays

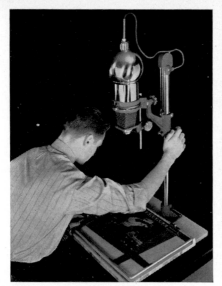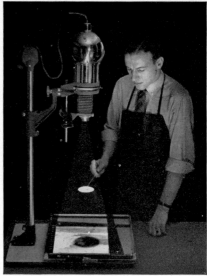

One of enlarging's features **is the control it affords**

from which pass through the negative (which stops or passes them according to the varying densities of the image) to a lens which transmits them in an expanding cone to the enlarging paper. Obviously the farther the paper is from the lens, the greater the expansion of the cone of projection —and the larger the projected image.

With this arrangement, it is apparent that you are dealing with a simpler problem than that of a camera, as far as proper focusing is concerned. For both the negative and the enlarging paper are flat; hence you need have no concern for depth of field. You simply watch the projected negative image for maximum sharpness as you move the lens in or out, in relation to the negative. The best working aperture for the projection lens is usually somewhat less than wide open; and one which permits a convenient and controllable exposure time—say, 10 seconds.

Under these circumstances, it is plainly important that the enlarger be designed to project a uniform intensity of light. There are three principal systems of illumination, capable of achieving such uniformity, without a "hot spot." And enlargers are "typed" accordingly.

Diffusion Enlargers

The diffusion enlarger seeks to get a uniform supply of light to the negative by means of a diffusing medium placed between the lamp and the negative. Usually, diffusion is supplied by a sheet of either ground glass or opal glass. The uniformity obtained depends, of course, not only on the type of glass used but also on the degree to which the light reaching it

is already spread. This factor, in turn, is controlled by the use of an "opal" bulb, by the shape of the lamp house, and by the position of the lamp in it. Some lamp houses are designed to "scramble" the light as completely as possible; others, particularly those of the parabolic type, seek to get the light to the diffuser in strict marching order.

The diffusion referred to, thus far, is that which takes place *before* the light reaches the negative. An enlarger with a perfect diffusion system affords enlarged print quality equaling that of contact prints. A good enlarger must be so constructed that, *after* the light passes through the negative, it is not reflected from the inside of the bellows, lens board or other parts. If it is, the stray light tends to wander into areas where there's supposed to be no light: reflection of this sort means gray, dimmed highlights in your enlargements.

Some of the finest enlargers, both professional and amateur, are of the diffusion type. Portrait studios use them because they can deliver matching contact prints and enlargements to their customers. The Kodak Advance Enlarger is outstanding among diffusion types for amateurs.

Condenser Enlargers

The old-time condenser enlarger had no diffusion whatsoever. The result was high optical efficiency accompanied by exaggeration of graininess and defects and by extreme contrast. To understand this increase in contrast, it is only necessary to consider the fact that the effective density of a negative depends upon (a) its light-stopping properties and (b) its light-scattering characteristics.

Thus, in a diffusion enlarger, the difference between two densities is wholly a matter of how much light each one stops. In the condenser enlarger the lower density stops some light and scatters some, while the higher density not only stops more but also scatters more, thereby creating a greater effective difference between the two silver deposits. In the condenser enlarger, with no diffusion, the resulting gain in contrast was too great for most practical uses.

This meant also that the "grain" in the film and all the tiny blemishes, scratches, and dust spots were projected as exaggerated parts of the image. And even the cleanest negative showed these defects when the enlargement was great. Thus, while the condenser enlarger was optically efficient it did tend to keep its owner and user humble with its uncompromising presentation of minute defects.

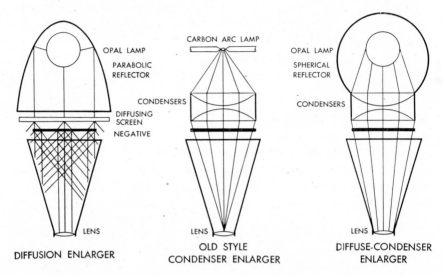

DIFFUSION ENLARGER

OLD STYLE CONDENSER ENLARGER

DIFFUSE-CONDENSER ENLARGER

Another point about this enlarger: because it depends on a precise optical system, the relative positions of the lamp filament and the condenser elements must be changed as lenses of varying focal lengths are used, or separate sets of condensers must be used with the different projection lenses.

Today the use of the pure condenser enlarger is limited almost exclusively to a few technical applications that are fairly remote from popular photography. But the condenser idea has been adapted and improved in the third basic enlarger type, the diffuse-condenser enlarger, diagrammed above and described below.

Diffuse-Condenser Enlargers

In this type of enlarger an opal bulb is substituted for the clear bulb of the original condenser type. Thus the optical system has diffuse light to work with. The results are better, for it affords slightly more contrast than a straight diffuser outfit, yet not quite as much as the clear bulb-condenser type, and tends to be less revealing as far as negative defects and graininess are concerned.

Negatives enlarged with the opal bulb-condenser enlarger may require a paper which is one contrast grade softer than that needed for best results in contact printing or diffusion type enlarging.

The Kodak Precision Enlarger A is not only a top-notch diffuse-condenser type but is adaptable to many other photographic uses such as copying, bench photography, etc.

Lenses for Enlargers

In general, any well-corrected lens, the focal length of which is at least equal to the diagonal of the largest negative to be enlarged, will serve in enlarging. Lenses made particularly for enlarging are corrected for those distances generally used in enlarging—and thus may differ slightly from ordinary camera lenses. However, many a successful amateur finds it both economical and efficient to use his camera lens in his enlarger.

This practice in general is more apt to prove satisfactory if you use a miniature lens and enlarge miniature negatives than if you enlarge larger negatives with longer focal length lenses. In the former case the magnification is greater and the lens is therefore used closer to the point of maximum correction.

Some lenses are unsatisfactory for enlarger use because, due to improper color correction, they fail to produce a visible image in exactly the same plane as the photographically effective image. Hence, focusing on the enlarger's paper board or easel with such a lens becomes a matter of approximation and guess work. With any good lens, however, trouble of this sort is automatically eliminated. Kodak Anastigmat and Ektar lenses, fully corrected for enlarging, are supplied in a number of focal lengths and can easily be fitted to any size enlarger lens board.

Automatic shutters are not usually needed in enlarging, as exposures are in terms of seconds, rather than hundredths of a second. The exposure is made by turning the light on and off rather than by any mechanism at or in the lens. A light switch which can be operated by foot pressure is advantageous, in that it leaves the operator's hands free for various manipulations during the exposure.

Practically every enlarger is equipped with a red safety screen which can be swung into position over the lens to permit safe readjustment of focus, or any other adjustment which may be necessary *after* the sensitive paper is in place.

Most modern enlargers employ some form of heat absorption or lamphouse ventilation so that the negative will not "fry" or blister as a result of intense heat from a long exposure. But, even so, it's a good idea to test out the heat safety of your enlarger by a series of long exposures,

using a discarded negative for the test. If you find that a minute's exposure produces no buckling or blistering in the negative, you're fairly safe; for you'll rarely need exposures of more than 20 or 30 seconds.

ENLARGING PAPERS

The chief difference between enlarging and contact papers is one of speed. In contact work, the printing lights are concentrated (and relatively close to the negative and paper) so that high speed is not important. In enlarging, the light passing through your negative is spread over a large sheet of paper and must pass through a small opening in a lens to get there, hence greater sensitivity becomes important.

Enlarging paper emulsions are of two general types, silver bromide and silver chloro-bromide. Kodabromide paper is of the latter type. It is slightly slower than a bromide paper and exposures are of suitable length for accurate timing and for control and manipulation. The tones of a finished chloro-bromide print are deep and rich, the first requisites of any good photograph. Bromide papers are available for use where extreme enlarging speed is required.

Enlarging papers, like contact papers, are to be had in great variety, ranging all the way from the glossy, super-smooth papers intended for ferrotyping, to papers with extremely coarse surface texture or pattern— papers whose use is limited (or should be) to those subjects which can justify them. In addition to variations in surface, there are variations in color, in weight and, of course, in contrast.

Prints on all surfaces of Kodabromide are contained in a highly functional form in the Print Quality Kodaguide. These prints also have calibrated gray scales and other interesting and useful data. A calculator simplifies the finding of new exposure times for changes in magnification, aperture, and type of paper. The kit also includes a booklet on making enlargements and a transparency for focusing and measuring magnification. If you have definitely passed the elementary stage in enlarging and are now striving to make the sort of prints you see on salon walls, this Kodaguide will interest you.

The following table lists the properties of some Kodak papers. As you try these suggestions, make an extra 8 x 10 print from each new surface you use. Put it into a notebook and you'll soon have a paper-subject reference book to which you can turn when choosing your papers for particular types of negatives.

Selecting Your Enlarging Paper

YOUR SUBJECT OR THE USE FOR YOUR PRINT	PAPER	PAPER SURFACE AND TINT
Scientific subjects *Photographs for publication* *For maximum brilliance and detail*	K O D A B R O M I D E	GLOSSY WHITE (F)
Commercial subjects *Display photographs* *Album enlargements* *Snow scenes* *Portraits in high key* *Smooth skin texture*		SMOOTH, LUSTRE WHITE (N)
		SMOOTH SEMI-MATTE WHITE (E)
		SEMI-MATTE NATURAL WHITE (A)
General pictorial *and portrait work*		FINE GRAIN, LUSTRE NATURAL WHITE (G)
		FINE GRAIN, LUSTRE OLD IVORY (P)
Character portraits *Large size pictorial prints* *Extreme enlargements from* *miniature films* *Table tops with massive areas*	K O D A K	MEDIUM ROUGH, LUSTRE NATURAL WHITE (R)
		MEDIUM ROUGH, LUSTRE OLD IVORY (S)
Specialized portrait *or pictorial effects*	O P A L	SUEDE, MATTE CREAM WHITE (V)
		SUEDE, MATTE OLD IVORY (W)

ENLARGING

The enlarging process, itself, is a fascinating one. For one thing, you have more at stake; a sheet of enlarging paper costs good money. Hence there's more than artistic aspiration involved as you prepare for action.

Preparations

Developer, stop-bath, hypo, and rinse are prepared and brought to the proper temperature just as for contact printing. The trays should all be a little larger than the largest print you contemplate making at any one session.

Be sure the enlarger lens is clean. *And* the negative. *And* the negative holder, especially if it is of the "glass sandwich" type. Remember you're going to enlarge; dust and dirt enlarge just as much as details of the image itself.

A safe light for enlarging is less bright than is permissible in contact

work. The yellow-green, Wratten OA Safelight should be used. Better run a test to be sure that you're not using too bright a bulb or using the light too close to your working area.

Have your paper handy, so that a sheet can be selected quickly and the package closed to prevent fogging when you turn on the white light for print inspection. Some amateurs have built light-tight paper drawers into their work benches just below their enlargers; good idea.

Procedure

Put a pencil back of your ear, don your apron, and get going.

1. Place the negative to be enlarged in the negative holder of the enlarger, emulsion side toward the lens.

2. Put a sheet of plain white, non-photographic paper in position on the paper board.

3. Open the lens to its fullest opening and—white light off, now—turn on the enlarger lamp. You'll see the projected negative image on the paper. By changing the lens-to-paper distance you get the size you want; a little further manipulation of the lens-to-negative relationship will give you exact focus. And *exact* it must be.

4. That done, switch off the enlarger lamp and place a test strip of enlarging paper on the paper board. A test strip for an 8 x 10 enlargement can be a very narrow slice (one 8 x 10 sheet can be cut into a dozen test strips, easily) but it should be placed so that it gets a representative assortment of the intensities in the projected image. Otherwise, it can afford no conclusive test.

5. Close down your lens to its best working aperture and make a test exposure series of, for example, 4, 8, and 16 seconds. This can be done by covering the strip, step by step, with a sheet of black paper during exposure. Mark the times on the back of the strip and,

6. Develop it for the recommended time. If one of the times seems right, make a full test strip at that time for a check. If development shows too obvious over- or underexposure on all steps of the first test, discard it and make another series, halving or doubling the times, as the case may demand. With the seemingly correct strip safely in the hypo, give it a moment or so and then—

7. Turn on the white light for a real inspection. Check it for focus, of course, but primarily for density and contrast. If everything looks right, that's fine. If it lacks brilliance, a test on contrastier paper should be made.

Thus, by trial-and-error, correct exposure on the right paper is determined. Another, and very neat, method of establishing correct enlarging exposure is offered in the Kodak Projection Print Scale. By means of a single test exposure, it gives you visual evidence of the best exposure time plus a plainly legible figure showing the necessary exposure time.

At first you may have to make tests on several contrast grades for comparison before discovering which one is the right one. Most beginners seem to have a tendency to make prints that are just a bit too flat. Perhaps it's because prints lose some contrast and brilliance as they dry. There may be another reason which you can avoid easily by timing your enlarging exposures for proper development in the recommended time. Pulling prints out of the developer before they've been in the full time, just because they're "dark enough," means a loss in contrast, too. Still another reason is that, in the dim light, prints look darker than they actually are.

8. So you go ahead with a full-size enlargement. Develop, rinse, fix, and wash carefully. An hour's good washing should be about right.

9. Dry the print, face down, on a big clean white blotter (you can buy photo-blotters quite reasonably) or on a piece of cheesecloth stretched on a rack.

And there you have a straight enlargement. It is just like a contact print, only bigger. It may be very good, too—exactly what you wanted. But the chances are that it can be improved. Here are some of the means by which true glorification of a picture can be realized:

Manipulation

CROPPING, which consists of enlarging only a portion of the negative, eliminates the undesirable parts. This can be done either by masking or framing the desired part of the negative itself, or by utilizing only a portion of the projected image. Cropping can be used to add emphasis, to improve composition, or to straighten either horizontal or vertical lines. Practically every negative, no matter how carefully composed can be improved by slight cropping.

SHADING of parts of the image during the exposure reduces the exposure of those parts and lightens them relative to the unshaded areas. A small black paper disc on the end of a wire is used to shade central areas while a black card can be used near the margins. This is also referred to as *dodging*. The dodgers should be held a few inches away from the paper and kept in slight motion during exposure to insure blending.

99

PRINTING IN is the local addition of exposure to selected parts of the enlargement on top of the overall exposure. Perhaps the entire sky needs more exposure, or the corners of the print need darkening to afford a natural frame. Frequently one or two small bright portions need extra time. A large black card with a hole cut in it is held between the lens and the paper; the hole allows light to get to the desired portion, while the card holds it back from the rest of the picture. As in shading, the *printing in* must blend naturally into the remainder of the picture, so the card needs to be kept in gentle motion.

Fine of the baby, not so good of mother. A straight enlargement doesn't help but, with vignetting, mother and background disappear

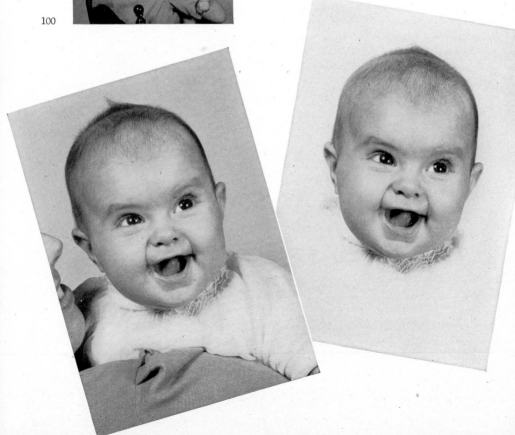

Vɪɢɴᴇᴛᴛɪɴɢ is a sort of glorified shading. It is an effect gained by shading all of the picture except for one central feature, leaving that emphasized. Used mostly, of course, in portrait photography, it is a convenient trick when you want an enlarged picture of one particular person in a group photograph.

Dɪꜰꜰᴜsɪɴɢ. Sometimes pictorial and portrait photographers achieve a soft "atmospheric" effect in their prints. In enlarging this may be done by holding a *diffusion disk* directly next to the enlarger lens during the exposure. This disk is a flat glass with slightly raised concentric rings pressed onto it. Light passing through the disk has its path altered just enough to break the sharpness of a straight line. Usually it is best to give half the exposure without the diffusion, and half with diffusion.

Crumpled cellophane and black net are sometimes used in place of the glass disk, but are not as suitable because they greatly reduce contrast and cause too much scattering or diffusing.

The negative had plenty of sky detail, but an enlargement, exposed for the foreground, failed to reveal it. By dodging, the sky was given the necessary additional printing exposure

101

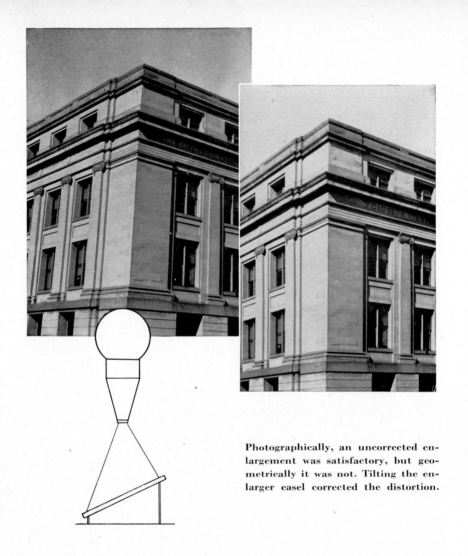

Photographically, an uncorrected enlargement was satisfactory, but geometrically it was not. Tilting the enlarger easel corrected the distortion.

CORRECTING DISTORTION. Enlarging allows for the possible correction of what may logically be termed distorted perspective. In the average snapshot of a building, made at close range, the sides of the building seem to lean in toward the center of the picture and the building appears to be falling back. The top of the building is farther away from the camera and is therefore reproduced on the film as smaller. Hence, some snapshots, otherwise beyond criticism, look quite unnatural.

To correct for this effect in enlarging, tilt the easel or paper board so the projected image of the bottom of the building is closer to the lens than the top part. Then the bottom of the building will be magnified

less; if the tilt is of the proper degree, the combination of camera distortion and the reverse enlarger distortion will be one of cancellation and the print will appear normal.

Some enlarger easels or paper boards have adjustable legs for tilting; with others you can simply lean one end of the board on a couple of books with the same result. Focus the image in the center and stop the lens down as far as possible for all-over sharpness.

The final enlarged print may represent a combination of all the above "doctors." Don't lose sight, however, of the fact that the more care you exercise in the original exposure and negative development, the less manipulating you'll be required to do.

CHECKING UP

Here are a few questions you might ask yourself as a sort of measuring stick for the quality of your enlarging.

1. "Have I selected the right contrast grade of paper?"

 You have, if your print shows the full tone range of which the paper is capable, and if you can see detail in both the picture highlights and shadows. There should be modeling and brilliance in any faces that show.

2. "Is the paper surface right for the subject?"

 It is, if it jibes with the chart in this chapter, or if it seems pleasing to you and to others.

3. "Have I exposed and developed it properly?"

 You have, if your print was so timed as to be fully developed in the recommended time. It will be free from streaks and stains if you kept it *well agitated* in the developer, stop bath, and hypo, and used fresh solutions.

4. "Is my print sharp?"

 It will be if your negative was sharp to begin with and you were careful in focusing your enlarger. Enlarger vibration during exposure will, of course, ruin the over-all sharpness and definition of the print.

5. "Will I—or anyone else—be able to enjoy this enlargement a few years from now?"

 Certainly—if fixation and washing are carried out according to both the letter and the spirit of the laws governing those processes. If you're doubtful, remember there's a test you can make. It's a Kodak formula, HT-1a.

Printing Latitude Experiment

Object:
To determine the extent to which over- and underexposure of printing and enlarging papers may be compensated for by over- and underdevelopment.

Equipment:
Facilities for printing and enlarging.

Procedure:
Using a negative of good quality, make the best possible contact print or enlargement on the paper to be tested. Follow the recommended development technique, but adjust the intensity of the printing light to provide a paper exposure of approximately twenty seconds for this good print.

Perhaps the best print from the negative you select will come from a short exposure. In that case smaller bulbs may be substituted for those in the printer, or a few sheets of white typewriter paper can be inserted between the lamps and the negative. In enlarging, simply adjust the diaphragm of the enlarger to give the suggested twenty second exposure.

Record your exact exposure and development times. Then make a series of prints, reducing the exposure time by three seconds for each successive one. Develop each print long enough to compensate for the lack of exposure. Make another series of prints with longer exposures, with a three-second increase in exposure time for each successive print in the series. Develop these

Extreme overexposure and underdevelopment result in a flat, muddy print

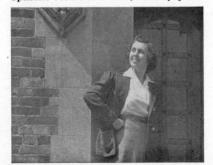

for shorter times in an attempt to compensate for the over-exposure.

Carry both the over- and underexposure series to the point where the resulting quality is definitely inferior.

Mount in order, for study and comparison. It will be obvious that while passable prints may be obtained through a considerable range, best prints result from correct timing and processing.

Questions:
1. What is the passable range?
2. How many prints are equally as fine as the correctly handled one?
3. How does contrast vary with the time of development?
4. What is wrong with the prints that are not wholly acceptable to you? Are they flat and muddy looking? Are they stained and yellowish?

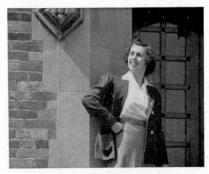

Properly exposed and developed, this print covers the full tonal scale

Extreme underexposure and overdevelopment produce flatness, fog, and stain

Sensitometry

WHEN YOU TAKE A PICTURE you have one specific result or effect in mind. "Trial and error" is one way of getting what you want, but it's uncertain, inconvenient, uneconomical, and often just plain impossible. Obviously, the better way is to be able to define your aim in terms of print quality, and to set about getting it systematically. That's where science comes in.

A good print, generally speaking, is one in which the full scale of the paper from white to black is utilized, and in which there is detail in both the highlight and shadow regions. But a really good print cannot be achieved without a good negative; negative quality is fundamental.

On the basis of very extensive study, photographic scientists have been able to make definite recommendations for the use of film, paper, and chemicals, all aimed at a good picture as the final objective. *Sensitometry* is the name attached to this phase of photography. It is concerned, as its name implies, with the measurement of sensitivity and the study of all technical factors effecting the use of sensitized materials.

In sensitometry the measurements and the language are specific and quantitative. They are the backbone of the exposure and development recommendations which accompany sensitive materials. Take them lightly for granted if you wish, but the fact remains that they are based on the fundamentals of the science of photographic materials. If you know these fundamentals, you are in a far better position to take full advantage of film and paper than one who does not; just as one who knows automotive mechanics is reasonably sure to get better mileage and smoother driving.

THE TERMINOLOGY

While most of the words of sensitometry are familiar enough, many have special meaning when applied in photography. For example, there's *exposure, opacity, transmission, density, speed, latitude,* etc. It is of course

possible to go through a fairly successful photographic life serenely una-
ware of them. It is also possible to live today without considering what's
involved in such terms as 50 miles per hour speed, 60 watt lamps, 90 horse
power engines, 70 degrees Fahrenheit, 1430 on the radio dial, or 20 miles-
to-a-gallon motoring efficiency; it's possible—but hardly practical.

Exposure

Speaking specifically of *exposure*, photo-scientists properly regard it as
the root of all photographic good and evil. For exposures result in silver
deposits in the film emulsion, and at precisely that point the success or
failure of the eventual picture hangs in the balance.

Exposure implies the total action of light on the sensitive film at any
particular point. It is a composite, the product of the illumination *(I)*,
as it reaches the film, and of the *time (t)* that light is allowed to act on
the film. It's a nicely symbolic coincidence that the basic equation of
photography reads thus:— $E = It$

For *exposure* is unquestionably "It" in photography.

During the instant the shutter of your camera is open, as you "take" a
picture, many different light intensities from the scene fall onto the film,
all for the same length of time. This means many varied exposures, all
of which go to make up the image or negative after development. The
scene is visible in real life and on the film only because of these intensity
differences.

In addition, *I* is controlled by adjusting the lens aperture, which uni-
formly raises or lowers the intensities of light reaching the film. If the
lens aperture is opened too far, under average conditions, the highest
intensities (the highlights) of the subject are overexposed; cut down the
aperture too far, and the low intensities (the shadows) become too weak
to register adequately.

The other variable, *time* or *t*, is a matter of shutter speeds. Change from
the conventional 1/50 second to 1/25 second and you obviously get
double the exposure. Many modern cameras give you a range of shutter
speeds from 1/400 second to one second, hence your factor, *t*, is really
quite variable.

Density

The result of exposure is, on development, a silver deposit on the film—
and that deposit is quite important, too. For on its adequacy and on the

inter-relationship of all the deposits on the film depends the quality of the eventual picture.

Roughly, here is the mathematical approach to density, or the all-important light-stopping qualities of the silver deposit.

1. Here's a developed film. In one section of it, in an area concerned with some such monotone subject as, for example, the side of a barn, there's a silver deposit labeled "A."

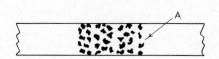 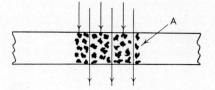

2. Suppose the deposit is just enough to permit half of the incident light to pass through.

3. Since the *transmission*, or light-passing characteristic, of any medium equals the light passed divided by the light incident, the transmission of A $= \frac{1}{2}$.

4. Divide the incident light by the light passed and you have the reciprocal of transmission, or a quality which is called *opacity*.*

5. The *opacity* of A $= 1 \div \frac{1}{2}$ or 2.

So far, so good. But opacity, as a basis for photographic computations, is clumsy, and not directly related to our visual impressions. The opacity of silver deposits in current films might easily vary from 0 to 500 or more. A chart, drawn to represent the growth of opacity in the film, might have to extend over vast expanses of graph paper. But, more important, the eye does not recognize tone differences in arithmetic proportions; it sees them in terms of logarithmic differences. Density is the term applied to the logarithm of opacity. If the opacity of the deposit A, mentioned two or three paragraphs ago, is 2, the density of that deposit is the logarithm of 2, which happens to be .3.

This term *density*, in its specialized photographic sense, is freely used in technical discussions. For example, you may be casually informed that some specific area has a density of 2.3. To figure out what that means,

*The science of photography needs some expert word craftsmen, for *opacity* is a poor word. It comes from "opaque" which is an absolute conception, not a relative one. Think it over.

arithmetically in terms of *transmission*, you grab your nearest "Handbook of Chemistry and Physics" and look up the antilog of 2.3 (the number which has 2.3 for its logarithm). It turns out to be 200. Therefore, backing into the equations, you establish that:

$$\text{Opacity} = 200$$

and that the corresponding transmission is 1/200.

In other words, only 1/200 of the incident light is transmitted.

In film testing laboratories, light sources of definitely known intensities and precisely measured exposure times are used. The instrument for exposing film in this exacting fashion is called a *sensitometer*. Your camera is a sensitometer minus the precise controls. You expose for known times, but not at known intensities.

There are also *densitometers*. These are used for measuring the densities of small areas of silver deposits. They are simply scientific extensions of the judgment you use when, scanning a negative, you announce that it is thin, or dense. Such optical or electrical devices are relatively expensive, but indispensible in such professional fields as the motion picture industry. If you wish to do a limited amount of density reading, such as for occasional color printing at home, you'll find the Kodak Densiguide useful. It contains a strip of measured densities which you can use for comparison with your film gray scale densities, and arrive at a reasonably accurate measurement.

The density of a silver image on paper is figured in quite the same way as those of film, except in place of transmission the amount of light reflected is measured. Paper densitometers illuminate the area to be measured with light from 45° angles and use a viewing direction which is at right angles to the paper.

All of this may seem to belong in the "interesting if true" category, but in the manufacture of film it is put to work in a number of constructive ways, ways which can be of real value to you as a user of the products. By comparing and controlling the relationship between exposure and density in films, remarkable uniformity can be maintained in the manufacture of the many types of films, and specific, pratical exposure recommendations can be made.

The Characteristic Curve

On the basis of such precision, it is possible—and useful—to establish exact relationships between exposure and density and to plot those relationships

on a graph. Because *density* is a logarithmic expression, *exposure* is transposed into logarithmic terms and becomes known as "log E," or the logarithm of the two factors which determine exposure, I x t.

The curve which results when density and log E are plotted as a function of one another looks like this for film.

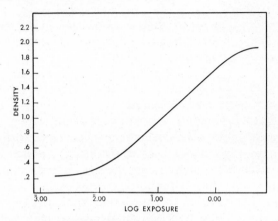

Because each film has a unique curve, peculiar to or characteristic of itself, and because it is possible to determine from the curve many of the *characteristics* of the film, the curves are known as *characteristic curves*.

One might rightfully expect that if the log exposure is doubled or tripled, the resulting density should double or triple, but film doesn't see things that way. If it did we'd have a graph like this—

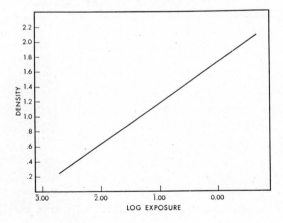

lose their separation from one another. Finally, with too little exposure, all but the brightest parts of the subject are the same—blank.

Such a picture is said to be made partly on and partly off the "toe" of the curve, and is underexposed.

One glance, then, at a characteristic curve tells us there are three more or less distinct parts to it. There is first a toe, then a straight line portion where density increases uniformly as the log exposure increases, and then a shoulder. All of these show degrees of density differences resulting from differences in exposure. Incidentally, be sure you keep in mind that density itself means little—it's almost entirely a matter of the relationship of all densities to one another that determines what kind of photograph you get.

Films which differ in the position of their curves along the log E axis respond to exposure quite differently. It is this fact that makes it necessary to have specific exposure recommendations for each type of film. It is the sole purpose of exposure guides to tell you what aperture and shutter speed you should use, at different levels of illumination. In following this guidance, you place your negative at such a position on the curve that, when it is developed and printed, you'll have a good picture.

Several additional terms serve to describe the characteristic curve, its shape and its parts, the first of these being *gradient*. Gradient is the slope of a line drawn tangent to the curve at any point. It represents the rate of density growth at that point. Thus on the extreme or flat end of the toe of the curve gradient is zero, but as you move to the right gradient

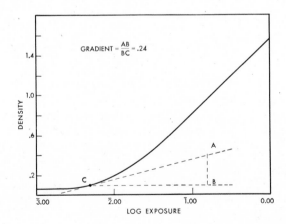

increases until it reaches its maximum on the straight line portion where it is called *gamma*. In your negative this means that shadows falling on the flat part of the curve have zero contrast; if they fall on the toe they have moderate contrast. (See curve on opposite page.)

$$\text{Gradient (G)} = \frac{AB}{BC} = 0.24$$

Then there is *average gradient*, the mathematical average of the gradient values for all the points on the curve between the points of minimum and maximum exposure. It is a quantitative measure of what has heretofore been referred to as negative contrast and depends upon such items as the film used, subject conditions, lens flare and development.

Extensive tests have shown that to be a wholly acceptable negative, that is, one capable of yielding an excellent print, the gradient at the point of minimum exposure must equal .3 of the average gradient. This means that at least a part of the subject is located on the toe of the curve, the shadows

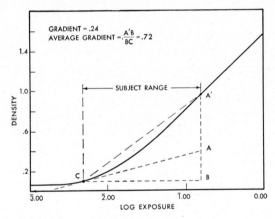

having moderate contrast, the high lights more contrast. More exposure—giving negatives located farther to the right on the curve—is permissible, but not less exposure, for with less exposure the shadows lose their detail. Exposure guides and calculators recommend times and apertures aimed to keep your negatives safely above the minimum, and provide leeway for any slight human errors in judging light and mechanical errors in equipment.

When you develop your negative you control the slope of the curve, hence the average gradient for your negative. Little development means

113

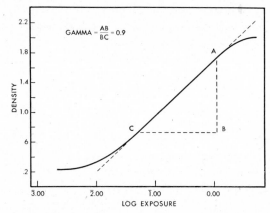

a flat, low-contrast negative; longer development means normal or higher contrast. The degree of development is measured in terms of *gamma*. Gamma compares the density increases with exposure increases on the straight line portion of the curve. It is entirely independent of camera exposure or subject, but is important in comparing results with different materials.

Characteristic curves are generally accompanied by a "time-gamma curve," for the customary developer. This is the result of plotting gamma as a function of the development time.

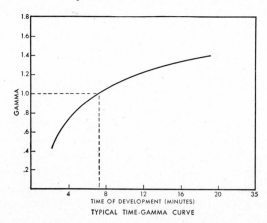

TYPICAL TIME-GAMMA CURVE

If you want to develop your film to a particular gamma, locate that value on the upright axis of the chart, draw a line through it parallel to

the time axis. From where this line intersects the curve, drop a perpendicular to the time axis. The intersection of this perpendicular and the time axis gives you the development time for the desired gamma.

In view of the several factors over which you can exercise control it becomes apparent that on your shoulders rests a large part of the success of the negative. In case of doubt, follow recommended procedures; they are firmly rooted in facts.

PAPER CHARACTERISTICS

A photographic paper emulsion responds to light in essentially the same way that film does, and a characteristic curve shows the relationship between density and log exposure. While you can change the slope of a film curve by changes in development, a paper curve is fairly fixed. It is for this reason that there are usually several different contrast grades of each paper type. Here's the curve for Velox No. 3. Note that its toe

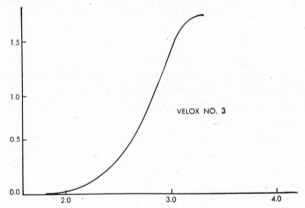

rises slowly but that at higher densities the contrast is much greater. Remember now that the negative becomes the "subject" for printing. The shadows of a good negative are a bit low in contrast; they transmit considerable printing light to produce the higher print densities in the regions where paper contrast is high. Conversely, the highlights in the negative are higher in contrast and are reproduced by the flatter, sweeping toe portion of paper. In other words, the shapes of film and paper curves have been engineered to fit each other.

Papers of lower and higher than normal contrast permit compensation for some errors in exposure, processing, variations in subjects, and variations

115

in equipment, but can by no means be thought of as cure-alls.

SPEED

The less camera exposure required in making a good negative, the faster the film is said to be, or the greater its *speed*. In terms of the curve, the farther the characteristic curve of the film comes to the left or low log E values, the "faster" the film is. From a more practical viewpoint the former definition is much more important. Considerable discussion has arisen as to just how comparative film speeds should be determined.

The American Standards Association system of speed determination is based on the minimum exposure required for an excellent negative. For application of this value, a safety factor is added; the factor depends on the exposure latitude of the film, and on the characteristics of the exposure-determining device with which the figure will be used.

The result is put into words on Kodaguides and into numbers called exposure indexes or speed numbers, for use with photo electric meters.

Speed considerations are important when it comes to determining actual camera exposures, that is, you must know how fast your film is. Beyond that point the importance of speed diminishes rapidly. Almost all films are fast enough for anything you are apt to be required to photograph. Extreme speed is attained only at the expense of other qualities—fine grain, for example. Ratings in terms of speed are not clues to quality which is so much more important in making good pictures. Uniformity in manufacture, color sensitivity, graininess—those are the points to look for rather than buying for speed alone.

LATITUDE

The classic definition of the word "Latitude" has always stated that it was the horizontal extent of the straight line portion of the characteristic curve. However, as the definitions of sensitometry have been shifted toward a more practical side, this concept has given way to what might better be called *camera exposure latitude*. This is the difference in camera exposure between the shortest and longest exposure resulting in negatives capable of printing into excellent pictures. (Since camera exposure latitude is influenced by the optical system used in the camera, no specific values can be assigned.) Most of the camera exposure latitude falls on the overexposure side, since recommendations are made to permit the use of nearly the least practical exposure.

RESOLVING POWER

Resolving power is the ability of a film to distinguish between very finely divided lines, hence to produce fine detail on extreme enlargement. This is naturally an important consideration in choosing films, especially in miniature photography where considerable enlargement is the rule.

If you try handwriting in small letters with pen and ink on blotting paper, all the detail runs together and is lost. On a hard-surfaced paper, microscopically fine ink lines can be kept separate and can be distinguished easily with an eyeglass.

With films it's much the same—only you write with light on film. The ability to produce critically sharp images—that is, resolving power—is measured in lines per millimeter, and

1. Increases with contrast of the test object.
2. Increases with contrast due to development.
3. Decreases with overexposure.
4. Varies from film to film.
5. Decreases with coarser grain size.

The illustrations show a resolving power test.

Kodak Panatomic-X Miniature Film Developed in D-76

Prints reproduced here represent resolving power at 75 times enlargement.

Upper Left: Underexposure and normal (12 minutes) development. Result: Loss of both resolution and detail.

Lower Left: Normal exposure and normal development. Result: Maximum resolution.

Upper Right: Overexposure and normal development. Result: Spread of light obscures fine detail.

Lower Right: Normal exposure and overdevelopment (36 minutes). Result: No apparent loss of resolving power, as compared to normal.

Moral: Correct exposure.

117

SO WHAT!

About now you are thinking—"How can I apply any of these things to my work to get more consistent results?" Here are some suggestions.

1. Follow directions; it's easiest and safest. If for one reason or another the directions don't fit your working conditions, vary your procedure as necessary.

2. If you have become accustomed to a particular type of film and have had excellent results by developing for a time which results in a gamma of .8, you can switch to another film whose characteristic curve is similar in shape to your first film, develop it to a gamma of .8 and expect the same picture contrast.

3. If you switch developers, say to get finer grain images, select the time which gives you the degree of development (gamma) you've found best, and you'll get the same contrast as originally. Developers vary considerably in the rate at which they work, but results at any gamma value are the same as far as contrast is concerned. This assumes the image in all cases is black, not brown, and is unstained.

4. A time-gamma curve will tell you the number of minutes required for any desired gamma in a given developer and temperature. By consulting the same curve you can tell how much you must increase or decrease your development time to make an appreciable change in the contrast of your negative. Similarly, you can tell just how accurate you must be in timing your development. If the gamma value to which you work falls on the flat portion of the time-gamma curve, extreme accuracy is not essential. If the value falls on the rapidly rising portion, accurate timing is necessary.

5. If you encounter a scene involving an unusually long brightness scale, make certain your exposure is sufficient to register the shadows far enough up on the toe of the curve to allow a differentiation of detail.

6. When you tackle the job of making color prints by separation negatives, it will be necessary to make three negatives through color filters. To be satisfactory the density and contrast must be nearly identical. This involves adjusting development times and balancing exposures. Density readings will be necessary and if you do not have a densitometer available, use a Kodak Densiguide.

7. If your system of picture making, including camera, usual subject

matter, film, development and printing, or enlarging requires on the average a No. 3 contrast grade paper, and you wish to use No. 2 paper, increase the *gamma* to which you develop by 20%. Conversely, if you're getting too much contrast and are forced to print most of your negatives on No. 1 paper, decrease your development time to reduce your gamma by 20%. For the changes in time required, consult the time gamma curve.

So runs the language of sensitometry, a living science. And because that science is dynamic and useful, it's a good thing to understand a little of it. There is no need to make a fetish of gamma or to consult the characteristic curve of your film before every shot. But it is a comfort to know that a lot of scientific spade work has been done by the photographic industry, not to impress or mystify but to permit more intelligent achievement of the ends of modern photography. Those ends are, simply, better pictures.

Latitude and Speed Test

Object:
To show the wide range of negative exposures which are capable of being printed into good pictures.

Equipment:
A camera with variable aperture and shutter speeds. (The shutter speeds should ideally extend from one second to 1/400th of a second. With those cameras not capable of that range, the experiment may be contracted.) Super-XX, or another panchromatic film. Facilities for printing.

Procedure:
On a bright, cloudless day select a subject in full sunlight and make the following exposures with the lens set at f/22:

1/400, 1/200, 1/100, 1/25, 1/5,
1, 8, 16 seconds.

After the films are developed according to recommended procedure, make the best print possible from each negative, using any of the six contrast grades of paper available.

Mount the prints in sequence on a notebook page or card. Encircle the ones with the least and longest exposures which printed satisfactorily. The longest printable exposure divided by the shortest will give the latitude, expressed as the exposure relationship between the extreme prints. For example: if the test shows that all negatives including the 1/200th of a second exposure and the 8 second exposure limits gave passable prints, the range would be 1,600 times.

If this test is repeated for several films, it can be used as a test of film speed. Film is fast only if you can make prints from negatives made with little exposure. If film A gives a print from the 1/200th negative and film B only from the 1/100th negative, film A is

119

approximately 2 times as fast as B.

To compare camera exposure latitude of black-and-white and Kodachrome film, make five exposures on the latter; one at the normal or recommended setting, one at one stop less than normal, one two stops less, one at one stop more than normal, and one two stops more.

Questions:

1. Compare the negative from which the first excellent print was obtained with the one having one step less exposure. What's missing in the one with less exposure which is present in the one with more exposure?

2. While good prints may have been obtained through a considerable range, how do those on the under- and overexposure side differ from the one correctly exposed?

A negative is satisfactory if a good print can be made from it. For this series, six negatives were exposed at, respectively, 1/100, 1/25, 1/5, 1, 2, and 8 seconds, all at f/22. Without recourse to high-contrast paper the over- and underexposed negatives would have been unprintable. Therefore latitude appears to be a function of both film and paper.

120

Filters

UNLESS you are an unusually astute—or lucky—person, something of this sort will have happened to you by this time:

Down along the shore, one fine day, you observe a beautiful scene—a scene which demands and deserves picturing. The sky is blue, the clouds are big and billowy; against this "back drop" a white lighthouse rears its slender form. In the foreground there are trees and rocks. The whole thing composes easily and well. In short, it is a ready-made picture, and you turn your camera loose on it with fine enthusiasm. It is a natural.

But when the negative is developed and a print made, you discover that something has gone haywire. There is no sign of that beautiful sky, the clouds have faded into insignificance, and the lighthouse itself has been lost, save for its windows and the glassed-in light chamber. Blues and whites have merged into blankness. The foreground is perfect. But the picture—the beautiful scene that tempted, beguiled, and inspired you —is gone.

It's discouraging, of course, but it is more mystifying. How is it possible that so much should drop out of a picture, leaving you nothing but negligible remnants? You experiment. You make similar shots on other days, under other light conditions, and with other exposures. Sometimes you get passable results, too. You discover that a really deep blue sky does tend to give you more cloud-sky contrast; and you may observe that a bit of underexposure helps to achieve the same ends. And various films, of course, vary in their color response. But your experimentation reveals to you no sound-and-certain technique until—usually at some veteran's suggestion—you decide to see what happens when you slip a color filter over your camera's lens. And when you do find out what happens, you immediately become filter-conscious, for filters are very important to you and to your pictures.

The sky was the same when both exposures were made; a yellow filter
over the lens made the difference

What Is a Filter?

A light filter consists of a piece of dyed gelatin or glass, held in place
immediately in front of the camera lens during the exposure. Rays of
light from the subject, striking the filter, are either absorbed or trans-
mitted, depending on their color relationship to the filter. It is sort of an
optical strainer for light waves. You use a filter which will absorb the
colors you want to appear darkened in the print and which will transmit
the colors you want relatively brightened.

Because the usefulness of filters depends on the nature of light, and
because it is a short step from filters to color photography, this is a good
point at which to delve a little deeper into some of light's characteristics.

Light travels in waves. The length of these waves from crest to crest
determines the color of the light. Red waves are long, green waves
shorter, blue waves shortest. Within these general wave length groups,
the shades of red, green, and blue vary with smaller wave changes.

Of course, if there are no waves, there is no light. If all the waves
travel together, the result is white—the presence of all colors. A mixture
of less but relatively equal parts of red, green, and blue results in gray—
in any "neutral" tone from black to white.

Red and green waves combine to form yellow. A yellow book is one

that reflects both red and green, absorbs blue. Likewise, all other colors are combinations of the three *primary light colors*—red, green, and blue.

Orange = red + some green
Yellow = red + green in equal parts
Pink = red + blue in equal parts
Darker pink = less red and less blue

Due to the very nature of filters, their ability to absorb certain wave lengths of light, they appear colored when held in front of a white light. A filter looks green if it *transmits* green, absorbs blue and red. Thus through a green filter, green objects look light—other colors not containing green are absorbed and appear black.

A yellow filter absorbs only blue and allows light from both green and red objects to pass through to the eye or film.

There are over a hundred light filters, all of different absorptive characteristics, hence of different colors. Those of real practical value to most photographers are limited to about half a dozen; the others afford a means of exact control over light for special purposes in commercial and scientific photography.

Which Filter to Use

Filters cannot be used without regard for the film in the camera. The film must be sensitive to the light passed by the filter; otherwise no image can be recorded. Orthochromatic films cannot be used to make negatives through a red filter, as they are sensitive only to blue and green, and these colors are absorbed by a red filter. Because of their sensitivity to the full range of colors, panchromatic films can be used with all filters.

In photographic usage there are three arbitrary words employed to describe filtered and unfiltered effects. A picture in which the tones have the same relative brightnesses that we see in the subject (assuming that we have normal color vision) is said to be *correct*.

When negatives are made under ordinary conditions and without a filter, the relatively high blue sensitivity of photographic emulsions records the blues in the subject as too bright. That's why the lighthouse, the sky, and the clouds all emerged as white. Panchromatic (Type C) films also record subject *reds* as too bright, in terms of what the eye sees. Such pictures suffer from *undercorrection*. When used in conjunction with the right films, certain filters absorb the too-active rays and allow a balanced or correct effect. These are referred to as *correction* filters.

123

Other filters cut out too much of the blue light and produce exaggerated effects, such as black skies. These are known as *overcorrection* filters. A somewhat incongruous term, it simply means "correction," carried to an extreme.

Listed here are the most widely used filters, together with their properties and major fields of usefulness.

Choosing Your Filter

YOUR SUBJECT	YOUR FILTER	YOUR FILM
For smooth skin texture and "corrected" skies	YELLOW FILTER WRATTEN K2	PAN B FILM SUCH AS PLUS-X, SUPER-XX
For haze penetration, contrast in marine scenes, sky-cloud contrast	ORANGE FILTER WRATTEN G	ANY PAN FILM
For exaggerated sky— cloud contrast, storm pictures, etc.	RED FILTER WRATTEN A	PAN B OR C FILM SUCH AS PLUS-X, SUPER-XX, TRI-X
For natural reproductions of blossoms, foliage, outdoor portraits against sky	BRIGHT GREEN FILTER WRATTEN X1	PAN B OR C FILM

Sometimes we hear reference to "contrast filters." This term refers more to the effect obtained than to any unusual characteristic of the filter by itself. The effect is a distortion of the brightness values so that two colors of about equal visual brightness photograph quite differently. The filter absorbs one, transmits the other. Almost any filter can produce this sort of subject contrast when used in the right place with a film capable of properly recording the differences the filter sets up. For example—a red filter is a "contrast" filter when used to photograph blueprints. Maximum contrast between the white lines and the blue background is obtained as the red filter transmits the red component of the white lines and absorbs all the blue from the background. If the subject were a red and yellow beach umbrella, the red filter could not be considered as adding contrast. Through a red filter both red and yellow look the same—and photograph the same.

The Contrast Viewing Kodaguide contains a sample set of filters through which you can view your subject to determine the effect of those filters on contrast. Frequent reference to this handy guide will provide good training in filter sense and when unusual color combinations pop up it will give you the answer.

Wratten Filters

Originally of English manufacture, and now produced by the Eastman Kodak Company, Wratten Light Filters have become more or less standard the world over in the past 30 years. They are available for photographic use in any or all of these three forms.

(1) *Dyed gelatin.* Made in gelatin sheets much like film support, the color absorption and transmission characteristics come from organic dyes of great purity. Both the supporting gelatin and the colors are held to extremely close physical and optical tolerances in manufacture.

Filters supplied in gelatin sheets are less expensive than in any other form. At the same time, they are less conveniently attached to the camera for use, and the finger prints and scratches that naturally accrue from handling cannot satisfactorily be removed.

(2) *Dyed gelatin cemented between glass.* Two distinct grades of glass are used. One, "B" glass, with a dyed gelatin filter cemented between it, provides perhaps the best combination available for average use. The same high standards of color purity are maintained as in the gelatin filter alone. The glass protects the filter from scratches and abra-

sions; finger marks can be more easily removed, and it is easily attached to the camera by means of a slip-on holder ring which fits neatly onto the lens mounting. "B" glass is sufficiently accurate optically to permit its use in most phases of amateur photography. And the price is such that every photographer can afford at least one such filter.

The other glass, a hand-ground and polished optical flat, is referred to as "A" glass. Filters of gelatin cemented between pieces of "A" glass are expensive but almost indispensable in aerial photography, photoengraving and other work in which perfect measurements and sharpness must be maintained. "A" glass has no magnifying power; hence it permits photographing to the extreme accuracies required in aerial surveys and mapping.

Filter Identification

Wratten Filters are assigned arbitrary letters or numbers for identification —K2, X1, A, B, C, etc. These are in no way concerned with the separate letters used to denote the kind of glass between which they are mounted. One merely has to remember the letter designation assigned to the filter of the color he uses.

You may have heard of using ordinary sunglasses as filters; it can be done, but it should be reserved for use only in dire emergencies. The tinting of such glasses has little photographic significance, the colors are seldom uniform, and the glass itself may not be optically respectable.

Filter Factors

Thus far, only one aspect of filters has been considered; their ability to change the relative print brightnesses of the subject colors. But equally important is the fact that a filter may cut out from ⅓ to ⅔ of the light available for making the picture. Naturally, therefore, a longer camera exposure is needed when a filter is used over the lens. The number of times which the proper unfiltered exposure must be increased when a filter is used is called the *filter factor*.

The filter factor depends upon the filter itself, the film, and the light source. And there is a nice interdependence between these three. For example, a red-transmitting filter used with a red-sensitive film does not involve as large a filter factor as one which transmits less red light.

The filter factor is also dependent on the light source. Outdoor light is bluish; most artificial light is reddish. A bluish filter used outdoors

therefore absorbs little of the existing light, and the exposure need not be increased materially to equal the exposure without a filter. Indoors with tungsten light, mostly red, a blue filter cuts out all but a small portion of the light and the blue-filtered exposure necessitates a relatively high factor.

In applying a filter factor to the calculation of exposure, you can work in three different ways. Assume the factor to be 4, and the normal "no-filter" exposure to be 1/50 at $f/11$. If you increase the time by 4, you have 1/12.5 second; 1/10 is close, so you can shoot at 1/10 at $f/11$ with the filter. If, on the other hand, you need to use 1/50 shutter speed, apply the factor to the lens aperture. Opening the diaphragm two stops quadruples your light volume; hence you can work at 1/50 at $f/5.6$. Or you can compromise by doubling both time and aperture; that gives you 1/25 at $f/8$.

Determining Filter Factors

Object:
To determine the filter factor for any film, filter and light source combination, using only ordinary camera equipment.

Equipment:
Any camera, plus the film and filter in question.

Procedure:
1. Obtain sheets of white, medium gray, dark gray, and black paper, each one foot square. Attach these to one another in order to form a strip four feet long.
2. Photograph this chart with no filter under lighting conditions similar to those to be used for pictures to be made subsequently with the film and filter, i. e. sun light or flood light. Obtain correct exposure, by trial if necessary, and correctly expose one film for later development.
3. Now photograph the chart under the same lighting conditions, but with the filter over the camera lens.

Make three exposures. For the first one, use twice the exposure given when no filter was used. Double that for the second—and double the second one for the third test. This will provide *filtered* pictures with 2-4-8 times normal exposure.
4. Develop the above 4 exposures simultaneously.
5. Compare the negatives visually by transmitted light. From the negatives made through the filter, select the one whose chart parallels in density the unfiltered chart. The increase in exposure represented by the matching filter negative, over the normal *no filter* exposure, is the filter factor and can safely be used as such under similar conditions at any time in the future.

If none of the three filter pictures matches the first exposure, make additional tests, increasing or decreasing the time as necessary until a close match is obtained.

Color Subtraction

Cyan, magenta, and yellow are overlapped to produce red, green, blue, and black subtractively.

Color Addition

Red, green, and blue, mixed additively, produce cyan, magenta, yellow, and white.

Color Wheel

The color wheel, reduced to twelve arbitrary hues. Opposite hues are complementary; hues touched by the triangle, as it is rotated, tend to be harmonious.

Color Photography

THERE'S MAGIC in that word "color." It has been to photographers what gold was to the prospectors of a century ago—or what a pennant is to some struggling second-division baseball team.

From the earliest days of photography men reasoned that, since color is a property of light and since light is the essence of photography, surely there should be some way to realize color photographically. The problem fascinated hundreds of men, absorbed the careers of many scientists. And the research still goes on, despite the fact that several excellent color processes are well established as part of modern photography.

Today's color photography is divided into two primary types—color transparencies and color prints. You look *through* transparencies and look *at* prints. In one case you're dealing with transmitted light; in the other you have reflected light. That distinction is basic.

Kodachrome Film provides the transparencies with which most of us are familiar. These include home movie films in color, or miniature transparencies in those little 2 x 2-inch slides which can either be projected, stereopticon fashion, or viewed directly, against a light. Kodachrome Film in larger sizes is used by scientists and commercial photographers for a variety of purposes, some of them as the originals of the color work we see in magazines and books.

Photographic color, in itself and in reproductions from it, has become so familiar today that most of us accept this modern miracle with complete composure—as casually as we tune in on an international radio hook-up. Of these two bits of magic, the radio is by far the more complex.

Photographic color has its roots in the nature of light. By the way, nail down that idea of *light*, for color in light is quite unlike color in pigments. For the moment, forget what you know about mixing paints; otherwise you let yourself in for a bit of confusion.

131

There are, as was said in reference to filters, just three basic or *primary colors of light—red, green, and blue.* When these are added together, in relatively equal parts, the result is "white." By varying the relative amounts of primary colors *any* color can be obtained.

Now, if all the blue is somehow removed from white light, and only red and green remain to be seen together, the sensation is—oddly enough —*yellow.* Hence, yellow is referred to as a *complementary color;* add it to blue light—a primary—and white light is "completed." White minus green becomes pink. Technically this pink is known as *magenta,* and magenta is the complement of green. When red is removed from white light, blue and green remain; they combine to form blue-green, called *cyan,* the complement of red.

For firsthand experience with color, cover three flashlight or slide projector lenses with colored gelatin filters, one red, one green, and one blue. In a darkened room, shine these one at a time onto white paper. You will see the primary colors. Then shine all three onto the paper at once, superimposing the colors. Your result, if the dyes in the gelatin are the required strength and the three lights equally bright, will be white, just as if you had an uncovered lens shedding light onto the paper.

Turn the lights off, one at a time, and notice how the complementary colors are formed. Now try all the different combinations. It's a strange phenomenon, well worth a little investigation.

These color fundamentals may be employed in two different ways to make color transparencies and color pictures by multiple projection. One process is called the *subtractive* and the other *additive.* Commercially available films are nearly all subtractive, but since the additive process was used first, it is described first here.

THE ADDITIVE PROCESS

As its name implies, the additive process depends solely on the addition of primary colors of light to give the desired colors in the final picture.

For an example of additive color photography, consider the following sequence of steps.

1. A color chart is photographed onto three separate sheets of black-and-white panchromatic film; one is exposed through a red filter, one through a green filter, and one through a blue filter. Light from the subject which is the same in color as the filter, passes, unchallenged, onto the film, in each case. Red goes through the red filter, and so on. Where

the color is complex, as with yellow, pink or white, the light passes through all filters whose colors are represented in the subject color. Yellow goes through the green and red filters, and white, naturally, through all three—because red, green, and blue are all represented in white. The three resulting negatives are silver records on film of the amounts of the primary colors in the subjects. They are appropriately referred to as *separation* negatives, for they separate the primary colors onto separate films.

2. Each of these negatives is next printed onto another black-and-white film, giving a positive image. The *clear film spaces* in these positives represent the primary colors in the subject. The black, or silver, areas indicate an absence of the primary color in those particular areas.

3. If the positive on which the clear spaces represent *red* is projected onto a screen by means of red light, the red of the subject will be reproduced in its entirety. Red will appear on the screen where there was red, pink, yellow, and white in the original. The same reasoning follows for the green and for the blue records.

4. If the three color records are projected simultaneously and the images superimposed, the full color reproduction will appear. Red and green, as projected, combine to form yellow; blue and red combine to form magenta, and so on. Varying intensities or saturations of the basic hues give an infinite variety of colors, bold or subtle. Only primary colors are used to gain the desired effect, an effect possible because these colors can be mixed to give *any* color. They are *added;* hence the technical term *additive process.*

You have undoubtedly heard of the Lumiere Autochrome color process, of Dufaycolor, and of Finlay Color, all based on the applications of additive principles.

These commercial applications of additive principles have been developed so that pictures can be taken on single films and viewed or projected directly as color transparencies. These are referred to commonly as screen plate processes, for a pattern or screen of miscroscopically small red, green, and blue color patches covers the film emulsion. During exposure they act as filters and respectively pass or withhold the subject colors. The resulting negative is a patchwork of separation negatives, all on one film surface. The developed image is photographically reversed to a positive either by bleaching, re-exposing and re-developing, or by making a print on another plate. In contact with the color screen, this positive acts

as a mask; when held before a viewing light, only the color of the unmasked patches appears.

The details of color in such a transparency are, in every case, combinations of colors, the visual effect created by the different combinations of light colors passed by the tiny filters.

One of the principal objections to the screen plate process is that the screen is noticeable; on enlargement it becomes objectionable. This practically precludes successful enlarged color prints from such transparencies.

THE SUBTRACTIVE PROCESS

Subtractive color processes depend upon the subtraction of unwanted colors from white light to reproduce the colors of the original.

They work this way, speaking schematically:

1. Three separation negatives are made on black-and-white films by the three primary colors — red, green and blue. The silver on each film represents a presence of the primary color in the subject; clear spaces indicate an absence of that primary.

2. Film positives are made from these negatives. In subtractive color their purpose is to cut the unwanted color out of the white viewing or projecting light. The positive made from the red filter negative must eliminate the unwanted red. Silver on film positives represents an absence of the respective filter colors in the original object. But, when you hold one before a viewing light, you discover that the silver cuts out *all* color, not just the *one* which is unwanted.

The trick, then, becomes one of substituting a dye for the silver deposit —a dye which will subtract only the unwanted color, not all colors. And it *is* a trick. At any rate, cyan dye (blue-green) is substituted for the silver deposits on the red filter positive, thereby filtering out red. Similarly, magenta coloring is substituted for the silver on the positive made from the green filter negative, and yellow for the silver on the positive from the blue filter negative. In summary, cyan is used to control the amount of red allowed to remain in the viewing light, magenta controls the green, and yellow takes care of the blue.

3. Suppose, now, that these three colored images are superimposed and matched, or registered, and viewed against a white surface. The white surface—being a source of white light—is giving off red, green, and blue, yet where cyan and magenta overlap, two colors are filtered out—namely, red and green—and only blue remains. Cyan and yellow, together, cut

out red and blue so that only green shows. Where all three complementary colors—cyan, magenta, and yellow—overlap, all three primary colors are eliminated, and the picture looks black.

By far the best known of all subtractive processes is Kodachrome. Kodachrome Film consists of three film layers on a single support—a veritable club sandwich of emulsions. Each emulsion makes a negative record of one color. When processed, in especially equipped processing stations, the negative images are individually developed, reversed to positives, and the cyan, magenta, and yellow dyes substituted for the silver in the appropriate layers. The same piece of film that was rolled through your camera comes back with the same three layers, dyes having been deposited in the layers to *subtract* from white light so as to give you a brilliant full-color reproduction.

Strangely, this processed Kodachrome transparency does not have a red layer. Where you see a red jacket or barn on the film there are two layers of color, yellow and magenta. When you hold the film up to the white light, the yellow subtracts the blue, the magenta takes out the green, and all that remains for you to see is red.

Kodachrome Film for still pictures is available for cameras using 35-mm. or Bantam films and for those using most sizes of sheet film. For movies in full color, Kodachrome is supplied in both 16-mm. and 8-mm. widths. It affords brilliant reproductions, can be used without any special equipment, and is developed for you by trained technicians. Freedom from any mosaic pattern or graininess permits considerable enlargement, making Kodachrome the popular film it is for both amateurs and professionals.

Prints from Kodachrome Transparencies

Originally Kodachrome transparencies could be viewed only as such, or projected onto a screen in a darkened room. Now, they can be printed in full color by the Eastman Kodak Company in any one of several sizes; these are called Kodachrome and Kodachrome Professional Prints. Kodachrome Prints are provided in specific sizes, 2¼ x 3¼, 3 x 4⅜, 5 x 7½, and 8 x 11 inches, straight enlargements from 35-mm. Kodachrome transparencies. Kodachrome Professional Prints, made from the "professional" Kodachrome Film transparencies, supplied in 8 x 10 and 11 x 14 sizes, are individually handled and can be cropped as desired.

Technically, these print processes closely parallel the Kodachrome

process itself. The sensitive emulsions are similar, but are coated on a white opaque support. In the Kodak laboratories, where these prints are made, the Kodachrome originals are enlarged onto the print material, which is developed and reversed as in Kodachrome processing. The color is seen by reflected light—light from the white support as it is transmitted by the color print dyes.

THE KODACOLOR PROCESS

The Kodacolor process, introduced early in 1942, is also based on the subtractive principle. Unlike Kodachrome, a "reversal" process in which the positive image is formed on the same film as the negative image, Kodacolor is a "negative-positive" process involving film negatives and paper prints.

Like Kodachrome Film, Kodacolor is a multiple layer "sandwich" type emulsion in which the primary colors are recorded on the separate layers. Subject blues are recorded by the top emulsion, green by the middle emulsion, and reds by the bottom emulsion.

Development of Kodacolor Film produces a negative silver image in all layers. As this development takes place, the by-products of development react with special chemical couplers, included in the emulsion during manufacture, to form colored dyes. These dyes are deposited in their respective emulsion layers in proportion to the amount of development which takes place. Thus, yellow is formed in the top layer, magenta in the middle layer, and cyan in the bottom layer; the images are negative. Then the silver is removed from the film, leaving only the colored negative image. Not only are the lights dark and the darks light, but all the colors are reversed. Blue sky appears brown, green grass is pinkish, flesh tones are dark and greenish, and so on.

From such Kodacolor negatives you can order color prints to be made by the same Kodak laboratories that processed your film. The paper on which the negatives are printed carries an emulsion very similar to the film itself. Small enlargements are printed from the color negatives and developed in much the same manner as Kodacolor Films are developed.

For example, yellow parts of the negative (blue in the original) transmit light, in printing, which is recorded in the green and red layers of the paper emulsion. When developed, silver and magenta and cyan color are formed in these layers. When the silver is removed, the overlapping colors subtract green and red from the white of the paper base and only

blue remains to be seen. The print is a negative of a negative—or a positive. Kodacolor negatives can also be used to make excellent black-and-white prints in the customary way; so their usefulness is twofold.

Kodacolor Film is available in all the principal roll film sizes, a fact which means full-color prints for the amateur on a snapshot basis. The film is loaded into the camera and exposures made in the ordinary way; but, because the process is so highly specialized, it is doubtful that processing can ever be done at home. It seems like a fairly simple, logical process, but it stems from a great deal of scientific control in processing. Hence, the necessity of ordering both Kodacolor negatives and positives through your Kodak dealer, who takes care of the transaction through a carefully devised and operated system.

ABOUT COLOR PRINT QUALITY

For one thing, the color print seldom gets the benefit of the "showmanship" which frequently attends the presentation of a color transparency. There is no darkened room, no brilliant image on a screen to attract and hold our undivided attention. While it may rival the transparency in technical excellence, the print has to struggle against the handicap of being looked at just as an ordinary picture is viewed—in the hand or as an enlargement, mounted and framed, on a wall. The light may be good or bad, and the distractions—including the other colors in the room— many. Thus, some color prints may seem disappointing.

We tend to scrutinize a color print with great care, quibbling over its hues and tones. Details which pass unobserved in a transparency are noted, and defects which cause us small concern in ordinary prints are accorded undue emphasis.

Contributing to this situation is the fact that in viewing projected transparencies in a darkened room our color perception is not distorted by surrounding walls, furniture, etc.; our eyes are free to adjust themselves to the color of the projected image. In viewing color prints, the colors are very likely to be affected in both value and hue by the color of our environment.

There's another angle—and a typically human one, too. True photographic color has been so long in arriving that we tend to be over-critical of it. Undoubtedly, this is a more healthful situation than would be the complacent acceptance of any color print as "wonderful" just because it is in color. But it's tough on the print.

Color, of course, involves still another difficulty—the fact that a great many people are color-blind and don't know it, or won't admit it. There are simple tests by which an eye specialist can clarify this situation; it is seldom easy, however, to get the right people to take the tests. Hence, it is most respectfully suggested that you set a good example and have the accuracy of your color perception determined before you embark on any serious color projects.

We all like color and color prints. We see color everywhere—in magazines, in books, on billboards, and so on. Color has an emotional impact; it does things to us. And it is going to be increasingly important, although it seems unlikely that color photography will ever completely supplant black-and-white. In photography, as in the other graphic arts, the medium must vary with the subject. There is and always will be need for etching, line drawing, tempora, and lithography as well as for paintings in oil or water colors. Similarly, a lot of photographic work will continue to be done better in black-and-white than in color, no matter how general or how easy color photography becomes.

Shooting in Color

THE INTRODUCTION of Kodachrome Film, back in 1935, was important. It was a scientific achievement of real value. But it was important for another reason, too; it forced many thousands of us to face the fact that we had been seeing too much by habit, and taking too much for granted as far as color was concerned.

The movie makers and miniature camera users, to whom Kodachrome Film was first made available, discovered that their processed Kodachrome did not always reveal colors as they were assumed to be. Snow, everyone knows, is white; yet in Kodachrome it sometimes came back with blue shadows in it. There were other discrepancies; flowers, flesh tones, and dresses of known color appeared, in Kodachrome, to be "off." Obviously, many agreed, the trouble was in the film. But a few discerning people guessed rightly that the trouble was more intimate than that; it lay in their own superficial observation and memory of color.

If we are frank with ourselves, most of us will have to admit that our knowledge of color is very feeble. We know that the colors of the flag are red, white, and blue; we know that red, amber, and green are the colors of traffic lights; we agree that the colors of a rainbow are beautiful and that a sunset often is sensationally colorful. All these facts we might just as well have learned in books, for we seldom verify them by actual observation.

Yet, on the basis of our incomplete knowledge or understanding of color, we do not hesitate to condemn a Kodachrome transparency. "Look," we say, "that dress of Sally's was white, but it's pinkish in the Kodachrome."

If we had really used our eyes at the time we made the exposure, we would have seen that there *was* pink in Sally's dress, for she was standing near a sunny red brick wall.

If Sally had been surrounded by green foliage, her dress might very reasonably have taken on a greenish cast; under open blue sky it would have appeared bluish. Light reflected from a brick wall, for example, really *is* red, and its effect on the dress is much the same as light from a red bulb. The influence of such colored reflections on all kinds of subjects is ever present and must be continuously watched, for it can easily be exaggerated by the color film.

In the face of the fact that color in photography is here, and is bound to become increasingly important, it is essential that we discard our habitual disregard of color and color harmony.

Of course, if we are to be satisfied with simple color snapshots, mere record pictures of places or events, a relatively mild readjustment of our sense of color values will be adequate. But if we are to create real pictures, if we are to use color intelligently, as a factor in setting the emotional key for a picture, or as a force in composition, then we need some fundamentals.

THE LANGUAGE OF COLOR

Even the least color-conscious of us is aware that all reds are not the same and that there are shades of color that are hard to classify. In fact, the variations in color are almost limitless; for practical purposes, however, color can be fairly accurately described in terms of three different qualities—*hue, value,* and *chroma.*

Hue is what most of us mean when we say "color." Red, orange, yellow, green, blue, and violet are the major hues, with such in-between hues as yellow-green, green-blue, and red-violet.

Then, within each hue there is *value* or brightness. A value scale in color, corresponds to a gray scale in black and white; it is lightness or darkness.

Finally, there is *chroma* which is a reference to the purity of a color, or to the extent that it is free from gray. Obviously the less gray there is in a color, the purer it is and the higher its "chroma."

On the basis of these three qualities any color can be accurately described. Progress is being made, especially among users of printing inks and paints, toward a system by which a series of index numbers can be used to describe any color—and with considerable precision, too. Thus, according to the Munsell system—the one which scientists seem to favor — a specific red can be designated as "R 4/14." R is for the

hue, red; the 4 shows the *value* thereof, and the 14 refers to its *chroma*.

Such indices are of no immediate use to the casual photographer, save as they indicate that the world of color is expanding both in comprehension and importance to the point where precise evaluations are necessary.

In color, as in light and many another branch of science, relativity plays a part. A specific blue-green, for example, appears to change not only in value but in hue when surrounded by different colors. Surround the blue-green with yellow, and it looks darker; center it in a field of dark green, and it appears lighter. A blue background brings out the green color by contrast, the same blue-green appears blue in front of a green backing. In black-and-white photography a similar phenomenon makes a medium gray seem darker on a white background than on a black one. This phenomenon is known as "simultaneous contrast."

Right there is a usable tool for workers in color photography. Nail it down.

Developing this theme a little farther, consider the uses of color to provide contrast. As you experiment with color, you will notice that any composition in which all the colors are of the same value tends to become a "color hash," without emphasis and therefore without meaning. Change-of-pace is just as important to the successful color worker as it is to an All-American halfback. This, however, is not a likely source of trouble, for color films tend to exaggerate color differences, thereby giving you, automatically, plenty of color contrast. Your problem may easily become one of subduing rather than intensifying those contrasts.

Many of us have grown up with a kind of fear of color—a fear which, like so many other fears, is born of ignorance. We have been told that some colors simply don't go together, yet those very colors have been utilized by "daring" designers to achieve notable results. We failed to note that the apparent flouting of the "rule" was, in reality, a clever use of subtly chosen values and chromas of the forbidden hue combinations. There is no escaping the fact that two colors of similar value and strong chroma do not make good neighbors. Take a strong red and its complementary color, blue-green; placed side by side they "vibrate" very unpleasantly. But vary the value or chroma of either, and you can achieve something usable.

Having mentioned complementary color, let's back up a moment. The various major and intermediate hues arrange themselves naturally in a kind of color wheel, as indicated in the diagram opposite page 131. It

141

can be made to serve a useful purpose. The two colors directly opposite one another on the wheel are complementary; any three of the colors touched by an isosceles triangle, rotated within the circle, are likely to be harmonious; and a combination of colors embracing an arc of several neighboring hues can be used to set the color key or mood. Thus, an autumn scene is very reasonably made up of the warm, ripe colors in the neighborhood of red. Along the roadside there's a delightful mixture of brilliant red, rusty red, reddish brown, brown, golden red, and yellow. For backgrounds there is the deep blue of a fall sky and the rich green of the pines, a perfect natural harmony. A "cold" picture, on the other hand, logically includes an arc of the green, blue-greens, blues, and so on.

It may be that the generally accepted ideas of the proper use of color stem directly from the color combinations of nature. At any rate, the great out-of-doors does provide the best textbook available on color harmony. Study it faithfully and you'll gradually absorb a real sense of color.

Speaking of "mixers," if you are contemplating indoor portraiture or table-top photography in color, you'll find medium blue and gold backgrounds friendly with almost all subjects. If one isn't, the other is. Outdoor sky blue is good background too, blending especially well with flesh tones.

Color and mood, or emotion, is another consideration that has baffled some of us. Red, we have been told, is angry, passionate, hot, and warlike. Yet what is more cheerful than the red of Christmas decorations? Blue and green, they say, are cool, restful, and full of peace; yet we speak dourly of "the blues."

The answer to these seeming difficulties lies, of course, in the functioning of the human judgment—based on an understanding of all the factors involved. The skillful artist sometimes appears to break the rules; actually he is only using them to gain an effect.

In your approach to color, as in your approach to all picture making, the only iron-clad, inviolable rule is *use your eyes*. To see, clearly and with appreciation, is the thing. There once was a wise man who told his prematurely sophisticated son, "Try looking at the world while you stand on your head. You'll see things in a new way, see new colors, get new ideas." The son got the idea. Doubtless you need no such drastic prescription, but it's certain that unless you do look for color you'll never see any but its most obvious and least interesting aspects.

Kodachrome and its derivative color processes have given us the means for vast new photographic pleasures and achievements. Those processes are not foolproof—but they are exciting and inciting. To succeed with color means more than making a snap of a pretty girl in a red coat; it means creating a setting and a composition which will reveal the girl most charmingly. The problem is not always simple, but it can be solved.

KODACHROME FILM TYPES

Four separate and distinct Kodachrome emulsions are available.

Daylight Type—For outdoor color pictures with 35-mm. and Bantam cameras, and for 16-mm. and 8-mm. motion picture cameras. Sensitized to give correct reproduction in sunlight.

Type A—For indoor color pictures made by the light of Photoflood lamps, with 35-mm. and Bantam cameras, 16-mm. and 8-mm. motion picture cameras. Extended blue sensitivity compensates for the lack of blue in tungsten light.

Professional Daylight Type—For outdoor color pictures with cameras using sheet film. Sensitive in same proportions as the Daylight Type Kodachrome mentioned above.

Professional Daylight Type—For outdoor color pictures with cameras film under professional studio conditions. Sensitized to balance with "3200°K" light which contains even less blue than Photoflood lamps.

As long as each of the films is used under the conditions for which it is intended, no special accessories are required. If, however, it becomes necessary to take pictures outdoors with an indoor film such as Type A, a filter must be slipped over the camera lens to *correct* the color of the light reaching the film. The Type A Kodachrome Filter for daylight is a light orange filter which takes enough blue away from daylight to counteract the extreme sensitivity of Type A film in the blue region. Fortunately, Daylight Type Kodachrome used outdoors without a filter and Type A used outdoors with the compensating filter require the same exposure.

When Daylight Type film is used indoors with Photoflood lamps, the results will be extremely red, unless a light blue filter—the Kodachrome Filter for Photoflood—is placed over the camera lens. Because Photoflood lamps contain much more red than sunlight, the blue filter is needed to reduce the red to a point where it balances the sensitivity of the Daylight

143

Type Kodachrome emulsion. Daylight Type film used under these conditions requires more exposure than Type A without the filter.

The same is true for the sheet Kodachrome films; either used out of its intended sphere needs a filter. It is not recommended, however, that daylight type film be used indoors, except with the daylight type Photoflash lamp.

KODACOLOR FILM

Kodacolor Film is available in a single type, intended primarily for use out of doors by daylight—and preferably by sunlight. It is an amateur snapshot film, not intended for professional studio work. Neither color filters nor Kodachrome filters can be used in exposing Kodacolor Film. The only light by which Kodacolor can be successfully used indoors is the blue-bulb Daylight Photoflash.

Exposure Latitude with Color Film

With black-and-white film you may sometimes over- or underexpose to a considerable extent, and still compensate for the error in printing. But no such compensation is possible in color work, for when you're "off the beam" in exposing color film, the colors themselves suffer. You get an image, but the colors are not correct.

Kodachrome Film requires that exposure be more exact. In using it, your variation from correct exposure cannot successfully vary more than half a stop, over or under. Kodacolor Film, with greater latitude, affords a leeway of one full stop, either way.

Fortunately, it is not difficult to achieve the necessary degree of accuracy in using either Kodachrome or Kodacolor Film. The instructions enclosed with the film are specific for a wide variety of picture-making conditions. These same instructions are amplified and put in extremely handy, ready-reference form in the Kodaguides which are available at Kodak dealers.

If yours is a sheet film camera, there is an interesting method by which you can check indoor exposures to be made on Kodachrome Professional Film, Type B. After the setup is complete and all lights finally adjusted, make a series of test exposures, using Kodak Super Speed Direct Positive Paper in film holders.

This paper is only a trifle—about ⅓ stop—slower than the Type B Kodachrome Film, hence your quickly obtained prints on the Direct Positive

Paper give you a fairly precise guide to the correct exposure. True, since the paper is ortho in sensitivity, a little experience in judging the paper's dark rendering of reds and browns may be needed, but that experience is very well worth gaining, in view of the economies involved in this testing method.

Lighting for Color

Use flat, even light, and let the colors take care of contrast and emphasis. So runs the basic rule of lighting for color photography. Like many another rule, it can be and has been successfully violated, but only by experts who knew what they were about.

Like all honest rules, it is no mere arbitrary matter. It makes sense. By simple, all-over lighting you give all of your colors a chance to rise up and be seen. The minute you add an emphasis with special lighting, or throw in a shadow for dramatic effect, you complicate things; for the colors do not behave as tones of black-and-white do. The colors take on totally new personalities, in terms of value and chroma, and may fall completely out of harmony with your color scheme.

Illuminate your shadows, don't let them go empty and black. In using both Kodachrome and Kodacolor Films you will discover that your best pictures—especially portraits—are made in sunlight when the sky is slightly hazy rather than perfectly clear. The same lens aperture as for clear sun will usually do.

While front lighting is preferable, it need not be *full* front lighting. Even in color, such lighting tends to be a little unhappy looking, especially in shots of people. Let the sun come in a little over your right or left shoulder; in so doing you gain facial modeling without sacrificing color and color values. Close-ups made in bright sunlight under a clear blue sky may require a reflector to throw light into the shadow side.

In picturing groups, it is even more important in color than in black-and-white work to be sure that all the members of the group have about the same light. If a few are in heavy shade, while the others are in direct sunlight, your picture will not be satisfactory.

While it is entirely possible to capture the flaming beauty of sunsets with either Kodachrome or Kodacolor Film, avoid making informal portraits by a low sun. For sunlight is very orange during the hour after sun-up or before sun-down, and the faces of people pictured at that time will emerge unpleasantly red in hue. It *is* true that some architectural,

145

mountain-top snow scenes, etc., are beautifully enhanced by the late sun, but such results are unpredictable and no specific advise can be offered other than to "try it and see." In all color work, it is inescapably important to remember that your working light has not only actinic value but color value as well; the color of the light is part of the picture.

Back-lighted color work is tricky; sometimes it can be very effective and dramatically beautiful. But don't bother with it until you are fairly sure of yourself with ordinary lighting. If and when the time comes for some back-lighted shots, you'll do well to provide some degree of frontal lighting, either by a flat reflector or a synchronized flash. Here again, be careful of the color of that frontal lighting. If you use a reflector, use a white one; if you use a flash, it should be a blue-tinted bulb such as the No. 21B or 5B Photoflash lamps, if used for supplementing outdoor light. Such fill-in lighting for back-lighted subjects is possible, of course, only at relatively close range.

Indoor lighting for color follows the general portrait procedure, but always with the proviso that the color of the light is right for the type of film used. With Kodachrome Film Type A, ordinary Photofloods are correct; for Kodachrome Professional Film Type B, the 3200°K studio lamps are required; and for Kodacolor Film only the blue light of the 21B or 5B Photoflashes is permissible.

Oops—Sorry!

Sometimes things go wrong. No use pretending they don't. But you can profit by your failures if you study them. Here's a catalog of effects and causes.

KODACHROME TRANSPARENCIES

Dense transparencies, in which the shadows are very dense and off-color and in which there are no brilliant highlights, are the result of *underexposure*.

Thin transparencies have washed out highlights and thin shadows unnaturally full of detail. *Overexposure.*

Predominantly blue transparencies result when Type A Kodachrome Film is used with daylight, without the necessary filter.

Predominantly red transparencies are inevitable when Daylight Kodachrome is used with Photoflood lamps and without the color-balancing filter. Pictures made at sunset or sunrise also tend to be reddish.

Much or vociferous color may almost drown your picture.

Color, for Color's Sake, is Not Enough

Subtle color carefully used, can be far more vivid and effective.

If You Are Color-Conscious . . .

You will remember that sunset light is much redder than midday light.

You will prefer open shade to contrasty lighting for outdoor portraits.

You will avoid unattractive color reflections, as from light green foliage.

Red or Green Fog will result if Kodachrome sheet film is loaded in a darkroom where a red or green safelight is used.

Yellow transparencies may very well be the result of having left a K2 filter on the camera lens. Similarly, a red or green filter will turn the transparencies red or green.

Loss of highlight or shadow detail may result from either too contrasty lighting or too contrasty subject matter.

KODACOLOR NEGATIVES AND PRINTS

When the Kodacolor negative is extremely thin overall, without detail in the lighter areas, the Kodacolor print will be generally dark and devoid of shadow detail. *Underexposure* is the cause.

When the negative is high in contrast as judged in accordance with usual black-and-white standards, the print will show faces and other highlights without color detail. That may mean *overexposure*, or excessive subject or lighting contrast.

Negative too blue, and print too orange—probably the result of using Kodacolor by artificial light with other than the blue flash bulbs.

Negative too purple, and print too yellow—somebody forgot to take a yellow filter off the camera's lens.

Take Care of Color Films

All films need and deserve careful storage. Color films and transparencies rate even greater care.

Before exposure, color film has very good "keeping" qualities. Of course, the film must be kept reasonably cool and dry.

After exposure, the film should be sent off for processing as soon as possible. If it is impossible to get it away promptly, give it every possible consideration. In the tropics or sub-tropics, seal the film against humidity after drying it first, and keep it in an icebox, if there's one handy.

When the processed film is returned to you, you'll be wise to see that it is given clean, dry, average temperature storage. Use and enjoy it, of course, but don't be careless with it, for you're dealing not with stable silver deposits on film, but with dyes. And dyes are delicate. Bright light, especially sunlight, has a deleterious effect on them. The particular dyes used in Kodachrome and Kodacolor Films, and in color prints, are as stable as possible, consistent with their other requirements. With care, you

149

will be able to enjoy them over a long period; without care—but why borrow trouble?

COLOR SHOWMANSHIP

Photographic color can be shown to your admiring friends in a manner which will hold their friendship and increase their admiration.

If you're showing miniature Kodachrome transparencies, *don't* pass the little slides out casually, for squinting scrutiny by the nearest light, whatever its intensity or color. If you cannot project them, at the moment, contrive somehow to give them a reasonably fair showing. You can, of course, buy little battery-operated devices which give you an illuminated and sometimes magnified view of a transparency. A simple viewer can be made easily with two sheets of cardboard, each about 5 x 7 inches in size. In one cut a centered opening 1¾ inches square; in the other one, the opening should be 2 x 2. Cement the two together, registering the two openings. You'll find that a Kodaslide fits neatly into the 2 x 2 space, and is held from falling out by the smaller opening. Hold this viewer about a foot above a sheet of white matte card on which a good strong light is directed. And there you are. A possible variant on this scheme is the addition of a sheet of matte-white cellulose acetate across the back of the card in which the smaller opening is cut. With this extra wrinkle, you can hold the viewer up directly in front of a light, and be sure of evenly diffused illumination. If your viewer is neatly made, you will have given your Kodaslides the advantage of greater potential appreciation and enjoyment which they deserve.

But projection, of course, is *the* way to present your Kodaslides. The glowing image on the screen in a darkened room automatically invites and retains the attention; it is big and easy to see and understand. The optical system of a good projector reveals the full beauty of the transparency; and the distractions of other colored objects are eliminated.

It is a good idea, in all such showings, to give your audience and your transparencies the benefit of a smooth performance. Try to have your screen up, the projector in place, and the focus adjusted before your audience gathers. Have your slides in logical order, ready to show. Arrange your pictures in a crescendo of interest, the best for the last. All such preparations, if performed before your audience, are distracting.

Many users of Kodaslides have gone far in their showmanship. Musical accompaniment, in a series of especially selected records, is one of the favored devices. The reading of great nature poems to accompany scenics

is another. Methods and plans, of course, will vary with your pictures and your audience. Sometimes you can ask nothing better than the spontaneous running-fire comment of your guests.

Black-and-White Prints from Kodachrome Transparencies

Because Kodachrome Film images are dye images and not silver grain images, there is almost complete freedom from graininess. This offers a real advantage, in that black-and-white prints, or even enlargements of considerable size, can be made from sheet film or 35-mm. or Bantam Kodachrome transparency originals. This can be done by printing or enlarging onto a reversal paper such as Kodak Direct Positive Paper. Some enthusiasts keep a file of such prints as a means of saving handling and general wear and tear on the Kodachrome originals.

A second method of obtaining black-and-white prints from color transparencies consists of making a projected black-and-white negative and then paper prints as follows:

1. Place the Kodachrome transparency in an enlarger with the emulsion side facing away from the enlarger lens. Focus the positive image onto a sheet of white paper. Make it such a size that the enlarged negative will be convenient to handle in your printer or enlarger.

2. With the enlarger light and all room lights off, replace the white paper with a sheet of low-contrast panchromatic film such as Kodak Plus-X Film Pack, or Super-XX sheet film. Make a test exposure. Develop and fix the test. If the negative seems too thin, give more exposure; if too dark, decrease the exposure. But do not increase the development time. If anything, you may have to decrease development slightly to lower your negative contrast.

3. From the correctly timed and enlarged black-and-white negative, either contact prints or enlargements can be made.

For special effects, color filters can be used over the enlarger lens, just as over the camera lens when making black-and-white negatives.

If you are strictly a color worker and do not have a darkroom and enlarger, you will find the Kodak Transparency Enlarger a simple, direct means for making black-and-white negatives from your transparencies. The enlarger looks like a camera, uses roll film, and involves no special technique in its operation.

151

Illumination for Color Photography

Object:

To determine what effect the color of the light source and the environment have on the resulting Kodachrome transparencies.

Equipment:

Kodachrome Film and a camera for exposing it.

Procedure:

Make exposures under as many of the following conditions as possible.

USING DAYLIGHT KODACHROME FILM

1. Outdoors with subject in direct sunlight, either mid-morning or mid-afternoon.
2. Outdoors with subject in direct sunlight, but just before sunset.
3. Outdoors in open shade, under a blue sky.
4. Outdoors with subject receiving reflected light from a red brick wall.
5. Outdoors on a bright day with subject alongside of green foliage.
6. Indoors on a bright day, supplementing daylight with regular Photoflood or flash.
7. Same as No. 5, but with a blue Photoflood or blue Photoflash.

USING KODACHROME FILM TYPE A OR B

1. Indoors using regular Photoflood light as illumination.
2. Indoors using regular tungsten bulbs for illumination.

If you have not already run the exposure series suggested in the experiment at the close of the Sensitometry Chapter, you may want to add it here.

Project or view the processed transparencies individually. Then compare them in groups, the correct with the incorrectly exposed or lighted pictures.

Questions:

1. How do the incorrectly exposed or lighted results vary from normal? Why?
2. Do the variations seem greater when the pictures are viewed individually or collectively?

What About Exposure Meters?

IN THE relatively simple photographic world of thirty years ago, the box camera was the common denominator of practically all amateurs. Because of its fixed focus, fixed aperture, and fixed single speed, there was no apparent exposure problem. Photographers made their pictures in full sunlight and averaged a high percentage of correctly exposed negatives.

Into this innocent situation crept technological progress, with faster, wide-aperture lenses which could be stopped down or opened up through a broad range of *f*-numbers; multiple speed shutters came along; and finally films of strange new speeds and color sensitivities were introduced. Camera users hailed each innovation with delight. As picture possibilities broadened, they became more adventurous, photographically speaking, and their batting averages sometimes slumped. Exposure, it was discovered, was no simple thing to be taken for granted. Some few wise ones remembered that the good old box cameras operated at about $f/16$ and $1/25$; they held to that formula in good light, and all was well.

But the rank and file felt that they had to make use of the extreme abilities of those fast lenses, high-speed shutters, and ultra-ultra films. In so doing, they often floundered around, making exposures with their fingers crossed.

Under these circumstances it was perfectly natural that a demand should arise for some device which would give an immediate and impersonal answer to the question, "What's the exposure?"

Of course, the manufacturers of film always have supplied a lot of pretty definite information with film. Inexpensive Kodaguides provide simple means by which correct exposures can be determined for Kodak Films—and with consistent accuracy, too. With the amiable perversity of human beings, many have ignored the free information or the very inexpensive guidance afforded by the cards.

Extinction Meters

In search of specific exposure guidance, many have made use of exposure meters which operate on the "extinction" principle. One holds the little gadget up to the eye and sights through it at the subject to be pictured. By turning a knob, a succession of arbitrary symbols is superimposed on the viewed scene, each successive symbol fading more and more into nothingness. The symbol which just barely escapes invisibility is the key to the exposure. By cross reference to a set of tables on the meter, a recommended exposure is arrived at.

As an optical device, the extinction meter has virtues. It works well for some users. But it has shortcomings, too. Its readings vary from one individual user to another, just as eyesight varies. Its use, under different conditions, finds the eye attempting to adjust itself to extreme variations —as in going from a bright street into a darkened movie. And it tends to be too highly localized in its readings, with the result that one area in a scene may be properly exposed while the rest of it is off.

Photocell Meters

It is the apparent power of decision which is one of the top assets of the photoelectric exposure meter. Think of it. You point one of these meters at a subject or scene to be photographed. Instantly a needle (acti-

One of the several inexpensive, explicit Kodaguides

154

Two popular photocell meters, the Weston and the General Electric

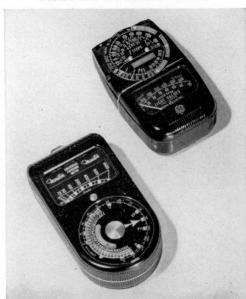

vated by the minute current generated in the photoelectric cell by the impact of the light) swings over on a calibrated scale and comes to a halt under some specific number. With that number as a basis, figuring the exposure is but an instant's work—work involving consideration of the meter rating for the film you're using, and the aperture or the shutter speed you wish to use. The result is specific, businesslike, impersonal. Thus, these meters appear to have licked the exposure problem. But wait a minute—that's not the whole story; it just can't be as simple as that.

In common with most other modern precision tools, there is always the factor of skill in use. The operator must understand how to use the meter before it can be of maximum practical value. It is not a cure-all for carelessness, and is not intended to be.

The usefulness of a meter obviously depends upon the availability of a number which represents the speed of the photographic film. These numbers are known as "emulsion speeds," they are inherent in their respective films and independent of any photoelectric measuring device.

The numbers which appear on meters are evolved from known emulsion speeds by procedures recommended by the American Standards Association and are called *speed numbers* or *exposure indexes*. These take into account not only the comparative film speeds, but also the characteristics of the meters for which they apply and the way it is intended that the meters should be used.

To be sure, the meter settings serve as guides but, since not all photographers are accustomed to exposing for the same effects nor in the same manner, the variation in their demands and techniques makes it impossible to issue any single set of meter settings for films which will satisfy everyone's requirements without alteration or modification. This is perhaps more serious in black-and-white work than in color photography, for in color the goal of all workers is limited to just about a single effect.

Some conversion tables have been published in order that one may change Weston or G. E. settings into Scheiner, D.I.N., and other systems. However, since the systems themselves are so fundamentally different, no real relationship exists and the use of these tables may lead to considerable error. If you wish to determine the speed of a specific film in terms of a system for which no ratings are available, here is a possible procedure.

Make a series of exposures arbitrarily applying a wide range of meter setting numbers to the film. Select a scene you feel is typical of those you are likely to encounter later on, and use your meter according to your

155

customary habits. After development, pick out the correctly exposed one. By referring to the setting used to make that negative, you'll discover the number you should use for future picture making.

As you make more and more pictures you probably will want to modify the meter setting to improve its validity under your own working conditions. Numbers arrived at in this manner are superior even to published data, for they apply not only to the film, but to your particular meter and to your way of using it.

Differences between the calibrations of several meters of the same manufacture sometimes reach troublesome proportions. Similarly, age and operating conditions, such as extreme cold, sometimes cause variations in shutter speeds. The variations in meters and cameras may tend to cancel each other. At other times they may be cumulative and increase the chance for trouble.

The increased demand for sensitivity in exposure meters has exaggerated another cause of error. Since, at present, there are limits to the sensitivity of both the photoelectric cell and the accompanying current indicator, some meter manufacturers have tended to produce instruments taking light from a greater and greater area. For a scene of given average brightness, such a procedure causes a correspondingly greater needle deflection. Such a wide angle of view need not be serious if the user is aware of it and uses the meter reasonably close to the principal subject to be photographed, tilts the meter slightly or makes any other adjustment which effectively limits the area covered to one nearly like the scene to be photographed.

At the same time, this close-up reading introduces another problem. Suppose three objects—for example, a white house, a light gray and a dark gray house— are to be photographed as separate pictures. The white house gives a high meter reading, so gets a short exposure. The light gray house gives a medium reading, hence receives a medium exposure. The dark gray house reflects very little light; a low reading and a long exposure result.

In the three negatives all the houses have the same tone, so you adjust your printing exposure to get a house that's white, one that's light gray and one dark gray. In doing so you get the tone of the house about right, but you lose the shadows or highlights of the surrounding landscape or foliage because they were under- or overexposed. The principle of the meter is the evaluation of average brightness, not single parts of the pic-

ture. The user should learn by experience to compromise between reading "close-up" and from the camera position for best results.

On days when the sky is free from clouds and when all objects are flooded with sunshine, the wide angle included by the meter makes very little difference for an average scene. However, with clouds in the sky or with spotty lighting, the wide angle is far more likely to produce erroneous results, particularly if one continues to use the meter at the camera position. Any accidental highlight or deep shadow just outside the picture area will produce an erroneous reading on meters taking in a wide angle.

To utilize the full capability of a meter, it is wise to keep in mind the relative color sensitivity of the eye, film emulsion, and photocell. In general the photocell exposure meter has its *maximum* sensitivity in the same region as the eye, but has greater relative sensitivity to both blue and red. This more nearly matches the color response of *panchromatic* emulsions now in use than it does the eye. There are other types of emulsion—infrared, for example—to which the cell has no comparable sensitivity.

You Are the Vital Factor

The only purpose, in indicating some of the problems inherent in the use of photoelectric meters, is to stress the fact that such meters are not as impersonal as at first they seem to be. Meters can be helpful when used with discretion and judgment. No meter is any better than its user. As it is with cameras, so it is with meters. *You* are the vital factor.

Assuming that you plan to use a photoelectric exposure meter, you have your choice of several makes, most of which can be relied on for consistent operation. In the past dozen years more than a hundred different varieties of meters have appeared on the market and new ones are still arriving. In price, they average about $20. All are competing with one another in appearance, convenience and sensitivity. Most of them are ingenious in design and of rugged construction. The life of a well-constructed meter seems at present to be indefinite, depending on the physical treatment to which it is subjected. The basic principle of their operation is identical, yet they differ in some respects. The Weston meter gives you readings in terms of subject brightness, whereas the G.E. can give you a reading either in terms of brightness or illumination; brightness ordinarily, or illumination at low levels when the hood is removed. Both meters permit you to arrive at your exposure calculation in terms of shutter speed when you wish to use a specific diaphragm opening or *vice versa*.

157

MAKING THE MOST OF YOUR METER

Any photoelectric exposure meter requires careful use if it is to deliver uniformly successful results. Here are outlined a half-dozen primary techniques of meter use. The tabulation on page 159 indicates the circumstances under which these techniques are likely to be most useful.

1. *Meter reading from the camera position.* This is the conventional procedure. It involves aiming the meter at the scene to be pictured. The exposure is figured directly from the resulting meter reading. In practice, however, difficulties arise, for the meter can only strike an average of the various light intensities in the scene, whereas the camera *images* them individually. Thus a brilliant sky, a strong but unimportant shadow, or an overbright foreground area may upset the average as interpreted by the meter. If you are aware of such disturbing factors, it's wise to compensate for them by aiming the meter so as to discount them. Experience alone can tell you how much meter deflection should be used. In general, the camera-position reading of the meter is useful but not universally successful and should not become an iron-clad habit.

2. *Close-up meter readings.* Close-up readings will often avoid the disturbing factors mentioned above, in picture situations which permit you to measure the important individual elements. Such meter readings should be made from the camera angle you plan to use and at a distance from the object roughly equal to its diameter (as seen from the camera angle). An adult face should be meter-read at a distance of about ten inches, whereas a horse should be read at six or seven feet. Take care lest you cast a shadow on any object you read, for the shadow will lead to a false reading.

A. *Middle tone reading.* For more or less flat scenes, involving a relatively small range of brightnesses, you can sometimes make direct readings of one or several of the important individual elements. Strike an average if necessary, and you have a workable index.

B. *Shadow detail reading.* In more contrasty scenes the darkest shadow or object in which you desire to show detail can be used as a means of establishing the correct exposure. Assuming that your dark object is not below the sensitivity range of your meter, take a close-up reading from it. The result, if applied to the whole scene, might easily produce heavy over-exposure in the brighter portions. For this reason, one of the meter manufacturers has included a multiplying factor of 16 times on its cal-

158

culator to make allowances. Using this arbitrary factor, you arrive at an index which will place the resulting negative high enough in the characteristic curve to preserve the shadow detail and, at the same time, give the higher lights a break.

C. *Highlight detail reading.* By reversing the procedure of B, the meter manufacturers advise that you can use the brightest object in which you wish to preserve detail and *divide* the reading by 8 to achieve an index which will assure a good degree of shadow detail.

D. The procedures B and C can be used, in effect, in combination; this is the *brightness range method.* The least bright and most bright objects are both individually read. Multiply the one by the other and take the square root of the product to arrive at a working index for the scene. For example, suppose that the low reading is 4 and the high is 400. 4 x 400 = 1600. The square root of 1600 is 40, which is your brightness index.

3. *Reading by incident light.* In theory, the incident light method gives you an index of exposure in terms of the intensity of light falling on a scene. For specialized photography—as in Hollywood—it is now the almost universally accepted technique, but it involves serious difficulties for the amateur. Direct sunlight, for example, is far beyond the brightness recording range of the average meter; to compensate for this excessive brilliance some photographers have evolved baffles or shields to place over the meter, thereby reducing the light's intensity to such an extent that proportional readings can be made. Each such devise involves a tailor-made series of calibrations, adapted to the light-absorbing factor of the baffle used.

A somewhat simpler application of the incident light method involves the translating of incident into reflected light by means of some arbitrarily selected medium, such as a gray card, a sheet of newspaper, or the palm of your hand. A definite guide to the potency of the light can be obtained by taking readings from this single intermediary. If it reads half as bright today as it did yesterday, doubled exposure is obviously called for.

The procedure to be followed in working out this method goes something like this. Decide, first, what intermediary you want to use. It should be something to which you can handily refer at any time, something not easily lost, something stable in color, matte in texture, and unchanging in shape. Want ad pages of newspapers the country over are much the same.

Fold such a page in half, read it from about 15 inches and you have a type of standard as readily obtained in San Diego as Syracuse. Go out in the street, for example, on a good picture making day and, in direct sunlight, take a reading, in approved close-up manner, from your selected intermediary. Record the reading or memorize it. Then, in the same light, make a series of pictures, all of the same scene. Begin with an exposure that's likely to be on the *under* side and work up to overexposure. Keep a record of the exposure for each shot. Then develop the films by your favorite method. When they are all finished, inspect them carefully and select the one which has the quality you'd like to have in all your pictures. Consulting your records, you find it was made at, say $f/11$ and $1/200$. And the meter reading from your intermediary was, for example, 500. Now, the next time you go out to make pictures, all you need do is to take another reading in full light from your faithful intermediary. If, again, it reads 500, you can rely on $f/11$ and $1/200$; but, if it reads only 250, you know you have to double your exposure, so you shoot at $f/11$ and $1/100$.

As you become familiar with this incident light method you will find that it is particularly useful in photographing interiors by artificial light. In fact, many photographers use it as a means of tailoring their light to meet their exposure desires. On the basis of such readings the lamps can be moved forward or back until the illumination is found to be right in terms of the film and exposure to be used.

• • •

There's no one explicit answer to the question of a meter's importance to the individual photographer. It's much like all other photographic accessories and niceties, $f/2$ lenses, flash guns, range finders and the like. You can make pictures—good pictures—without them as long as you confine yourself to what might be called "average" subjects, those in good light or those for which exposures are specifically recommended by the Kodaguides. But when you attempt the unusual, that is, pictures in deep shade, interiors illuminated by a variety of lights, then the accessories and the meter can be definitely helpful.

Keep in mind that blind reliance on a meter is not the answer to any exposure problem; similarly, you are not guaranteed good pictures just because your lens is rated $f/2$. The more experience you have with a meter the less you will be forced to resort to its use, for you will acquire a more seasoned "exposure sense." At the same time the readings you do make should become more and more meaningful.

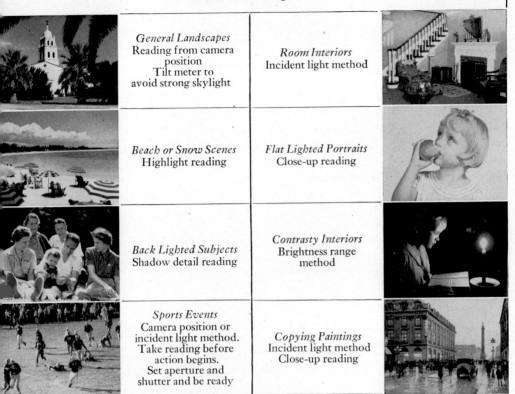

General Landscapes Reading from camera position Tilt meter to avoid strong skylight	*Room Interiors* Incident light method
Beach or Snow Scenes Highlight reading	*Flat Lighted Portraits* Close-up reading
Back Lighted Subjects Shadow detail reading	*Contrasty Interiors* Brightness range method
Sports Events Camera position or incident light method. Take reading before action begins. Set aperture and shutter and be ready	*Copying Paintings* Incident light method Close-up reading

A Camera As An Exposure Meter

Object:

To determine the effectiveness of a ground glass camera as an extinction type exposure meter for estimating exposures either indoors or out, under conditions of dim lighting.

Equipment:

A camera with ground glass focusing.

Procedure:

Using a focusing cloth, focus the subject on the ground glass with the camera lens wide open. When your eyes are fully adjusted to the light of the ground glass image, close the lens diaphragm gradually until details in the darkest important part of the subject are barely distinguishable. Note the lens aperture and expose according to the following table.

If shadow detail is barely distinguishable at	Use Kodak Super-XX Film, $f/11$ for daylight pictures or between $f/11$ and $f/16$ for interiors by artificial light, and expose for
$f/8$	32 sec.
$f/16$	8 sec.
$f/32$	2 sec.
$f/64$	½ sec.

Exposure at $f/16$ for daylight or between $f/16$ and $f/11$ for interiors by artificial light, when using Kodak Super-XX Film.

161

Pictures, Free Style

"I DON'T know much about art, but I know what I like."

You've heard—or made—that classic remark many times. It is classic because, although trite, it is the average man's bristling defense of his own taste against what he feels to be the mysterious and dogmatic rules of professional art. And the phrase, "I know what I like," indicates that the browbeaten average man makes a strong distinction between pictures he considers good and those he thinks are poor.

Simmered down, it implies that some pictures mean something to him, while others stutter, limp, and fall flat.

And the secret of a picture that does its job neatly is mainly a matter of arrangement. Call it composition if you like, but composition is essentially a matter of arranging the various elements in a picture so that, together, they make sense—the sense the artist wanted to convey.

It's arrangement that makes the difference between sense and nonsense in practically anything. You don't say to a friend, "Country how cameras about hike our a in the with?" To be sure, a long-suffering friend might spend a while trying to dope out what you had said, but you're on your way a lot sooner when you say, "How about a hike in the country with our cameras?" You've simply arranged the words so that they make sense. It's the same in music. There are 88 keys on a piano, but you don't get music by leaning on all of them at once. You select a few to produce a song, and a few others to provide harmony for it.

So it is with pictures. If you fail to arrange the various things in your picture so that they make sense, you can't have a successful picture, and no amount of darkroom magic can make it so.

Fortunately, there are a few basic rules of arrangement, rules which are not presented arbitrarily, because they were not drawn up arbitrarily. They grew, slowly, out of the accumulated experience of the race.

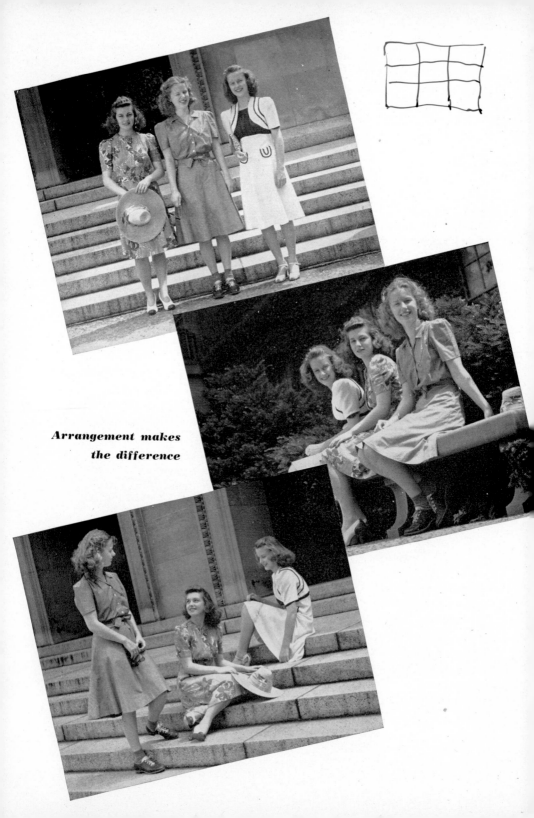

*Arrangement makes
the difference*

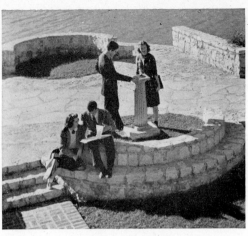

What's this picture supposed to say? No question about this one

First, a picture must have *emphasis*. Some one thing or group of things must stand out unmistakably as the reason for the picture. In the rectangle of the picture area there must be one major feature, something which appears important, significant, or interesting. A picture without this one dominant element is like a sentence without a subject; it doesn't mean anything.

Practically all of the other "rules" of composition are concerned with the ways and means of producing pictorial emphasis. They may be grouped handily into two major classes, one dealing with what might be called the "plane geometry" of composition, and the other with the use of color or tone contrasts. And, of course, there's a good deal of overlapping and combination.

Probably the most useful of all the geometric systems is a simple matter called "the thirds." It works this way. Divide your picture area into thirds, vertically and horizontally. Any of the four points at which the lines cross, within the picture space, has been found to be a "natural" for the placement of a subject which is intended to be dominant. And secondary points of interest can be located at or near any of the other three intersections.

This, frankly, is a rule-of-thumb, not to be slavishly used. But you will find that it works, works particularly well when you're dealing with action and movement. A little further investigation will show that it is rather closely related to the principle of "dynamic symmetry" which is a fascinating affair, a little too specialized for discussion here. The picture and sketch, overpage, show the application of the "thirds" idea.

165

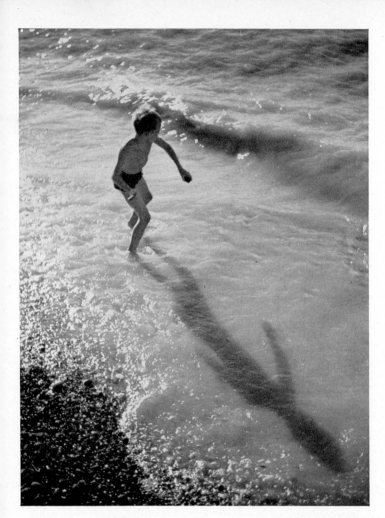

The "rule of the thirds" at work. Try it on some of your own pictures.

Among the other geometric schemes of arrangement there's a whole group based on the flow or direction of "lines" in a picture—lines which may be real and visible, or merely implied. A gesture, an extended arm, or the concentrated attention of several pairs of eyes can create definite lines, and the eye of the beholder will tend to follow those lines. The letters of the alphabet are sometimes arbitrarily used to describe types of linear arrangement. For example, the various elements of your picture may arrange themselves in an "A", or pyramid. Likewise you'll find picture possibilities in arrangements corresponding to "S", "C", "L", "O", "N", "T", "V", "Y", and "Z". In no case is it important to start out with the intention of making, for example, a picture arranged "T" fashion. The

166

important thing is to arrange the elements in your pictures so that they make sense. If you succeed they probably conform to one of the letter patterns.

Overlapping this set of rules-of-thumb is another which is concerned with the contrast of directional lines in your picture. In the "T" arrangement, for example, the horizontal and vertical lines come together at a stark right angle, much as a side road bangs into a highway. The point of contact is a danger point, a point where you expect things to happen. The same is true of "L" or "Z" shapes; the points where two directional lines come to a sudden contact are bound to get a good deal of the eyes' attention.

If you transform the sharp angles into soft curves, as in the "S" and "C" shapes, you eliminate the clash of lines and achieve, instead, a directional flow of action and interest.

When all is said and done, the function of composition is to interest the eye of the beholder. And, quite as important, the lines of flow or points of

167

You may detect the alphabetical influence on the compositional lines of these pictures

collision in a picture should help to tell its story. Obviously, an angular composition, full of contrasts and linear collisions, isn't appropriate when you're picturing a quiet and lovely young lady; if you're depicting a modern dancer in one of those stark and militant routines, full of sound and fury, you naturally don't choose a soft, flowing composition of the "C" or "S" type. More likely, your compositional lines will resemble a "Y" or a "K".

Now about the use of color or tone to create emphasis. "Color" refers, here, to the color of the subject in terms of the blacks, whites, and grays in the conventional black-and-white photographic print.

The most important use of color is as a means of contrast, of causing one thing to stand out clearly in relation to something else. A white powder puff on a sheet of white paper affords practically no contrast, and a picture thereof would be a tough proposition, involving very careful lighting. But, put that powder puff on a mahogany table—and immediately the color contrast is strong and easily depicted.

You can add emphasis to your pictures by photographing light against dark and dark against light as illustrated on the opposite page.

Emphasis in Color

In color photography, with a whole spectrum of color to complicate the situation, the matter of light against dark and dark against light must be approached with caution. Keep in mind that color films have limited latitude and that it is necessary to avoid *excessive* differences in brightness between subject and background. Remember, too, to make certain that the principal colors harmonize.

For example, suppose your subject is a young lady all dressed up in her bright new, yellow, spring suit. Photographed with the clear, deep blue sky as a background, she will be beautifully yet subtley complimented; the attention of all those who see the picture will be attracted at once to the young lady. Pictured against a purple drape in the home studio there would be sufficient difference in brightness, but the distracting clash of colors would destroy the effects of even the best lighting and composition.

In other words, color photography both simplifies and complicates this business of contrast emphasis. It simplifies in the fact that the color differences themselves afford contrast; and it complicates the situation because colors can be mutually harmonious or discordant.

To return to black-and-white photography, it is obvious that any pic-

Contrast compels

. . . whether it's light against
dark or dark against light

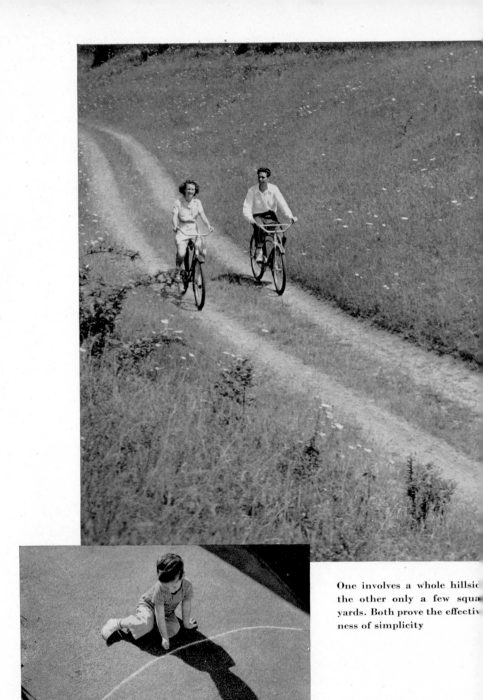

One involves a whole hillsid
the other only a few squa
yards. Both prove the effectiv
ness of simplicity

ture is made up of various tones or colors of light, ranging from the brightest lights, or highlights, to the deepest black. It is in your arrangement of these several tones that emphasis can be gained or lost.

The human eye has a special liking for highlights, for lustre. We like diamonds and silk and polished wood, because we like the gleam of light in and on them. So the successful photographer makes sure that his highlights fall where they do the most good, create the most emphasis. Like a smart jeweler who displays his gems on dark velvet, the photographer puts his most important highlights close to a dark area. Then those highlights really shine.

Carrying on, for a moment, with the jeweler, you will find that he seldom plunks down a whole bevy of gems for your inspection, all at once. No indeed. He gives each one a separate showing on the velvet. That way, each shines and sparkles without interference or competition. In other words, he is a canny user of the principles of emphasis and unity.

Emphasis was mentioned a few pages back; *unity* is closely akin to it, for it implies unmistakable emphasis, gained through the elimination of non-essentials. And both *emphasis* and *unity* combine to mean, essentially, *simplicity*. If there is any one word which has the magic secret of success in it, that word is *simplicity*. For in simplicity you gain efficiency by cutting out those things which are not important to the theme of your picture; in simplicity you tell your story without hazard of being misunderstood; and in simplicity it is far easier to approach that mysterious intangible called beauty.

Study Pictures—All Pictures

Form the habit of looking at all pictures carefully, to determine, first, whether or not they appeal to you and, if so, why. Then, second, try to analyze their compositional plans. Apply your study to your own camera work. Give it a critical going-over.

In studying pictures, there's a simple little device you should have. You can make it in two minutes from a generous sheet of white cardboard. Simply cut out two "L" shaped pieces and use them to frame any part of an average-sized picture. Vary the size of area included in the "frame;" move it around over the picture under scrutiny. There's no better nor more interesting way to discover how and why a picture succeeds or fails and how it can be improved.

In the course of your viewing of pictures, you will frequently find

With two L-shaped "croppers"
it's easy to discover the heart
of a picture

reason to ask yourself, "Did the maker of this picture plan it this way or did it merely happen?" The only way to reach any conclusion on this question is to investigate, for yourself, the difference between planned and unplanned pictures. (It is obvious, of course, that the so-called "table top" photographs, and all commercial pictures, come within the planned group. For the moment, however, let's concentrate on the more general kind of photography—informal groups, activities, scenics, and so on.)

If you are an orderly, methodical type of person, you'll find the planned picture a practically instinctive matter. With you, the idea of the picture

comes first. You will probably make several progressive rough pencil sketches of the picture you want to make. And then you'll scout around a bit, looking for the right location. Having found it, you'll make a fairly accurate estimate of the time of day when the light is right; you may even make a few alterations in the landscape to make it conform to your basic idea. In every step, you are deliberate, working toward a pre-determined goal. This is, essentially, the professional approach, with chance or luck ruled out as far as possible.

But those who go about their picture making without specific planning insist that theirs is the way truly to enjoy photography. There's no denying that one of photography's great fascinations is its opportunism—its capacity to grasp and record unpremeditated situations and scenes. And it really is fun to set out on a camera prowl, solely for the purpose of discovering unsuspected picture material in the everyday world. It's good picture-eye training, too.

Devotees of the catch-as-catch-can type of picture making show great skill in grasping the pictorial possibilities of things-as-they-are. And the way they convert those possibilities into fine pictures is remarkable.

Fortunately, it is unnecessary for the aspirant in photography to cast

A sketch may merely suggest a general plan or, as in this case, it may be an accurate preview of the finished picture

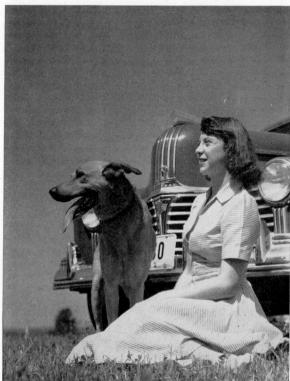

173

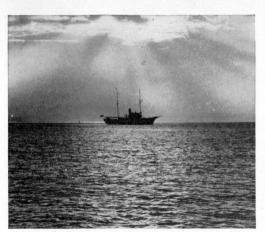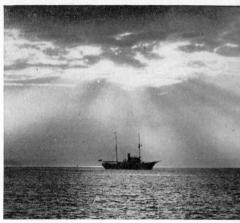

Don't let the horizon split your picture in halves; make it work for you

his lot exclusively with either of these schools of thought. Indeed, it is definitely unwise to do so. However, the more attention you pay to planning, the better you equip yourself to take advantage of unexpected opportunities. The self-discipline imposed by planning tends to eliminate buck fever and ineffectualness when something fine but unexpected comes along. Almost automatically you select a vantage point, a camera angle, and a concentration of interest which give you not merely a pictorial record but a picture which makes capital of the opportunity.

After some practicing you may find that you, like many others, belong to a group of "middle men." Confronted with a picture possibility, you recognize that somewhere in the scene is a neat composition. Unable to pick it out definitely and lacking time to make a detail study in the camera finder, you make shots from several different angles that seem to have the wanted material in them. Then, after the negatives have been developed, you bring out the best arrangement, create pictorial emphasis by cropping, dodging, and shading while making enlargements. Purists may scorn composition in terms of the enlarging easel, but practical-minded souls are grateful for it and embrace it.

It is the ability to work both by plan and by "spontaneous combustion," to give the planned picture animation and to make the unplanned picture appear to have happened for his own special benefit, that distinguishes the well-rounded photographer.

A FEW DON'TS AND DO'S

While the "laws" of composition are sometimes successfully violated, those laws are so valid from a common sense point of view that they

Above, left, is a perfectly good little snapshot. The quality is good and the composition, while very ordinary, does not offend. The same subject is given enhanced interest and vitality by slightly raising and tilting the camera to produce a more dynamic compositional scheme

Below, left, an example of camera "sprouts." To avoid such unfortunate results, keep an eye on what lies beyond your subject. Usually, the sky will afford your most convenient and flattering background

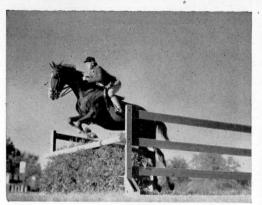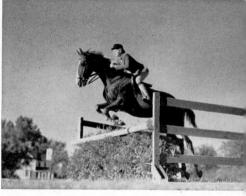

Let your subject move into—not out of—the picture space

should be part of every camera user's subconscious background. Here are some of them.

1. Avoid halving of your picture, either vertically or horizontally. A picture that "splits in the middle" tends to lack strength and interest. So keep horizon lines above or below the "equator" of your picture area.

2. Try to keep your major interest out of the dead center of your picture. It's a static spot. If there's action indicated, let it lead *into* the picture, not out of it.

3. Avoid confusing backgrounds. Many an informal portrait has been marred by a background which, for no good reason, demands the lion's share of interest. Unsightly buildings, the monotonous siding of a house, a background tree or post which appears to sprout from a person's head or shoulders; these are things to watch and to avoid. The sky is about the finest of all backgrounds, because it is unobtrusive and infinitely varied, and because it usually forces you to use a fairly low camera angle, an angle that gives your subjects a psychological advantage, thereby giving *you* a better picture.

4. Allow more space for your subjects to look and move *into* than out of. Think of the side of your print as a wall. People usually prefer to stand with their backs to a wall.

Any list of *do's* and *don'ts* must obviously be incomplete. Your concern is more with *do's*, anyway.

The first, the basic rule for the aspiring photographer is, *keep your camera busy*. In your pictures, whether they are successes or failures, you'll find information that is twice as convincing as anything you may merely be told. For in photography, as in every other human activity, it's practice that counts. Learning without doing is generally unsatisfactory.

Action and composition combine to produce rhythm and strength

Compositional lines dominate, yet they are kept from running away with the picture by the relatively small figures

Land, Sea, and Sky

THERE IS SCENERY—and scenery. Some of it is so obvious that it prac-
tically knocks you down. The Grand Canyon, Niagara Falls, Natural
Bridge, Half Dome Mountain—these and dozens of other similar phenom-
ena carry a wallop that none can avoid. Picture postcards by the million
proclaim their glories; a fair week-end at any well-publicized scenic
center leaves a trail of empty film cartons, ample evidence that snap-
shooters have been seeing the sights in more ways than one.

But photographing such "naturals" is a little too easy, too obvious for
a steady diet. The true photographer knows that his greatest pleasure
comes in picturing scenes that others have overlooked, in finding and
glorifying unexploited beauties.

Mr. Maeterlinck's play, "The Blue Bird," is built on the thesis that one
may search far and wide for the blue bird of happiness only to find it, at
last, in one's own back yard. Similarly, one may travel to all sorts of
famous beauty spots only to discover that the most deeply satisfying
scenic pictures can be made within a few miles of home. Any such dis-
covery, however, depends solely on the relish and intelligence with which
you use your eyes.

The picturing of any scenery, be it world-famous or your own personal
"find," can be humdrum or exciting. It's up to you. Forthwith, then,
consider some of the means by which natural beauties can be immortalized
on film.

THE GRAND VIEW

First, the spectacular, far-flung panorama of grandeur. In this classifica-
tion fall the majority of mountain scenes. The problem, in the face of
such lavish scenery, is where to stop, or what not to include. And the
answer lies in getting right back to the first principles of composition.

179

It may be imperceptible, but it's there just the same and may show up in your prints. When using black-and-white film, a yellow or orange filter will eliminate most of this haze and enable you to show details on the far horizons. This may be desirable in some kinds of documentary photography, but pictorially the photograph is better if the haze shows as a part of the view. It adds to the illusion of distance and depth by separating the various receding planes in the picture.

When color film is used, haze not only obscures distant detail, but reflects a great deal of blue light from the sky, which in the photograph affects the color of all parts of the scene covered by the haze. Hence, when using Kodachrome Film, you really gain by also using a haze filter.

Possibly the most important content of the scenic shot, especially in the mountains, is a great deal of very powerful light. *Actinic* is the word for it. Because of it you can cut your basic exposures somewhat; up in the mountains, a mile high or thereabouts, the reduction may be a half stop, that is, 50% or even a bit more.

But the intensity of the light isn't as significant to your picture as the angle at which the light reaches the scene. Some angles, you'll discover, belittle; others glorify. Obviously, you'll wait for the moment of glorification. Note the word "wait," for good scenics are not made casually. They deserve patience; if they're good, they are usually the fruit of patience. Full, front light, with the sun at your back is seldom the right lighting for large-scale shots. A bit of cross light, you'll find, reveals more interesting contours and variations. Back lighting, of course, gives you shapes and outlines, with relatively little detail.

Another factor to watch is that of distance. You may be tempted to stand on the brink of Inspiration Point (there's at least one of these at every well-regulated beauty spot) and aim out over miles of valley toward the distant peaks. The result may be fairly good, but it seldom has the "feel" of vast distance—and that feeling is one of the emotional considerations which should not be ignored. To get the veritable sense of distance, find some significant bit of foreground which will give your picture a jumping-off place, for *distance* depends on its relationship to *nearness* to be at all significant. Show that relationship and capitalize on it. The old trick of showing a member of your party in the foreground, his back to the camera, is not at all to be scorned. Sometimes it may offer you your only foreground interest.

All scenics of this type are made, of course, with the lens focused at

infinity. In order to get maximum depth, the diaphragm is usually stopped down as far as the exigencies of exposure will permit.

THE INTIMATE VIEW

Related to the grand view type of scenic is another which can be called the Intimate View. It differs from the grand view primarily in scale and in subject matter. Where your grand view may deal with a vista of many miles and a mountain, the intimate view is concerned with a few hundred yards and, for example, a rural church steeple.

Obviously a little different treatment is needed. You want a good bit of significant foreground detail, such as a tree branch which frames your view. And you're dealing with individual shapes of trees, fences, roads and buildings, rather than with masses of forests, rocky slopes, and cloud shadows. It is in this type of scenic that you are most likely to discover your "blue bird" pictures—the home scenes which you and your friends have overlooked because they are so familiar.

From the standpoint of composition, little more can be added to the rules already outlined. Just be certain your picture holds together and that the wandering eye of the observer will always be led by your arrange-

Left, intimate views generally benefit when natural "frames" are used.

Below, pictorial interest can be found in the most commonplace subjects—even mail boxes

183

ment to the center of interest. A pathway, roadway, or foreground people leading or pointing to this center are effective tools.

Pictures of mirror-like reflections from water deserve special mention; those are the pictures you make from alongside the mill pond or quiet lake. Since the water absorbs about half the light from the scene, you will need at least a full stop more exposure than is required by the direct view. And make sure that no one can ever question which way is right-side-up in any reflection picture of yours. Break the perfect reflection with ripples from a tossed stone, or use a strong foreground feature to establish right-side-upness.

For all landscapes, in black-and-white work, you're practically lost without a filter. It's true, as was said in talking of filters, that it is possible to achieve relatively successful results solely in terms of controlled exposure—provided the light conditions are in your favor. But it's risky to work that way, especially when filters are so inexpensive and so easy to use. For average scenes, a simple, light yellow filter—such as the Wratten K2—should give you sufficient correction. It will help preserve sky-cloud contrast and will tend to keep foliage from going too dark.

If you're concentrating on clouds, with the landscape serving only as a base for your picture, the Wratten A filter (red) with panchromatic film will give you high cloud-and-sky contrast, together with all there is to be had in the way of cloud texture.

Scenics with Infrared and Pan Films

While infrared film, used with a red filter, is not suggested for the general run of scenics, there are times when it serves interestingly and well. It unveils distance as no other medium does, and the results may be of interest both scientifically and artistically.

Full development of infrared film negatives produces strikingly dramatic "posterish" effects. Clear skies reproduce as black, green grass and trees as snowy white. Faces appear chalky.

With less development, very pleasing and unusual, somewhat "ethereal" results can be obtained. Try a few infrared landscape exposures. Develop some fully; develop others only about ¾ of the time recommended in the instructions packed with the film. There has been some controversy on focusing for infrared shots. While the infrared rays do converge slightly behind the focal plane of the other rays, the correction required is so slight (¼%) that it can be accomplished more practically by simply

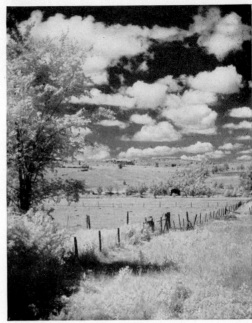

A vivid example of the power of infrared to change and to "reveal" a scene

stopping the lens down to $f/16$ or thereabouts. This requires a tripod which, incidentally, is always worth-while in serious pictorial shots.

In black-and-white scenic photography, there's no point in using the ultra-high-speed films. Usually a good, standard speed, fine-grain film, such as Kodak Plus-X, will do all that you need. For work with a variety of filters you'll need a panchromatic emulsion, but if you're using only the blue-restraining filters you'll find that such a film as Kodak Verichrome works out admirably. Not long ago, a perplexed camera user complained that he got no image at all, "not a darn thing," when he tried to photograph Old Faithful, in Yellowstone, using ortho film and a red filter. A puzzling phenomenon, indeed, until the nice relationship between filter and film color sensitivity is remembered.

Sunsets

Sooner or later, everyone tries a sunset. And the result is frequently disappointing. The reason, therefore, is found in the fact that the visual appeal of a sunset is largely a matter of *color*—of subtle, shifting color. With color film you can capture such beauty easily. If, perchance, you underexpose slightly, the colors will be deepened and you'll get a more vivid effect. Slight overexposure will soften the colors and make them

185

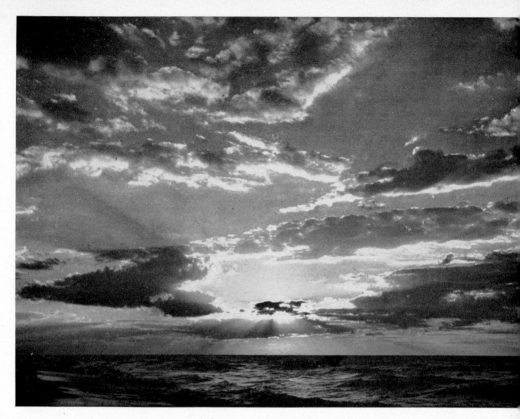

A flaming, red-and-gold sunset, pictured with ortho film

more delicate. You can't miss. But in black-and-white you'll encounter more difficulty. And it's hard to prescribe a definite sunset technique—again because of the unpredictable quality and color of the light. In some cases an ortho film will work well, especially when you've a lot of orange, red, and yellow to deal with, again, your dominant colors may be on the cool or blue end of the spectrum, and you'll naturally have to change to pan, plus a filter, to get what you want. By all means try a sunset or two; whether or not you're entirely successful, you'll be garnering some useful experience.

Before leaving landscapes, there's one other subject to consider, because it's bound to come up.

Panoramas

From a strictly pictorial point of view, panoramas do not make sense. The human eye doesn't embrace the far-flung horizon in full panoramic

fashion. For the sake of a record, however, a panorama can be justified.

Unless you own one of those trick, clockwork panorama cameras—and the chances are easily a million to one that you don't—you will have to make a panorama by overlapping a series of shots, all made from the same point. In theory, the camera should be pivoted, for the successive shots, on a point exactly under the lens; in practice, pivoting on the tripod socket works fairly well. Overlap each exposure about one-third. And if the complete arc involves you in considerable variation in lighting, make progressive exposure adjustment. When your prints are finished, experiment will show you the best possible points at which to join one to 187

Two stages in the completion of a composite panorama. After the individual units are matched and mounted together, a copy negative is made of the whole thing and either contact printed or enlarged

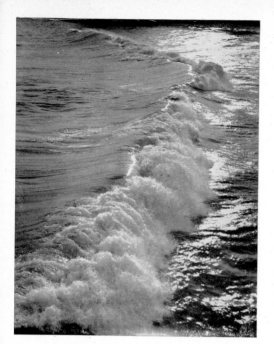

For moods, nothing compares with the sea

LAND, SEA AND SKY

another. Usually, strong vertical lines in the panoramic scene will give you good joining places. Mount the joined series on a card, and make a copy negative of the complete paste-up. And there's your panorama, complete in one negative.

SEASCAPES

Marine scenes are in some ways more difficult than landscapes, especially if you try to picture a broad expanse composed exclusively of water and sky. With such material, it is obviously a problem to establish a main center of interest or to utilize any of the tried-and-true compositional schemes. The most famous marine painters have solved this problem in two categorical ways; they have either used large foreground waves and a lot of detailed texture as the interest-nubbins of their paintings, or they have introduced boats, birds, or some very impressive clouds to break up the monotony of sky and water.

Of course, the minute you start bringing in birds, boats, bathers, or what-not, you simplify the whole thing, for your interest centers can then be nicely organized. Frequently, in photographing landscapes and marine views, you find that distant but important features are reduced in size to mere specks. These are clear-cut cases calling for the use of a lens of longer focal length. Its narrow angle of view eliminates the unwanted surrounding detail and affords larger images of the more important and desired distant subjects.

In one aspect, marine views differ drastically from landscapes. Back lighting can be, and frequently is, used to excellent effect. With the light coming toward you over the water, you pick up a multitude of glinting waves, and these glints, dapples, and sparkles of light give your picture a very special kind of animation. Under such circumstances, of course, foreground objects—boats and such—are rendered as silhouetted shapes, and the pictorial photographer finds ample reason for rejoicing in this state of affairs.

For back and strongly cross-lighted subjects anywhere, beware lest the sun's rays reach your camera lens directly. The result of that may be the setting up of reflections and flares within the lens. Hold your hand or hat out to cast a shadow on the lens. Otherwise, you'll find a shadowy image of the iris diaphragm on your negative. The use of a lens hood to shade your lens from direct rays in cross lighting will be a big help. Of course, if you really want the sun in the picture, you'll have to cut down

the diaphragm almost to the extreme, and speed up your shutter. The resulting picture will be one of those pseudo-moonlight jobs, and may be very attractive, too.

Speaking of moonlight, you may be tempted to make some pictures in the full of the moon. Try it. It's an interesting experience. But remember, bright moonlight is really very dim light; a time exposure is certain to be your only recourse in picturing moonlit scenes. There is, however, an interesting exception to this. If you want to picture the moon itself, then your problem becomes one of shooting a subject in direct sunlight; hence, you can use a snapshot exposure. Sounds absurd, doesn't it? But a recent experiment, made with a home movie camera, proved it to be fact.

Take Time Out for Beauty

In the old days, long before anyone thought of speaking "candid" and "photography" in the same breath, amateur photographers concerned themselves almost exclusively with "views." Those were leisurely, unsophisticated days, and pastoral scenes were part of them. Today, the mood of the world in general and of photography in particular has changed. The tempo is swift, our emotions are brittle, and we lean naturally toward irony and satire. Hence, it is good for us to take time out, once in a while, and to prowl with our cameras, seeking out a little of natural beauty and serenity. We can use all we can find.

Action

PRIMITIVE PHOTOGRAPHY was a cumbersome thing, dependent on long time-exposures. Subjects were propped up with head rests and arm rests; they were stiff and unnatural. Even so, the camera was much faster than the swiftest artist in creating a detailed, factual record. Ever since that time, photography has been increasing in speed. New films, better lenses, fleeter shutters, and special lights have all helped to knife time into thinner and thinner slices. Today, pictures are made quite casually at a millionth of a second. And greater speeds are not improbable.

Naturally, speeds of the astronomical sort are primarily for laboratory use; most of us will get along—and very well, too—if our cameras are capable of speeds up to 1/200 second. Camera shutters with rated speeds up to 1/400 are fairly common. Shutter speeds of 1/1000 are, for the most part, luxuries, just as a 150 H. P. motor car is a luxury. A clever driver of a 75 H. P. car can outmaneuver an eager but uncertain driver of a 150 H. P. job; just so, a canny photographer whose camera's top speed is 1/200 can bring home better action pictures than those made by an enthusiast equipped with a higher speed outfit and less good judgment.

Speed, as Mr. Einstein is said to have indicated, is relative. And, as a corollary to that profundity, be it added that there are more ways than one to skin a cat.

The fascination of picturing speed is a real thing. No small boy with a Brownie can resist the temptation to photograph a plane, or a racing car, or a track race, or the Overland Limited. And, almost as often as not, he gets a fair picture, despite the fact that a Brownie's shutter works at a speed somewhere between 1/25 and 1/50. Theoretically the thing's impossible. But remember Mr. Einstein.

It is in the field of straight-line action—a plane, a train, a race—that relativity is photographically most important. Stand close beside a highway

and watch the cars come along steadily at the legal limit. While they're still a hundred yards up the road, they give you no real sense of speed; they merely grow larger. Closer, they grow larger fast. Then, as they pass, you have to swing your head swiftly to follow them. The "growing" goes into reverse and the cars diminish in size, swiftly, then slowly.

Camera-wise, this simple phenomenon means merely that it takes much more shutter speed to "stop" action as it crosses the camera's axis than when that action is approaching or receding.

Back to the highway for a moment, only this time stand at least 100 feet away from the traffic. The angle between yourself and the oncoming cars is greater; their speed, at a distance, is a little more apparent but, oddly enough, the speed at which they pass directly in front of you seems less than when you were standing close-by. At any rate, you don't have to swivel your head as fast to follow the action. Translate that into photography. It means that you need a little more shutter speed to catch the approaching or receding cars, and not quite as much speed to stop the cross-axis movement as when you were close to the traffic.

Calculating Exposures for Speed Work

Here's a tabulation which puts the whole situation into compact form. It rates a bit of study. It is, frankly, conservative, in that it indicates shutter speeds which will certainly give you sharp, enlargeable negatives. Johnny with his Brownie may be well satisfied with his results made at, say, 1/40 when the table indicates 1/100 as the right speed; but try enlarging those Brownie negatives a few diameters, and you'll find them plenty blurred. But don't chide Johnny; he'll learn.

ACTION-STOPPING GUIDE

FOR SUBJECTS SUCH AS	DISTANCE FROM CAMERA	SHUTTER SPEEDS FOR SUBJECTS MOVING		
		DIRECTLY HEAD-ON	AT ABOUT 45°	AT ABOUT 90°
Pedestrians, construction work, most ordinary activities	25 feet	1/100	1/200	1/400
	50 feet	1/50	1/100	1/200
	100 feet	1/25	1/50	1/100
Most sports and more energetic activities	25 feet	1/200	1/400	1/1000
	50 feet	1/100	1/200	1/400
	100 feet	1/50	1/100	1/200
Fast cars, trains, planes, and other swift motion	25 feet	1/400	1/1000
	50 feet	1/200	1/400	1/1000
	100 feet	1/100	1/200	1/400

There's a mathematical formula by means of which you can work out your own tabulation, suited specifically to your lens and shutter. It runs this way:

Shutter speed calculation for motion at right angles to the camera axis

$$\text{Shutter Speed} = \frac{\text{Distance in feet x circle of confusion}}{\text{Focal length of lens x speed in feet per second}}$$

or

$$\text{S.S.} = \frac{\text{D x c.c.}}{\text{F x S}}$$

For motion at 45° angle, S.S. (as above) x 3/2

For motion head on, S.S. (as above) x 3/1

Sample Situation

You wish to photograph a city street scene involving ordinary traffic running at say 20 miles per hour. When photographing at 50 feet from the action, as the cars run across in front of the camera, what shutter speed would be required? Assume the lens being used has a focal length of 4 inches and the tolerable circle of confusion is 1/200 inch.

Answer

15 m.p.h. equals approximately 30 feet per second

$$\text{Shutter speed} = \frac{50 \text{ x } 1/200}{4 \text{ x } 30} = \frac{\frac{1}{4}}{120} = \frac{.25}{120} = \frac{1}{480} \text{ sec.}$$

Since this is beyond the capabilities of the fastest conventional shutter, you may take the cars as they approach at an angle—say 45°. In that case

$$\text{Shutter speed} = \frac{1}{480} \text{ x } \frac{3}{2} = \frac{3}{960} = \frac{1}{320} \text{ sec.}$$

This is within reason for some cameras, but not for the majority. Consider, then, the possibilities of shooting head on. The equation works out this way:

$$\text{Shutter speed} = \frac{1}{480} \text{ x } \frac{3}{1} = \frac{3}{480} = \frac{1}{160} \text{ sec.}$$

If that is still too much shutter speed for your equipment, you can always back farther away—and re-figure.

The only purpose in mentioning this formula is to suggest that you work out one or two equations based on situations you have already

experienced—or on a setup you may encounter, any day now. If you are going out to photograph races of any sort, a little of this figuring beforehand may save a lot of explaining afterwards. Then, having thereby nailed down a fact or two, go on about your action photography on the basis of your own good judgment and common sense—the two most important of all photographic "accessories."

Poised Action

In many sports, particularly in races, movement is constant enough to permit picture making in terms of calculated speeds. But there are other sports in which the action is spasmodic, defying calculation. In those sports, the instants when action is poised are, pictorially, just as vivid and interesting as the moments when action is wildest. Take pole vaulting, for instance. At the very top of the vault, with the vaulter's body flung out horizontally over the bar, action is relatively quiet—yet it's the best pictorial moment in this field event. This peak instant can be "stopped" with much less shutter speed than either the rise or fall.

194

These look like top speed, but . . .

Baseball has a number of moments which are full of poised action. The pitcher winds up and then unwinds to throw his speed-ball. In that instant, between winding and unwinding, action is suspended, yet a picture of it tells a story of speed and power. An instant later, having released the ball, the pitcher is again poised—all his energy having gone into the delivery. There's another pictorial moment. To picture either of these moments you need to work swiftly, but a high shutter speed is less important to your success than an understanding of the sport and of the personal style of the athlete before your lens.

Check over other sports, other activities which seem, off-hand to call for top speed. Rowing, basketball, fancy diving, tennis, hunting—in all of these the best picture moments are not necessarily those in which action is most frenzied. It takes practice to learn exactly what and when those moments are; reading about them is just a start. Keep your eyes peeled for pictures when you read the sports page of the newspaper. Analyze the pictures. There are real lessons to be learned from them.

Or watch a veteran sports photographer at work. He knows sports so well that he can predict the next most likely developments during play—and moves over to take advantage of them.

Even in boxing, a good photographer gets his pictures as the blows land, not as they travel. There was that famous instance at the Louis-Nova fight in '41. Two photographers, on directly opposite sides of the ring, saw a heavy punch coming and shot just as it landed. Both used Photoflashes, of course, but—one of the lamps failed to work. The Photographer whose light had failed discovered, on developing the film, that he had a picture—a most unusual and vivid silhouette—*made by the light of his competitor's flash.* The fighters hid the other man's flash bulb, so the silhouette effect was perfect—and dramatic. The only moral to this yarn is that experience teaches pressmen and other pro's that there are right instants for any shots. The photographers on opposite sides of the ring were right—and right together, within the same hundredth of a second.

Another factor in action photography is a purely personal one—the speed and precision of your own nervous and muscular reactions. How long after your mind says, "Shoot!" does it take your shutter finger to respond? If your reaction time is slow—and that's nothing to be ashamed

A poised instant comes at the end of the "follow-through" in many sports. Such instants need more alertness than shutter speed, yet they are full of a sense of action

196

of—you simply have to train yourself to work a little farther ahead of the action. Those two photographers at the fight didn't wait to see that blow land; they saw it coming and, each according to his own reaction time, sent the shooting order down to his trigger finger.

Poise vs. Pose

There's a world of difference between pictures of real action and those of posed action. We have all seen posed pictures, ostensibly showing people involved in some such simple business as walking. But those pictures didn't fool us for a second; for the balance wasn't the real dynamic balance of honest motion.

You may possibly be called upon to make some action pictures of individual athletes. The first thought is posing—but don't do it. Focus your camera and then let the basketball player pass or bounce the ball as you make the pictures. He doesn't have to do it with fury, but he shouldn't "pretend." Remember, too, that some attention should be paid to lighting in these pictures. The flat single flash may be the only answer on a rush

There's a middle ground between intensely active and posed pictures of athletes. With some care in lighting, such pictures are more than mere "records."

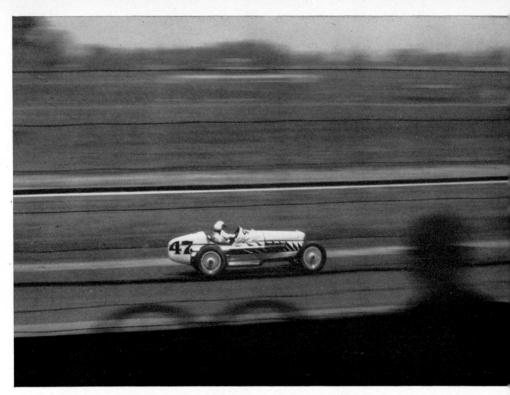

**"Panning" with the action can produce excellent pictures of
high-speed action—with a low speed shutter**

picture but, if time permits, set up a couple of Photofloods or add an
extension flash and shoot for a modeled lighting. You'll be well rewarded
for your added effort.

Panoraming

Panoraming is a good trick to know, especially if you're trying to photo-
graph a passing car or train and you are using a relatively slow-speed
shutter. Follow the action with your camera, shooting as you follow. It
takes a little care, but it is certainly not difficult. Eye glued to your
camera's viewfinder, you spot your subject as it comes along; pivot your
head and shoulders so that you keep that subject in the finder. At the
right instant, without interrupting your smooth pivoting, you click the
shutter and follow through, as in golf.

The result will show the car, or whatever it may be, clearly—but the
fore- and backgrounds will be a mass of horizontal blurs or streaks. The
sense of speed will be nicely registered and you will have made a picture

at, say, 1/50 that would have required 1/1000 without that "panning" technique. It's fun to do, too.

Before tackling any speed or swift action photography, it's a good idea to know what to expect of your shutter. Between-the-lens shutters, in general, rarely do better than 1/400, or thereabouts. And, as has been indicated, that's fairly ample. Focal plane shutters can work faster, but they have a strange quirk that should be understood.

Focal Plane Phenomenon

The slot in the focal plane shutter usually works from top to bottom; in other words it uncovers the top of the film first. The image it admits is, of course, inverted; hence the wheels of a car are registered on the film before the body. In the split second of the shutter movement down across the film, a passing car moves forward considerably. The resulting negative shows a beautifully exaggerated sense of speed, with the wheels rendered almost as ovals and the whole car canted rakishly forward in what appears to be a passionate lust for miles-per-hour. Naturally, the slower the shutter speed, and the smaller the slit in the shutter curtain, the greater this "italic" effect. If the camera is turned so that the shutter slot travels *with* the motion of the image, the subject will look stretched out; if the slot moves in the opposite direction from the motion, the subject will appear pushed in, or shortened.

Speed, as was said a while back, is inescapably fascinating. But the ability to stop swift movement should not obscure the fact that we are making—or hope to make—pictures. And pictures, to be successful, have to have some sort of composition and meaning. Otherwise they're the merest snap-shots. So watch your backgrounds; be sure they will be backgrounds and not protective or confusing camouflage. Try to get your action to lead into the picture, not out of it. In short, make pictures.

Both shots were made with a focal plane shutter at 1/295. Left, curtain traveled in same direction as car; right, in opposite direction

199

Subject Motion Experiment

Object:

To determine the shutter speeds necessary to stop the motion of a person walking (A) across in front of a camera and (B) toward the camera.

Equipment:

A camera with a range of shutter speeds. A tripod will be helpful.

Procedure:

Set up the camera and focus it on a point fifteen feet distant. Mark the point focused on by dropping a small piece of paper or a handkerchief. Now, have the subject walk across in front of the camera at military pace,* passing directly over your marker. When he is over the marker, make an exposure using the fastest shutter speed your camera permits. As your subject repeats his pacing, make exposures at successively slower shutter speeds until you have

employed all the speeds available on your camera. Shoot in the middle of the stride and you'll catch the action at its fastest.

Don't forget to adjust the diaphragm (*f*-number) to balance each speed.

Repeat the series of speed exposures as the subject walks *toward* the camera, snapping the shutter as he crosses the marker at the same pace used in the first set.

After the films are developed and printed, mount the pictures in sequence and mark the ones showing no apparent motion. Verify your findings by applying the formula for determining appropriate shutter speeds, suggested in the preceding chapter.

Interesting variations on this experiment can be worked out by photographing an automobile traveling at a constant and known rate of speed at a known distance from the camera in a series of shutter speed tests.

200 *Military cadence is 128 steps to the minute— 30 inches to the step.

½₅ sec. ⅟₅₀ sec. ⅟₁₀₀ sec. ½₀₀ sec.

 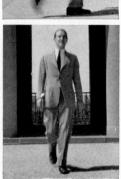 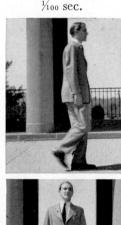

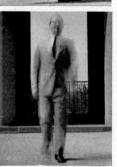 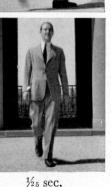

⅟₁₀ sec. ½₅ sec. ⅟₅₀ sec. ⅟₁₀₀ sec.

By Flood and Flash

PHOTOGRAPHICALLY speaking, neither flood nor flash belongs in the catastrophe column. Fact is, two of the most fortunate things that have ever happened to photography have been the "flood" and the "flash" lamps.

Both introduced a new and badly needed tool for the specific use of those who couldn't support a whole battery of high-powered lights, Hollywood fashion. And their use has not been limited to the amateur. They are "musts" for commercial and news photographers as well.

The Flood Lamp

The "flood" lamp is simply an incandescent lamp burning under an overload of electricity. There are various legends surrounding its introduction into photography, but they are all based on the fact that someone took a 100-watt bulb of the type used on railway trains, where the voltage runs at about 64, and subjected it to the full impact of ordinary domestic current—110 volts, more or less. The surprised railway train bulb lighted up furiously, delivering an intensity of light approximately equal to that of an ordinary but expensive 500-watt lamp. Naturally, it burned out in an hour or two but during its life it gave "a lovely light," much in the manner of the abused candle in Edna St. Vincent Millay's famous poem.

The advent of this overloaded but very useful lamp in 1931 coincided with the arrival of panchromatic film. The new lamp and the new, fast films worked together beautifully.

In no time at all, relatively speaking, a new era in photography arrived. Hitherto, photography by artificial light had been almost exclusively the province of professionals with well and expensively equipped studios. With the new lamp and the new film, indoor photography came within the ken of anyone with a few dollars to spend.

Both still and movie amateurs began, with enthusiasm, to explore the

possibilities of work by artificial light. It was fun. And the results were interesting.

Naturally, the lamp makers soon appreciated the vast appeal and value of these lamps and began to develop them. Presently the No. 2 Photoflood appeared. Like the No. 1, it could be used in any standard light socket, but its special appeal lay in the fact that it delivered twice as much light and lasted three times as long.

Later, came the R-2 Photoflood, a wide, flat bulb which contains its own reflector lining. The bulb is about as bright as the regular No. 2 bulb, and provides its own reflector. It's handy where portability is a desirable feature. Then there is the No. 4 Photoflood—1,000 watts for a ten-hour life—but this is, and should be, specifically a studio unit.

Since most household electrical circuits are fused for 15 ampere maximum loads, it is not safe to use more than 6 No. 1 Photofloods or 3 No. 2 Photofloods altogether on the same circuit. If the maximum number of bulbs are burned simultaneously, other loads, such as ordinary room lights and the radio, should be shut off.

The Flash Bulb

The flash bulb is the modern version of that ancient pyrotechnical display, the powder flash. Up to about 1930, the flashlights used by intrepid photographers were actually fireworks—magnesium powder touched off by a spark, to the accompaniment of noise, confusion, smoke and, frequently, a hurry-up call for an ambulance; for many a photographer was seriously injured by those old flashes.

The flash bulb of today is also a matter of fireworks, but now it's a "bonfire in a bulb," all nicely under control. The first such flash bulbs contained a small, easily fused wire, a quantity of aluminum foil and oxygen. When the wire was fused by an electrical current it instantly ignited the foil which burned swiftly and brilliantly in the oxygen. Later, a tangled length of shredded aluminum foil was substituted for the crumpled foil.

A newer type of flash bulb, called the Speed Midget or SM, was introduced about ten years after the first of these modern flashes. It is a small, walnut-sized lamp in which the "bonfire" is the burning of a chemical paste coated around the two small lead-in wires. The bulb is filled with oxygen, as were its predecessors, but the resulting flash is shorter, about 1/200 second. One of the big advantages of this type bulb is that it permits

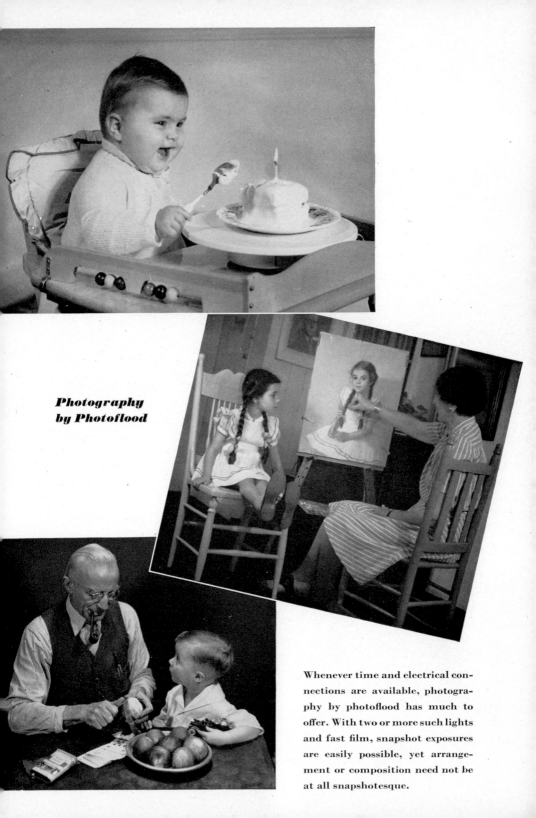

Photography by Photoflood

Whenever time and electrical connections are available, photography by photoflood has much to offer. With two or more such lights and fast film, snapshot exposures are easily possible, yet arrangement or composition need not be at all snapshotesque.

*Photography
by Photoflash*

With compact flash equip
ment mounted directly
his camera, the photogr
pher can shoot from plac
and at angles which would
difficult or impossible
floods were the only ligh
available.

With flash and synchroniz
it is easy to get fully light
candid, or unposed, shots
shots such as this, whic
make a beautiful suppl
ment for formal, conve
tional wedding pictures.

greatly simplified synchronization with the camera shutter. Mechanisms for synchronizing the slow burning, older style bulb had to hold back the shutter until the bulb began to burn. This required intricate mechanisms and adjustments. Because of the speed with which it burns, the Speed Midget can be fired and the shutter opened simultaneously. The simple contacts it requires are easily incorporated in the shutter itself.

All the new flash bulbs provide a high intensity of light—an intensity so great that even the relatively slow ortho films can be relied on for successful work. The little flash lamps, used with small synchro-flash cameras and, by means of adapters, with many press cameras, have a bayonet base; the larger bulbs are about the size of an ordinary 60-watt lamp and have standard screw bases. All flash bulbs of this type are coated with a plastic-like lacquer which prevents the scattering of glass in case the glass fractures with the flash. These bulbs are, of course, dead after a single flash.

The filament—the match or sparkplug that starts the flash—can be designed to function at any voltage, but most flash bulbs in use today require only a feeble voltage. Two small dry batteries of the ordinary flashlight variety pack ample power for igniting many a flash bulb. Do not use 110-volt house current to fire flashes unless the manufacturer specifically advises that method in the instructions printed on the lamp carton. To fire with such high voltage invites blown fuses and lamp explosions.

Flash Synchronizers

So far, the possibility of firing the bulb synchronously with the opening of the shutter has just been mentioned. Flash synchronizers are the devices for accomplishing the feat; certainly without them the modern flash would mean little. Synchronizers are mechanically and/or electrically operated and contain, usually, two or three small flashlight batteries.

Left, synchronized flash outfit

Below, a line-up of flash lamps

205

When the firing button is pressed, current flows from the batteries to the flash bulb and it begins to burn. A delay device slows the opening of the shutter until that fire is well started within the bulb. The bulb reaches a peak of illumination and, as it dies away, the shutter is again closed. All this, of course, is within hundredths of a second. The length of the delay in opening the shutter may be easily adjusted to take full advantage of the peak of the bulb's light output. This means that photographers can make high speed "synchronized" flash pictures capable of stopping most kinds of action. After the first adjustment with the shutter, there is little or no worry connected with accurate timing.

Newspaper photographers have come to depend on these synchronizers as the solution of all artificial lighting problems. Amateurs, as well as newsmen, have also capitalized on the possibilities in the use of several flashes, placed for best effect, and fired synchronously.

Exposures with Flashes

A neat system is now in use in making flash exposure recommendations. For each shutter setting, film and lamp combination, a *guide number* is issued. To find the aperture required, one merely divides the guide number by the distance from the lamp to the subject—the answer is the $f/$ number. Or you can divide the guide number by the $f/$ value and find the appropriate distance.

For example: Suppose we are to make an "open flash" picture. (That's where you set the shutter on *bulb*, open it, flash the lamp by hand and then close the shutter.) If the film is Kodak Super-XX and we are using a No. 5 Photoflash lamp, the guide number, we learn from the lamp manufacturer's pamphlet, is 280. At 10 feet, then, we should use $f/28$, at 20 feet $f/14$. If, for some reason, we wanted to use $f/8$, we would be forced to back up to 35 feet—or use a less intense bulb.

Color Temperature

Physicists have long used a scale for measuring the color of light given off by burning matter. Just as we say that we like our living room to be kept at 70°F, physicists speak of the color-temperature of a standard domestic electric light as, on the average, 2600°K. The "K" stands for Lord Kelvin, who evolved the system and the theory back of it—a theory based on the type of light which a wholly black, inert body emits when heated. "Red hot," we all know, is not as hot as "white hot." Photo-

graphically speaking, then, a lamp rated at 3400°K emits a whiter light than one rated at 2600°K. The Photoflood is rated at about 3380°K; the Photoflash at 3600-3900°K.

To the casual photographer, this color-temperature business is of relatively little importance in black-and-white work; to all serious workers in color photography, it is a factor of great importance.

For example, there are 3200°K lamps for use when making Kodachrome shots (using Type B Kodachrome—an emulsion specifically color balanced for studio work). The movie studios use 3380°K lamps in shooting Technicolor; other lamps, such as the Daylight Photoflood have color temperatures of about 5000°K—and that's not too far from the color temperature of natural daylight. This means that the "blue" lamps can be mixed with daylight when using the Daylight Type Kodachrome film.

Few of these specialized lights are practical for the amateur whose principal concern it is to use the proper Photoflood lamps for Type A Kodachrome Film. But it is sobering to realize that lighting is an exact science—one of the several sciences with which the practicing photographer must have more than a nodding acquaintance.

Two other forms of photographic lighting equipment should be mentioned because they are destined to become important.

The Kodatron Speedlamp

The first is the speedlamp, invented by Dr. Harold E. Edgerton and his associates, of the Massachusetts Institute of Technology. Its first and most obvious point of difference from other flash outfits is that it can be used over and over, for thousands of flash shots. Its second distinction is the extreme speed of the flash, approximately 1/10,000 second. This, of course, is far faster than any camera shutter; it is so fast that, regardless of the camera's shutter setting, it "stops" hitherto "unstoppable" action. If you blink your eyes at the right moment you will miss seeing the flash. And, in the third place, the Kodatron Speedlamp delivers a terrific intensity of light, roughly equivalent to that of 50,000 ordinary 40-watt tungsten lamps. Obviously with so much light, exposures can be made at otherwise impossible apertures and distances.

The functioning of the Kodatron lamp depends on a supply of 60-cycle, 110-volt alternating current which, by means of a special transformer, is stepped up to 2000 volts. A rectifier tube changes the A.C. into D.C.

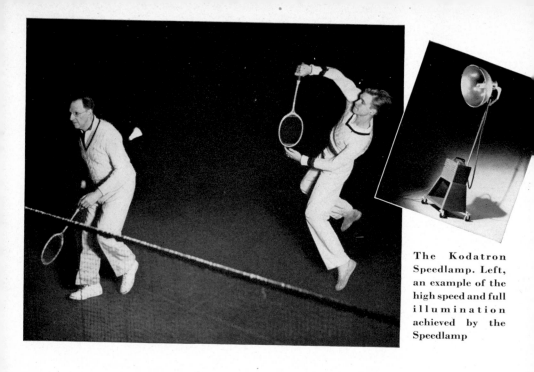

The Kodatron Speedlamp. Left, an example of the high speed and full illumination achieved by the Speedlamp

which is used to charge a condenser. When the flash trip is released, the energy stored in the condenser is discharged by a Strobotron Tube through the Kodatron Tube in about 1/10,000 of a second. This sounds a little like a Rube Goldberg cartoon, but the end result is no joke. The Kodatron Speedlamp has already proved its capacity for handling a lot of studio work successfully. A smaller, readily portable model, of special interest to press photographers, is in prospect.

By the way, there is a clever system by which several Kodatron Speed-lamps can be fired in unison. They can, of course, be wired together, but that sometimes is cumbersome. They can be especially fitted with neat little photoelectric cell trippers, which keep an eye peeled for the signal from the Kodatron nearest the camera. When it flashes, the several little electric eyes catch its first glimmer and, responding, set off their own Kodatrons. Quite a trick, too, when you're slicing time into such thin sections as 1/10,000 second.

Fluorescent Light

The second of the newer photographic illuminants is fluorescent lighting. Certainly the wild-fire spread of fluorescent lighting in shops, factories, restaurants, and offices all over the country has forced most of us to admit

that here, indeed, is really Something. There is plenty to indicate that today's fluorescent tubes are but the first signs of a major development.

The white fluorescent light—cool to the touch but with an extremely high color temperature—is excellent, when used with Eastman Ortho-X Film, for much photographic work. It is highly actinic and it casts soft shadows. It is economical in operation. Whether or not it will replace other forms of studio light remains to be seen.

The use of fluorescent light as the light source in enlargers of the diffuse type is one of several projects now under investigation. It is certain that we are today only beginning to explore the possibilities of fluorescence.

Reflectors

In photography there are two kinds of reflectors, (1) those which are fitted directly to the lights, to concentrate and direct the flow of light, and (2) those which are placed, well away from the light source, to bounce light back on to the shadow side of the subject. For the sake of clarity, let's call them, respectively, lamp reflectors and subject reflectors.

To make a photograph with artificial lights which are not equipped with lamp reflectors is sheer waste. A well-designed reflector concentrates the light where it can do the most good and vastly increases its efficiency. Some reflectors are mirror-like in their polish, and produce hard, sharply defined shadows; others have a rough or granular surface, and, as a result, yield a more diffuse light. Some produce a wide cone of light— a "flood"—while others are virtual spotlights.

A subject reflector can be anything that will reflect light into the shadows. Obviously, a big sheet of gray cardboard will reflect less light than a white card of the same size. A mirror will reflect practically all of its incident light; a concave, mirror-like surface will produce a hot spot of intense illumination by reflection. And so on.

Watch a veteran studio man work. He pays as much attention to the type and placement of his subject reflectors as to the source reflectors. For he knows that "empty" shadows can, in some cases, ruin his picture.

LIGHTS AT WORK

Lighting is exacting work, but intensely interesting. And you needn't have a whole battery of floods and banks of spots and half a dozen varieties of subject reflectors to experience the peculiar pleasures of the art of lighting. One or two Photofloods or even a few ordinary Mazda lamps

209

in some sort of reflectors and a few sheets of white cardboard for subject reflectors—some such simple equipment will give you ample material for study, and for achievement.

Of all lighting problems, the one which is most frequently encountered is that of the informal group in the living room at home.

"Family" Pictures

The word family is quoted, above, merely because it's a generously embracing term, amply wide enough to include the intimate friends who belong in such pictures. Theoretically, at least, there's no need for haste in making these pictures. You can proceed more or less at leisure. So you *plan* the picture, working toward a specific composition. It may be some such simple matter as mother or dad reading to the youngsters.

As unobtrusively as possible, set up your lights. Make your lighting friendly and "homey;" don't give it an unnatural over-all harshness. Use Photofloods, capitalizing their economy, their flexibility, and their ability to "double" reasonably as ordinary lamps in bridge lamps and other such fixtures. Use a good, fast pan film—Kodak Super-XX or Plus-X—which gives you good skin tones and a generally normal black-and-white interpretation of colors.

Watch out for reflections of the bright lights in windows, in polished furniture, and in mirrors. Such reflections have an annoying habit of appearing less disturbing "on the set" than in the finished negative.

Take advantage of the softness of diffused light reflected from white cards, light walls, light-colored clothing, etc. In other words, get the full value of your lights. In so doing you are almost sure to get a pleasanter, more intimate total effect.

210

Flat lighting plus confusing reflections

"Portrait" lighting, better arrangement, and less confusion

Party Pictures

For capturing the cheerful mood of a party, the synchronized Photoflash is well suited. It is best used with an ortho film.

Naturally, a good many party shots can only be made—on the wing—with a single flash at the camera. But you'll be wise to rig up an extension for a second flash, well removed from the camera, by means of which you can encompass a larger area—and also obtain a little less ruthless lighting.

Here, again, watch out for those troublesome reflections in windows and mirrors. In using Photofloods you can, at leisure, make sure that the reflections are avoided, but in flash work you have no such opportunity. However, a good eye, backed by common sense, will usually see you through.

Groups—More or Less Formal

The fine art of lighting individuals for portraiture is a special subject, which rates—and gets—a chapter to itself. But the problem of lighting a group of people, indoors, is a little less specific and can properly be outlined here.

A group cannot be considered as an individual, with a highlight here and a shadow there; no indeed, for the purpose of a group shot is to reveal a number of people, each well and recognizably presented. One way out is to use strong frontal lighting, as with a strong flash bulb at the camera. That way, you will get a picture, but not as interesting a picture as one which is made with unbalanced light, so that each face in the group gets the benefit of a little modulation. Use two flashes on the same circuit—or two Photofloods, if you prefer—with one light a little above and to the right of the camera and the other about level with the camera, a little to the left and slightly back. Vary such a scheme as much as you wish, but try to avoid the straight front light; it's uninteresting.

Check Your Outlets

Before you undertake anything at all ambitious in the way of indoor shots, with or without people, make sure (1) that there are sufficient electrical outlets for your purposes, (2) that they can be conveniently reached by the wires with which your lamps are connected and, (3) that the wall outlets and your plugs are of the same type. Given time, you can correct all such circumstances; to try to adapt yourself to them at the last minute is an invitation to panic.

Interiors—Day and Night

There's a constant demand for pictures of interiors of your own home or of those of friends. An "interior" is not an easy assignment. By day, the first question to be settled is, "How about the light outdoors?" If it's a brilliant, sunny day, with direct sunlight streaming in the windows, your problem is really tough. For those sunny windows are bound to be areas of overexposure. Ditto for patches of sun on the floor or on a polished piece of furniture. You can, with a battery of brilliant lights or discreetly used Photoflashes, build up an over-all intensity of light to reduce the relative hotness of the sunny spots; an exceedingly "fine" (high shutter speed—small aperture) exposure will then give you a good result. But, lacking a big battery of lights, the best solution is to wait for dusk, when the light outdoors will be about the same as that which can be created within. After dark, the windows themselves will lose interest. This does not mean that such interior pictures should not be made after dark—for less window interest will mean more interest elsewhere, which may be quite desirable.

An old solution of the sunny day problem was a double exposure—a very short one with the window shades up, followed by a longer one with the shades pulled down. But this trick was never sure-fire; today, with draperies used more frequently than blinds, the double-shot technique increases in difficulty and uncertainty.

If the room is, as indicated, relatively small, and with light-colored walls, the problem of photographing solely with artificial light is not difficult. Two or three No. 2 Photofloods should suffice. Here are some points to watch:

1. Multiple—and hard—shadows, cast by table legs, bridge lamps and such. Put some cheesecloth diffusers in front of your lamps (far enough from the bulbs to prevent scorching); your hard shadows will fade away.

2. Take care lest direct reflections from the lights appear in the picture.

3. Beware of spotty illumination. If you want to put emphasis on one particular area, that's perfectly justifiable; unintentional emphasis from improper or accidental direction of light is the villain to watch.

In picturing most small rooms, you'll find that your lights will have to be arranged, usually, fairly close to the camera. If you can introduce some cross lighting to relieve the flatness of full frontal lighting, the picture will achieve a pleasant sense of depth.

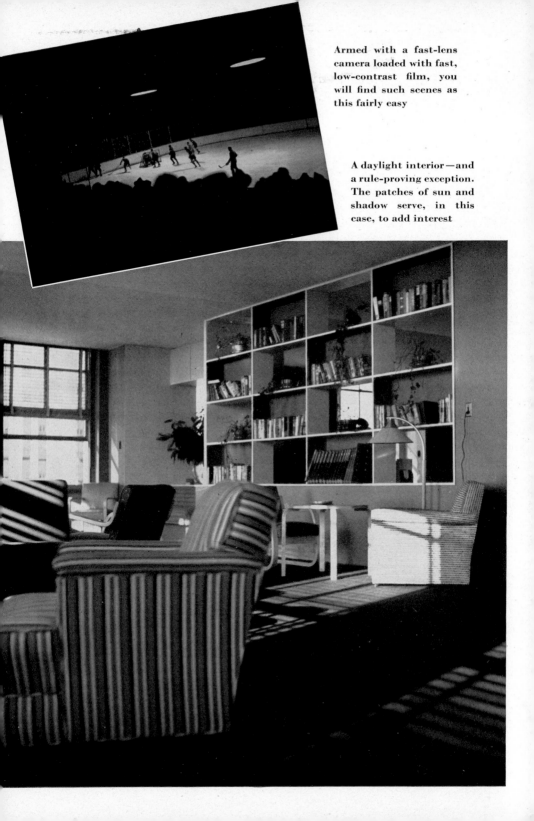

Armed with a fast-lens camera loaded with fast, low-contrast film, you will find such scenes as this fairly easy

A daylight interior—and a rule-proving exception. The patches of sun and shadow serve, in this case, to add interest

If you're working with a minimum number of lights, plan for a long exposure at a small lens opening; then, during the exposure, wig-wag one of your lights gently over the whole scene, thereby throwing light into darker corners. This *painting* with light is fascinating; the only teacher thereof is Old Man Experience himself. Keep in mind that this recommendation applies only to rooms without people in them.

When you're faced with the job of picturing larger rooms—club rooms, chapels, auditoriums, and so on—you really have your hands full. You can no longer rely on a bevy of lights grouped near the camera, for the intensity of light has a distressing habit of falling off "inversely as the square of the distance."* You simply *have* to get lights into the distant reaches of the room.

Usually, you'll be able to plant lights behind doors or pillars so that, hidden from the camera, they will illuminate those far areas. Lights placed in this manner will also afford cross lighting, which gives furniture shape and relief from the background.

In this talk of room lighting, so far, the use of Photoflood lamps has been assumed, primarily because they permit you to build up, visibly and definitely, your lighting scheme. If you need greater brilliance, you can substitute Photoflash bulbs, at the last minute, and—with all the lamps on one circuit—blaze away on a most impressive scale. (It is important, here, to be sure that the Photoflash lamps so used operate properly on standard domestic current. Otherwise, you'll have a lot of trouble on your hands.) Many "pro" photographers use up dozens of flashes on a single shot. It's all very showy and impressive—and expensive.

To go to the other extreme in lighting—suppose you cannot obtain sufficient Photoflood or Photoflash lamps to meet your requirements. Then what? Well, ordinary 100-watt lamps can be substituted for specialized photo lamps. Obviously, you will need either many more lights or very much longer exposures. If 100-watt lamps are substituted for No. 1 Photofloods, multiply your exposure time by a general factor of *six*. To be entirely safe, make the factor *seven;* in rare cases a factor of *five* will suffice.

It is also a very simple matter to photograph a room by its usual lighting. The result is generally pleasing—if the room's lighting itself is pleasant. In fact, it is sometimes difficult to improve on a room's ordinary

*If objects A and B receive light from the same source and B is *twice* as far from the light as A, B receives only ¼ as much light, etc.

An interior, pictured by
its own, ordinary lighting

One 100-watt, one 150-watt lamp, both at
6 feet, 1/2 at *f*/8, Kodak Super-XX Film

lighting by using photographic lights. The Kodak Home Lighting Guide, available at Kodak dealers', covers this situation explicitly.

Outdoors with Lights

There is, inescapably, a fascination about making pictures outdoors at night. Probably the reason for it is its seeming unreasonableness. At any rate, night pictures are part of every photographer's repertoire.

For pictures of people, of close-up action at night, there's no substitute for the Photoflash lamp. For the flash is wholly independent of other lights and works perfectly when the subjects are fairly close to the camera. Beyond 50 feet even the best flash is somewhat inadequate, but at ordinary snapshot range, it is just right. In all cases, try to avoid "foreground flare" —strong reflections of the flash from nearby objects, such as the side of a car, a doorway, or even the ground in front of the camera.

For the special benefit of the snapshooter, Brownies and other such simple, inexpensive cameras have been rigged with synchronizers and neat little battery-operated flash outfits, many of them based on the golf-ball size flash bulbs. The results to be had are delightful; certainly they are perfect as snapshot records of picnics and nocturnal excursions on land or water.

Opportunities for any but conventional, full-front synchronized flash shots are neither obvious nor rich when you're working out of doors. But an effort to get away from that flatness can pay dividends.

Pictures of People

BY FAR the most interesting thing to the human race is—the human race. That's why pictures of people constitute such a huge proportion of all the pictures in the world.

The cycle through which most photo enthusiasts go is revealing. At first, they concentrate almost exclusively on people—schoolmates, playmates, the gang. Then they discover that the world at large is pictorial, so they add landscapes and scenic views to their picture making. They may reach a stage where, for the moment, both people and scenery seem a bit commonplace—and they shy off on a tangent, looking for unconventionality. Eventually, they tire of the strain, for unconventionality must become more and more unconventional to keep its punch—and back they come to picturing people. And they do it better because of their richer experience and the perspective and understanding gained in the course of the cycle.

Of course, this cycle is not airtight. There are exceptions. But it is as true as any generality can be. Let the most hard-boiled "abstractionist" —one whose pictures are concerned with brittle patterns or abstract forms —become a parent, and he will promptly go in for an orgy of picturing a certain young person. It's perfectly right that this should happen, so don't let your temptation to be human bother you.

But be reasonable about it. Don't succumb to the notion that all you need do to get a picture of a person is to aim your camera at him and push the shutter button. Pleasing personality pictures sometimes happen that way, but they are accidents.

There are, of course, two schools of thought about pictures of people. On one side is the idea that a portrait should idealize the subject. The other insists that a realistic portrayal is the only proper thing, no matter how it hurts. Extremists in both camps produce some remarkable results

A happy subject is a busy subject

—slicked-up masks on one side and brutalizations on the other. But the most successful portraitists avoid the extremes; they idealize without falsifying and are candid in retaining the lines, the irregularities which reveal the subject. In short, they remember that the prime function of a portrait is to "look like him."

Theoretically, our literal-minded cameras should never fail in producing faithful portraits; for the camera, legend has it, never lies. Maybe not, but light and shade and angles of vision and accidents of attitude, background, and posture can combine to do a baleful lot of falsifying.

Our concern, then, is the procedure which, given reasonable support in technique, will produce valid portraits.

OUTDOOR PORTRAITS

The informal outdoor portrait, despite the ease with which indoor work can now be done, remains the type of portrait with which most of us will have most to do. The trick in it is to lift it out of the "lucky snapshot" class. Fortunately, there's nothing difficult about it.

The first rule in such work is again *simplicity*—simplicity in composi-

219

tion and simplicity in idea. Otherwise your subject will be lost. Except as a stunt, you would never try to make a portrait of your favorite aunt as she struggled to keep her feet, her purse, and her poise in a subway at the rush hour. Any inappropriate background, any hodge-podge of lights and shadows, tends to defeat the purposes of portraiture.

The second rule is—unless you are dealing with a professional model— don't get your subject primarily concerned with "having his picture took." Give him something to do. Most of us have a fearsome, "lost" feeling when we are being photographed. It is because we are, for the moment, forced into a kind of suspended animation, deprived of all the comforting small activities of living. That's not right, for it doesn't lead to good pictures. Let your subject talk, or fondle a dog, or do any of a thousand and one things which are natural and appropriate for him to do. Action, or implied action, helps to give your picture interest and animation.

The third rule is to use close-ups. If you are going to portray some-body, do it; don't make a long shot of it. (This assumes, of course, that your camera can be focused for work at close range or that it is equipped with a simple supplementary lens which permits close-ups.) By "close-ups" it is not intended to imply the kind of monstrosity which makes every pore of the skin look like a moon crater as seen through the Yerkes

220

Soft, feminine lighting

Strong, masculine lighting

telescope. A simple rule is to shoot at a comfortable "conversational" distance. You rarely carry on a conversation at a range of six inches, nor do you back off twenty feet.

Fourth, use your lighting to help portray the character of your subject. Thus, cross lighting, with its sharply defined shadows, is appropriate for portraits of strong, vigorous, forthright subjects, while soft shadows achieved by softer, diffused light, definitely set the key for portraits of little girls and for femininity in general. Over-harsh shadows, usually accompanying brilliant sunlight, can be softened by using a reflector on the shadow side. Most such reflectors are merely large sheets of white cardboard, but there are photographers who use parabolic metal reflectors; these devices are easily misused, as they give a "hot spot" of reflected light in a very definite area, with results that are sometimes excellent and, just as often, crude and laughable.

This is as good a point as any to mention the business of using synchronized flash bulbs for outdoor portraits. You have doubtless seen examples of this technique. The result is that subjects which, under the obvious natural light conditions, would be rendered in semi-silhouette become brilliant on the shadow side, when flash-lit. Sometimes the result is pleasing; more often it looks like plain fakery and therefore becomes uncomfortable. In other words, it is all a matter of taste; if you like such shots, go ahead.

Another point about light. Avoid the midday sun for portraiture; it produces deep, unpleasant shadows under the brows, nose, and mouth. The slanting sun of morning or afternoon gives more pleasant results. Never force a subject to look directly at the sun; squints are sinful. It's far better to have shadows than squints.

The fifth point is one of the most important. It concerns backgrounds. Modern miniature cameras, with their short-focus lenses and great depth of field, emphasize the necessity for care in selecting backgrounds. A telephone pole, a garage, or a billboard so far away that you neglect it as you use your view finder may, in the finished print, loom up importantly — and impertinently — in the background and demoralize your portrait.

It is disheartening to see—as we do—so many pictures of people in which the backgrounds are distracting, inappropriate, intrusive. It is simply because the camera users (they aren't photographers) do not use their eyes, either in or out of the view finders. They spot their primary subject

221

Always watch your backgrounds. They can make or break your pictures

and *assume* that all is well beyond. It is not a safe assumption.

By far the best background is sky, with or without clouds. With black-and-white film, use a yellow filter to be sure of ample sky tone; the same filter will give you good skin tone. Red filters are out; they render your subjects pallid and unreal-looking.

Finally, beware of stunt angles. In most cases they produce nothing but unreasonable distortion. There are good and bad angles for portraiture, varying with individuals, but extremes are practically never justified.

It is never safe to be completely dogmatic about rules in photography. After writing an article which stated that the best pictures of black dogs were made against light backgrounds, a writer on photography received from a correspondent a magnificent shot of a black Scottie against an equally black background. Still, it was such an exceptional picture that it proved the writer's rule. Hence, the following recommendations for lighting, film, and paper appropriate for black-and-white pictures of various subjects are offered without hesitation.

Pictures of People

Subject	Suggested Action	Lighting	Film	Paper
BABIES	Playing peek-a-boo in basket. — The first steps. — Sitting on blanket. — Playing with rattle.	*Back light with reflector.* If outdoors avoid strong sun in their eyes.	Fast Pan. For fast shutter speeds and soft contrast.	Smooth Semi-Matte
YOUNGSTERS	With toys and playthings in costumes and baseball outfits.	Almost full front light.	Pan.	Smooth Semi-Matte
HIGH SCHOOL AND COLLEGE AGE	Sports participation with campus architecture as backgrounds. With books. — Hobbies.	Cross lighting. If it tends toward harshness try a reflector.	Pan. Make it a fine-grain Pan. if you use a miniature.	Almost any surface—depends upon subject. Use glossy paper for yearbook newspaper shots.
MIDDLE AGED	Hobby picture such as golf — on picnics — with road maps for travel pictures.	Cross light for men. Front light for women.	Ortho for men. Pan. for women.	Medium rough semi-matte.
OLDER PEOPLE	Action and expression to portray character.	Cross light for character studies. Diffuse light for women —this will soften skin texture.	Ortho for strength. Pan. for softness.	Texture papers either rough or med. rough.

223

There's free style in outdoor portraits, too. Real freedom is frequently achieved by fashion photographers in their constant search for novelty

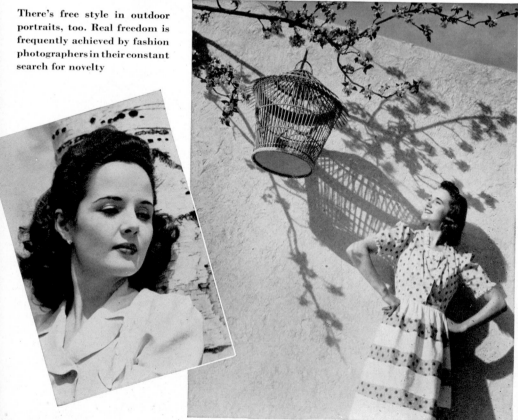

Portraits Outdoors in Color

Looking back over these rules, let's see how they apply to outdoor portraits on Kodachrome or Kodacolor Film. Simplicity is of course paramount, not only in composition and idea, but in color itself. Combine a few colors wisely, not gaudily, so they do not detract from the personality of your subject. Don't feel that you need all the colors of the rainbow for a good color picture.

When it comes to lighting outdoors for color, be on the look out for dense shadows. It will probably be necessary to use the reflector a little closer to the subject than you do in black-and-white work. The softer lighting afforded by hazy days often permits the most pleasing results, since the shadows aren't as black and sharply defined. Kodachrome pictures made on dull or cloudy days are apt to be bluish in color unless a haze filter is used over the lens. It is undesirable to try to use Kodacolor under this condition.

Just before sunset the color of the light is markedly red; it is only natural that pictures made at that time sometimes appear abnormally colored. Avoid this difficulty by making your color pictures of people earlier than two hours before sunset.

When it comes to backgrounds for color portraits outdoors, you might try these: plain blue sky (one of nature's finest gifts to photographers), the blended colors of autumn foliage, or the shade of trees for very dark effects if your subject is in sunlight.

INDOOR PORTRAITS

The primary difference between indoor and outdoor portraiture lies in the far greater control of light possible in indoor work. Even with a brace of Photoflood lamps in simple reflectors you can work wonders right in your own living room; add a cardboard subject reflector and an improvised spotlight and you have a home setup capable of considerable versatility. Play around with such simple, inexpensive equipment for a while. Then you may discover the need for more specialized lighting tools, but don't let it fret you. As has been said before and shall doubtless be said here again, an ounce or two of perception and imagination, coupled with a little ingenuity, is worth tons of expensive gadgetry.

To prove the point, overpage is a group of portraits made with one light only, plus the suggested reflector. Some are good, some bad. But they show what to expect when the light comes from those angles.

One light, close to the camera ... raised, and moved to the left ... then to the back, with a reflector
to lighten the face

In indoor work the basic considerations of simplicity in composition and background hold just as true as in outdoor portraiture. Action, real or implied, is necessarily a bit more limited; and the inevitable nearness of the background may make you more aware of it and hence more careful. You will undoubtedly want to work with the camera on a tripod, despite the fact that snapshots indoors are easily possible. But you are after more than snaps; so don't use snap methods.

The use of lights is, in itself, an art, and not an art which can be standardized to fit all cases and conditions. There is, however, a kind of A-B-C of lighting, and it goes like this.

"A" is the over-all light, placed so that it comes in on the subject's face at about a 45° angle. The side of the face nearest the light is fully revealed, while the off side goes considerably into the shade, excepting a triangular patch under the eye. That patch is often used as a kind of key to the whole problem of facial lighting. This single "A" light, unsupplemented, results in a contrasty, generally unsatisfactory portrait.

So, the "B" light is brought into play. This is the "fill-in" light, the light that fills in those empty shadows. It can be either a reflector or a second light; at any rate, it is lower in intensity than the "A" light. Flat, equalized light is uninteresting; hence the "B" light is either of lower wattage or is used at a greater distance.

Now, with the subject's face well lighted, how about something to give it relief—to make it stand out clearly from the background? Very well, use light "C" to create some interesting highlights along the side and top of the head. "C" can be aimed in at any angle which seems desirable, as long as it doesn't upset the frontal lighting. Sometimes "C" is a carefully handled spotlight; sometimes it is guarded by screens to delimit its scope.

226

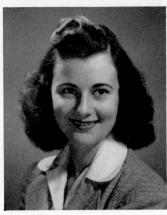

| With the "A" light only | The "B" is added . . . | and then the "C" |

And there's the A-B-C of lighting. It is rudimentary, yet capable of such infinite variation that its possibilities are practically inexhaustible. Try it and see.

For black-and-white pictures, the particular bulbs used for this lighting are relatively unimportant as long as the amount of light used is properly balanced. However, when making indoor pictures with Kodachrome Film, make sure your bulbs are appropriate for your film; any of the white Photofloods are suitable for Kodachrome Type A and 3200°K Mazda lamps are right for Kodachrome Professional Film Type B. Again, when arranging the lights for the color photographs, balance the illumination to avoid excessive contrast. A ratio of 4:1 between highlight and shadow brightness is considered a maximum by some workers and while not an absolute limit will serve as a good basic guide.

Of course, it is possible to elaborate lighting, to add the effects of spots, baby spots, highlight reflectors, and so on until you are all tangled with wires and diffusers and reflectors. It may seem pretty impressive, too, but it doesn't mean a thing unless each light and each reflector and diffuser has a specific and calculated function, just as the many "voices" of an orchestra play their parts in creating the full beauty of a symphony.

As far as camera equipment for portraiture is concerned, it is likely that your regular outfit will serve nicely. However, the use of a lens with longer than usual focal length will be found advantageous; its narrow angle of view permits the making of full-frame close-ups at greater than your usual close-up distance—a factor in your subject's peace of mind and your own convenience in posing and direction. With a longer focal length you have another advantage—less depth of field—hence less chance of sharp background intrusions.

227

In portraiture it is easily possible to become obsessed with technique, with systems and devices. It is therefore a good idea to stop, every so often, and contemplate the fact that the end of portraiture is to depict a person, not to display your cleverness. It's the old business about ends and means; the experienced photographer commands his means, driving them expertly to an explicit end.

Home Portrait Lighting Experiment

Object:

To show the variety of very pleasing and successful portrait lightings possible with limited home lighting equipment.

Equipment:

Three lamps in reflectors. A camera for making close-ups, that is, one focusing as close as 3½ or 4 feet or one with a portrait attachment.

Procedure:

Make one photograph according to each of the following suggested patterns, arranging the lights to conform with the illustrations.

Print or enlarge the developed negatives on a texture surface paper. Mount them on cards and rule neat lines around the prints for the finishing touch.

There are Tricks in all Trades

EVERY DAY and in every job that comes to hand, an expert photographer utilizes many a deft little trick to gain a particular effect, to save time, to eliminate or forestall trouble, or to make amends for a mistake. Some of these tricks involve only the photographer's way of handling his equipment and include variations on the theme of the chapter "Be Camera Wise." Other tricks are more directly concerned with the means of producing unusual pictures. Both are learned only through long, practical experience. If you persevere in photography, you will learn them—and you will create a new set suited to your own equipment, working conditions, and your own temper.

In these pages there is no attempt to offer a short-cut substitute for experience, but a few of the well-established techniques by which specific ends can be gained are herewith outlined.

Spotting and Retouching

First, a note or two on eliminating the tiny white and black specks on finished prints and negatives. These may result from dust that settles on the film in the camera before exposure, dirt accumulated on the negative while drying, dust on the enlarger glass, and so on. Dirt has a demoralizing affinity for both prints and negatives.

The really careful worker keeps his camera, darkroom, and enlarger clean; it is just common sense to work that way. But dust *is* elusive stuff. In spite of the utmost care, it finds its way into places where it causes photographic trouble in varying degrees. But almost every print, enlargements in particular, can be improved by some "touching up." "Touch up" is the best name for this kind of spotting, since the technique involved is one of very lightly touching the white spot with a pencil lead until the accumulation of touch marks blends perfectly with the surrounding tones. Soft

229

pencils should be used to blend spots with dark surroundings, harder ones to blend with lighter tones.

For your first experience with spotting and retouching, go to work on some prints. Any print will do. You'll find some spots to be touched up even on a clean-looking print. If, perchance, you do a better job of learning than spotting, don't worry; the prints can be discarded and others made. Start with the small spots, then tackle the larger ones as you gain a little more confidence in your own ability. Special retouching pencils, available at low cost at most photographic and stationery stores, have leads that mark without leaving shiny or glossy lines. It is in this respect that ordinary pencils are not satisfactory—the lines and dots made with them have a sheen that makes the spotting job too easily noticeable. These pencil lines will not "take" on glossy ferrotyped paper but will work nicely on most other surfaces.

Some workers prefer spotting inks or paints to pencils; they are a bit more difficult to handle, but once you get the knack of them, you'll turn out considerably neater work. They can be used on glossy as well as matte-surfaced paper. A tiny brush is wetted, twisted between the fingers to an extremely fine point, and the water-soluble paint picked up off a card on which it is supplied, and spotted or stroked lightly onto the print. In this same manner, dark spots may be lightened simply by the application of a little white over the black specks. The white and black paints, if carefully mixed, can be used to match any required shade of gray.

It is a mistake to pass off a spotting job as something that can be done in a hurry. Speed almost inevitably winds up in the application of too much paint, or in spreading or smearing of the applications. Good spotting is slow and exacting. You will be safe if you will only remember that it's easy to add *more* "touch up" and almost impossible to "untouch."

When you have acquired reasonable proficiency in print spotting, you will be interested in trying your hand on negatives. Start on waste negatives. You'll not want to take the chance of spoiling good ones. Negative retouching is really an expert, precision craft in itself, one which takes a great deal of patience and practice.

On the light or transparent parts of negatives, retouching is much like print spotting, except that the negative emulsion must be treated or "doped" with an oil-like retouching fluid, so the touch marks of the pencil lead will "take." Professionals say it gives the negative a "tooth." With cotton a drop of this fluid is spread evenly over the area to be retouched.

Where there is an excess of silver, it must be etched away with a very small, delicate, razor-sharp knife. Good etching is not as easy as spotting, for the silver must not only be evenly scraped away, but must be shaded and blended with surrounding parts of the picture, so as not to be detectable in the print.

One big difficulty in negative retouching arises from the fact that you may subsequently want to enlarge the negative. In doing so, you magnify all the touch-up marks, which, unless expertly done, may be worse than the original blemishes.

So, with these points in mind, get some pencils, retouching fluid, an etching knife, and some fine sandpaper for sharpening your pencils. The total cost will probably not exceed $1.50. Rig up an illuminator on which you can see the negative blemishes and comfortably work on them. Use a magnifying glass to watch your work; it's easier on your eyes and you'll do better retouching.

Paper Negatives

From the pictorialist comes a specialized photographic process, the paper negative, considered by its exponents too dignified to be called a trick.

The paper negative process has several variations, but they all allow for extremes in retouching and doctoring before the final print.

1. Make a straight enlargement the same size as the final print is to be, but considerably darker than usual. This is necessary because the print will subsequently be used as a transparency. Use single-weight, smooth paper.

2. Place the dried print face down on an illuminator where all parts of the picture needing further darkening can be so treated. Darken large masses or areas with a dab of lampblack on a cotton tuft, small areas or lines with a regular soft pencil. After a little practice you can even put in clouds and take out trees or barns. You can, that is, if you're really very good. The curse of the paper negative is enthusiastic but inept workmanship.

3. Make a contact print from the retouched paper print. When developed, this gives a negative on paper with a slightly granular texture from the paper fibre. This should also be darker than a usual print. Use single-weight paper, of course.

4. Touch up the paper negative, using lampblack and pencil to darken the negative areas. This will mean the lightening of final print areas.

231

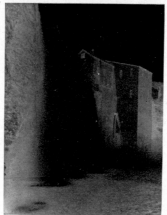

The evolution of a paper negative print

Left, above, is a straight print from the original negative. The sky is a monotone, the falling water lacks sparkle, part of the foreground is too heavy, and a few windows in the old mill are needlessly conspicuous. The center picture is the front of paper negative. It is on the back of this that the corrective work is done, as indicated in the right hand illustration above. Finally, having created a "fortified" negative, a new print is produced, as shown at the right.

5. Make the final print by contact from the paper negative on any surface or contrast desired.

Many workers project the original negative onto a sheet of film, so the only paper part of the process is the paper negative. This has the advantage of assisting in the retention of greater detail in the final picture, but does not afford the beginner the wide retouching range of the straight paper positive-negative process.

Multiple Exposures

Just about the most common photographic boner is the double exposure, the miserable, unhappy result of forgetting to turn the film to the next number between exposures. But there is a special kind of double, or triple or quadruple exposure than can be fun; it can provide some very interesting pictures, too.

Commercial photographers use this multiple exposure plan to make a series of story-telling pictures all on one film, often for advertising purposes. They are sometimes called *montage* effects. Similarly Hollywood cameramen make ghost pictures, shooting the background scene first and then, with a second exposure on the same film, superimpose the ghost on the scene. With the same general plan you can make such trick pictures as these:

Dad playing checkers with himself.

The baby as her own tea party guest.

Sister waving a salute from inside a milk bottle.

This is the way it's done. The essential parts of the picture are exposed separately on the same piece of film. The only requisite is a black background, for only the main part of the subject must be allowed to affect the film. For example, to picture Dad beating himself at checkers, seat him at the checkerboard making a play; the background is black, and there is no chair at the opposite side of the table. One exposure is made. Dad and his chair are then moved to the other side of the board, where he sits in contemplation. On the same piece of film, the second exposure is made, and since the black background did not affect the film on the original exposure, there is a picture of Dad on that side, too. The checkerboard will be double exposed but it makes no difference, if it's not moved between times. The camera, of course, must be on a tripod, and unmoved between shots.

The quartet, presented on the following page, is an elaboration of this multiple exposure idea—and executed with great gusto. As with most really successful jobs, simplicity is its keynote. "Props" are almost eliminated, so that our attention has a chance to rest on and relish the variations in expression, and in "voice" achieved by the singer. Such a picture as this is would make an excellent, a memorable Christmas card.

The milk bottle trick is somewhat complicated by the differences in scale involved—the bottle is a close-up shot and the girl to be shown in it

finished enlargement, put the sheets on an illuminator and trace the important features in ink.

Some workers draw directly on the print, then bleach the photographic image out, but it's difficult to see just what kind of a job you're doing; it involves a chemical bleaching operation—and if you make a mistake you must start all over again.

Here's a sample of what can be done. In this case both the drawing and photograph served as illustrations for an article on building a boat trailer.

From a photograph . . . a working drawing

Intensification

Someday, despite your complete and masterful command of all the factors of exposure and development, you may find yourself faced with the problem of getting a good print from a negative which is, to be blunt about it, *too thin*. Even No. 5 paper cannot save you. What to do? Retake the picture if at all possible. But if you can't take it again, you may be able to save the situation by chemical treatment to intensify the faint image you have.

If the lack of density comes from underexposure, there's not much that can be done. On the other hand, if it is flat or thin from underdevelopment, "intensification" will probably help. Intensification, remember, is an antidote for underdevelopment only; for underexposure there's no real hope or help.

Every formulary lists several intensifiers. Familiarize yourself with one —then hold it in your bag of tricks as a last resort.

Reduction

If, through some misfortune, your negatives are too dense, the remedies are many and the results varied. The "reduction" of silver is accomplished in a physical sense—there is simply less of it when the process is complete. The word as used here should not be confused with the chemical reduction of exposed silver bromide during the original development.

According to results, reduction and reducers may be classified as follows:

1. *Subtractive* reducers take equal amounts of silver from all densities. They are used principally to correct for overexposure and fog.

2. *Proportional* reducers take from each density an amount proportional to that density. They correct for excessive contrast.

3. *Super-proportional* reducers are simply proportional reducers of an extreme potency for the treatment of extreme cases of high contrast.

Formulas for reducers are as abundant as those for intensifiers and, like intensifiers, belong in the "life saver" class.

Toning Experiment

Object:

To illustrate the different effects of a sulphide toner on chloride, chloro-bromide and bromide emulsions.

Equipment:

Printing and enlarging facilities.

Procedure:

Make three prints from a good quality negative, one on each of the following papers: Azo (chloride); Kodabromide (chloro-bromide); and Royal (bromide). These prints should be somewhat darker than usual, as this method of toning reduces the over-all density slightly. Be sure that all the prints are washed thoroughly after fixation.

Bleach the prints in the following solution until only a very faint image remains.

Potassium ferricyanide . . 40 grams
Potassium bromide 10 grams
Water 1,000 cc

Wash all of the above yellow solution from the prints and then redevelop the images in this:

Sodium sulphide 10 grams
Water 1,000 cc

This toner can be purchased in small tubes or mixed from bulk chemicals.

Develop until the mottle and spottiness have left the print, usually about thirty seconds. Wash in running water for half an hour and dry. Mount the prints for future reference.

All toning steps can be carried out in white light.

Questions:

1. Which of the three emulsion types is most affected by the toning?

2. To which class of toners does the sulphide toner belong?

3. For what types of subject matter would sulphide toned prints be most appropriate?

Special Purpose Photography

MODERN PHOTOGRAPHY is as diverse as the interests and professions of men. It is the eye of the astronomer, in an almost literal sense; it is the guide and fact-finder for surgeons, dentists, and metallurgists; it is the scout and map-maker for armies—and the tool of cities in the administration of the present and in planning for the future. Photography, directly or indirectly, figures in the production of practically all advertising, as it does in all types of exposition. It is a growing medium for the illustration of fiction; it is basic in such matter-of-fact affairs as blueprints, Photostats, and bank records. The war-born Seventh Symphony of Shostakovich came overseas as a roll of film; and millions of soldier letters, each a tiny bit of film, have flown the seven seas. The development of new military aircraft has been immensely accelerated by the application of photography to the making of patterns and templates.

Photography, in some form or other, impinges on a far wider range of human activities than most of us realize. Obviously, the more we understand about it, and how it is used, the better we are equipped for our own special jobs.

It is, of course, quite impossible for the average amateur to equal the equipment—to say nothing of the hard-won experience—of the professional photographic specialist. It is, however, entirely possible for the amateur to undertake, for himself and on a limited scale, some forms of special-purpose photography. Indeed, the ability to carry out some of these photographic operations may make the difference between real distinction and mere competence in his chosen vocation or avocation.

The processes briefed here are those which are believed to be most useful to the average amateur in the extension of his photographic interests or as applied to his activities in any of scores of fields which may seem wholly unrelated to photography.

COPYING

To some, the most humdrum job in photography is that of making copies of drawings, paintings, or photographs. Yet there are experts who make good livings at it because they substitute imagination and skill for ordinary humdrum methods.

The basis setup for copying involves perfect symmetry. The camera is accurately centered on the material to be copied (the "copy") and the illumination is nicely balanced to provide smooth, glareless, shadowless lighting. The sketch shows the relationship between copy, camera, and lights. The strict centering of the camera on the copy and the precise paralleling of film and copy are not merely arbitrary rules; they are essential if the copying is to be free of distortion.

Because of variations in reflectors, it is a good idea to build up the lighting for each job methodically. Illuminate the copy with *one* of the lights as evenly as possible, retaining a 45° angle to the copy. Then turn that light off and repeat the process with the other one. Thus, when both are turned on, you can be sure of maximum uniformity. The technique of copying can be, and often is, thoroughly mechanized and automatic, for the goal of copying is seldom a "creative" photograph. It is, rather, the most slavish possible reproduction of something already created.

And that's why copying *is* humdrum, so long as it is concerned solely with black-and-white reproductions of clean black-and-white originals. But, let the copy be a painting, in water color or oil, let it be stained with 239

Perfect copying depends on accurate symmetry in setup and lighting

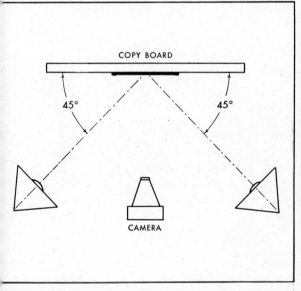

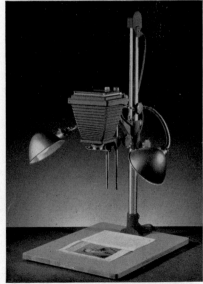

age or chemicals, faded, a page from a book which must be kept intact— let all these or a thousand other variations come along, and the humdrum business of copying becomes an art, worthy of and demanding a specialist in the selection of films and filters.

In all copying, whether it be simple or complex, accurate exposure is essential. In straight photography it is possible to fudge a bit, to exercise artistic license a little; but the result of your copying has to stand the acid test of direct comparison with the original. If your copy isn't extremely close to a true reproduction, it's a failure. Hence, exposure and development must be just as accurate as focus and lighting.

Copying Line Work

In copying drawings, wood cuts, music, blueprints, etc., your major concern is maximum contrast, to give strong, clean, black lines on white paper, crisp lettering, and so on. Eastman Contrast Process Ortho and Contrast Process Panchromatic Sheet Films are best for such work. Properly exposed and developed, they print easily and well on normal contrast paper. The recommended developers for these films produce high contrast because of their high hydroquinone content. Accurate exposure is a prerequisite to good copy work. Run a test exposure just to make certain your setup is perfectly arranged before attempting any mass copying.

Copies of blueprints benefit by the use of a red filter which, in conjunction with the process pan film, assures the reproduction of blue as black, with the white lines standing out clearly.

Filters, naturally, are also useful when you are dealing with other line work in color, if either the paper itself or the lines are colored. For example, to get a clear, sharp, black-and-white copy of a drawing or design involving blue, red, or black lines on green paper, you'd best use a B (green) filter with the high-contrast pan film. The theory is to use a filter which transmits the color of the paper easily but does not transmit the color of the inked lines.

Copying Photographs

Under this head are included "continuous-tone" originals—such as wash drawings. Whereas all parts of the line copying process are designed to accentuate contrast, continuous-tone copying involves the use of moderate contrast methods all the way. A fine-grain film is indicated, with soft development. The color sensitivity of the film is unimportant.

240

Should rough surface texture or wrinkles in the original give you glinting reflections, experiment with a change in lighting angles, with diffusion frames over the lights or—if you are fortunate enough to have them—with Pola-Screens over both the lights and the camera lens.

Copying Color

The purpose of copying oil paintings, water colors, etc., is generally to achieve a black-and-white record. So, it's best to use a fine-grain, panchromatic film, with a filter to correct for the light used—a Wratten X1 (yellow green) for tungsten light and a K2 (light yellow) for daylight.

If you are interested in depicting texture, such as brush marks in painting or the weave of the cloth in a colored fabric, increase the light on one side or the other.

Naturally, the best copies of color are in color. The same general rules of balanced lighting apply. But make certain that the lamps are correct for the type of film used. You may expect to get excellent copies of water colors and oils. Experience indicates that there is usually a slight loss in saturation when copying most printing inks, and you may encounter occasional color changes in some unusual blues and greens.

Since you cannot run into the darkroom immediately to develop your Kodachrome Film, make a range of exposures varying each one by half a stop or by a factor of 1.4. If you do a considerable amount of copying you will soon establish your own standard setup and exposure conditions, and will be able to hit the right exposure almost automatically. This, of course, holds for black-and-white copying as well. The Direct Positive paper method for determining exposure time as described in the chapter, "Shooting in Color," can also be applied directly to making color copies on Kodachrome Film.

The technique of copying is no arbitrary thing; it must be flexible and adaptable despite its basic simplicity. The photographer with a sound understanding of color, films, and development will not find copying—or any other phase of photography—a bore.

One more suggestion—not exactly photographic, but related. The law prohibits the copying of stamps, money, bonds, citizenship papers, and other Governmental documents, but for a few exceptions such as:

1. The copying of coins for the purpose of illustration in numismatic, historical, and educational publications.

2. The copying of foreign postage stamps for the purpose of illustrating

philatelic or historical publications, provided the illustrations are in black and white only, are so defaced as to indicate that they can not be adapted for use as stamps, and are at least four times as large as the original.

3. The copying, in black and white only, of United States stamps for the purpose of illustrating philatelic publications, provided the illustrations are either less than three-quarters or more than one and one-half times the size of the original.

In the interests of "safety first," get written permission from the copyright owner before copying any copyrighted material.

Making Black-and-White Slides for Projection

This is a darkroom proposition often closely tied up with copying. Whether you are a teacher, lecturer, salesman, or photographer, you probably will sometime want to tell your story in slides.

There are two standard slide sizes, 2 x 2-inch and 3¼ x 4-inch. In either case, the problem is to make a positive copy on film, which is subsequently masked and bound between thin glass of the right size.

If you plan to make 2 x 2-inch slides, for use in a Kodaslide Projector, the simplest procedure is to make contact prints from 35 mm. or Bantam negatives directly onto Kodak Safety Positive Film. Because of the great magnification which screen projection entails, it is important that the detail of the negative be preserved to the utmost—and that means perfect contact during the printing exposure. You'll need somewhat less light, or shorter exposure, than for paper printing.

If the negatives from which you make your 2 x 2 slides (the maximum masked openings in which measure $1\frac{1}{32}$ x $1\frac{1}{2}$) are larger than the Bantam or 35 mm. format, a reduction in size is needed. And here's where copying technique comes in; for the best and easiest method is to make a copy from the trans-illuminated negative, using a miniature camera. The negative is placed on a ground- or opal glass illuminator, with all marginal light masked out. From there on, the procedure is straight copying, but with extraordinary care to retain sharpness and squared-up proportions.

A variant of this method involves the use of a portion of a negative, as exposed in a larger camera. For this work, a camera with ground-glass focusing is almost a necessity; without some such visible means of checking alignment and focusing, the accuracy so important to slide making may be lost.

Another procedure is open to those who have enlargers which can be adapted for reducing. The negative is placed in the carrier as usual, and the film is substituted for the printing paper on the easel. Black paper should underlay the film, to absorb and prevent the reflection of light which may penetrate the film during the exposure.

A 3¼ x 4-inch slide is generally made by printing directly onto a glass plate which, after development, is masked and bound with a clear glass. Film positives may be made and mounted between glass of this size for projection too, but projectors of the larger variety have powerful lamps in them and get quite hot; hence the film may be scorched if left in too long.

Good slides, properly presented, steal the show on any lecture, educational, or entertainment program. Better be prepared.

PHOTOGRAPHY BY POLARIZED LIGHT

Also falling under the general heading of "Special Purpose Photography," is the use of polarized light in making pictures.

Normal light rays consist of waves—waves vibrating in all planes and at right angles to the direction of travel. Light, which has, by nature or by optical means, been reduced to vibrations only in one plane is said to be *polarized*. To our eyes, polarized light looks quite like any other kind, but photographed through a Pola-Screen, there's all the difference in the world.

Nature Polarizes Light

1. Light coming from a clear blue sky at an angle of 90° from the sun is polarized. If the sun is directly overhead, light from the sky near the horizon in any direction is polarized. When the sun is low in the west, light from an arc from the northern horizon extending overhead and to the southern horizon is polarized. In all cases only a *clear sky* favors polarization.
2. Light reflected from non-metallic surfaces at an angle of from 32 degrees to 37 degrees is polarized. This includes reflections at those angles from pavement, store windows, the enamelled parts of automobiles, polished table tops, etc.

All other light which vibrates in all directions is said to be unpolarized. Light can be optically polarized, too, for photographic purposes by

passing it through a filter-like Pola-Screen. A Pola-Screen is made by laminating Polaroid sheeting between two pieces of thin glass. It may be regarded as an optical picket fence. As light passes through the "pickets," all but one direction of vibration is eliminated.

In most cases, Pola-Screens are used over the lens, as filters are. When "crossed" with the rays of light already polarized by nature, the light is withheld and just doesn't get through to the film.

Uses for Pola-Screens

1. In making a landscape which includes sky light coming from an angle of 90° to the sun. The sky will reproduce darker, for the light coming from it is polarized and can be cut out by the Pola-Screen. The color balance of the remainder of the picture will not be disturbed. In fact, the use of a Pola-Screen is the only way you can get darker than usual blue skies and accentuated sky-cloud contrast in color photography.

2. When photographing store windows during the daytime, reflections from buildings across the street may obscure detail from within the window. If the camera is placed so that the reflection seen is a "35° angle" reflection, and a Pola-Screen placed over the lens in a position to cut out the naturally polarized reflection, full detail beyond the glass is photographed.

3. You can eliminate glaring surface reflections which visually and photographically obscure surface detail, such as those from the top of a highly polished table. Get your camera into a position so the reflection

Troublesome reflections . . . eliminated by a Pola-Screen

rays are polarized; then cut them out with a Pola-Screen.

Obviously, Pola-Screens eliminate a considerable portion of the light waves, since they pass only those vibrating in one general direction. Thus when a Pola-Screen is used over the lens, filter-fashion, it has a factor of from 2 to 4 times, depending upon the particular type used.

Pola-Screens are supplied in larger sizes for use over studio lights. With them, the commercial photographer can avoid objectionable surface reflections by polarizing his light at the source, and controlling it with another Pola-Screen over the lens.

While Pola-Screens cost more than conventional filters, and their uses are special and limited, there are pictures that simply cannot be made any other way. If your picture making necessitates such photographs, a Pola-Screen will be a real investment.

STILL LIFE AND TABLE TOPPERY

Many of us get our first intimations of special purpose photography from our experience with some sort of still life photography. The important factors are all there—a picture idea, props to pose and arrange, and lighting problems to be solved.

"Still life" photography is, in a sense, a misnomer. For it is the function of the photographer to make his subject—no matter how "still"—come alive. It must, to succeed, have pictorial vitality and interest.

The necessary equipment need not be elaborate. A simple camera, a camera support, and a few lights can, if necessary, achieve considerable still life success. But you're far better off if you have a camera which permits (1) accurate viewing and focusing on a ground-glass screen, without worry about parallax and, (2) close-up focus. A small view camera is ideal for this type of work; lacking one, be sure you make the proper allowances for parallax and equip yourself with an accessory lens of the Portra type.

The professional's aim, in still life work, is generally to produce the most attractive possible "portrait" of his subject, a portrait which, when reproduced in an advertisement, will arouse the acquisitive instincts of prospective purchasers. But the still life shots that most non-professionals make are "idea" pictures—pictures made with the purpose of revealing some combination of lines, curves, masses, and tones that the photographer finds interesting or exciting. Both the pro' and the amateur use much the same means to produce their slightly different ends. Both need a table or

245

ARCHITECTURAL PHOTOGRAPHY

Architectural work is related more closely to outdoor portraiture than to any other kind of photography. It's a matter of selecting the most interestesting, most flattering angles. Sun angles have to be watched and the best one used. Cross lighting and extended shadows show shape and give the feeling of depth. Distortion has to be eliminated or used deliberately to achieve a dramatic effect. Sometimes the photographer must work under cramped conditions; for example, he may have to picture a tall building from an "across the street" vantage point. Therefore, he must know his wide-angle lenses. At other times, he may have to record a detail far up on the facade; long-focus lenses are then clearly in order.

For architectural photography a view camera, with a full complement of swings and distortion rectifiers is needed. Ground glass focusing and composing are essential. Small apertures are needed to assure maximum depth of field; so exposure times will probably be long. In view of all these, a tripod camera support is important. (Notice the series of architectural photos on the opposite page.) Architectural photographers are very keen about dark sky backgrounds which make buildings stand out in bold, shining relief. Hence, many of such pictures are heavily filtered. Sometimes, even so, the sky remains uninteresting; the resourceful photographer then "prints in" a suitable sky, using one of the several sky-and-cloud negatives he keeps on file expressly for such a purpose.

SCHOOL AND CLUB PHOTOGRAPHY

There are the hundreds of informal pictures needed for every high school and college yearbook. These include such matters as pep meetings, campus "atmosphere" shots, graduation sidelights, etc. Those who make such pictures must be equipped to work under conditions which parallel those encountered by press photographers. They need not merely cameras, flashguns, and such, but they must have the skill and timing and poise needed to take in their stride a basketball game in the afternoon and a P.T.A. meeting in the evening. Gathering informal photographs for a yearbook can be valuable training if it is undertaken seriously. Many a first-rate photographic career has started on the campus.

Garden Clubs

All such groups appreciate photographs taken to record the picture story of a season's achievements. Here, of course, the emphasis falls on color-

Successful architectural photography is nine-tenths
point-of-view — with a sense of significant details and
angles and the photographic "know how" taken for granted

color in terms of Kodachrome transparencies which can be shown by projection at club meetings or, perhaps, in terms of Kodacolor Prints that can be passed around for individual inspection.

The technique of flower photography is specialized; in the photographic journals are many articles dealing with its various phases. The major considerations, you will find, are (a) diffuse lighting, to minimize harsh, black shadows and (b) various means by which single flowers or plants can be isolated from confusing or distracting surroundings. A word of warning —don't use half-way measures on flowers. Either make clean-cut recognizable close-ups or show the whole garden. Midway shots tend to be confusing.

PHOTOGRAPHY CAN'T DO EVERYTHING

One of the natural temptations of the enthusiastic amateur is to assume that photography can do anything that any other form of graphic art can do. Photographs are made which try to be etchings, paintings, posters, cartoons, or low-relief sculpture. Sometimes they succeed. But photography is at its best when it is being frankly itself.

The field in which photography has the greatest difficulty is humor— the natural province of the cartoon. For photography and humor do not mix naturally. Photography is realistic; humor is not.

Cameras, of course, can record cuteness, the pranks of youngsters, and animals, or situations which evoke a chuckle. But, a photograph is bound to reality by the literalness of the camera; it is extremely difficult for it to achieve the unfettered freedom of a cartoon. Our leading magazines of humor recognize this fact. There is nothing to worry about in this situation. Photography is an upstanding, tremendously capable and vivid medium; the fact that it has limitations only endears it to its devotees.

Table-Top Lighting Experiment

Object:
To illustrate the three basic lighting effects (front, back, and side lighting) on objects that are spherical and cubical.

Equipment:
A camera capable of making close-ups, a Photoflood lamp in a reflector and a sheet of white cardboard.

Procedure:
Place some single-colored ball, such as a tennis ball, in front of your camera on a table. The camera-to-subject distance should be adjusted so the image nearly fills the available film area.

Make four pictures, one each with the light in these positions:

A. *As close to the camera as possible,* illuminating the ball from the *front.*

B. *Behind the ball.* The light should be raised or lowered slightly so as not to shine directly into the lens.

C. *At one side,* shining at right angles to the direction in which the camera is pointed.

D. *As in C,* but with a white card held in a position to reflect some light onto the shadow side of the ball, plus the back light.

Repeat the exposures and lightings using a square box and cylinder as the subjects. The accompanying illustrations should give you some ideas.

If the light from the Photoflood bulb is too bright, the intensity can be cut down by arranging two cardboard masks in front of the light.

Mount the finished prints as a permanent record. Try variations of these lightings and notice the great number of effects obtainable.

251

| Front light | Back light | Side light | Side and back lights, plus reflector |

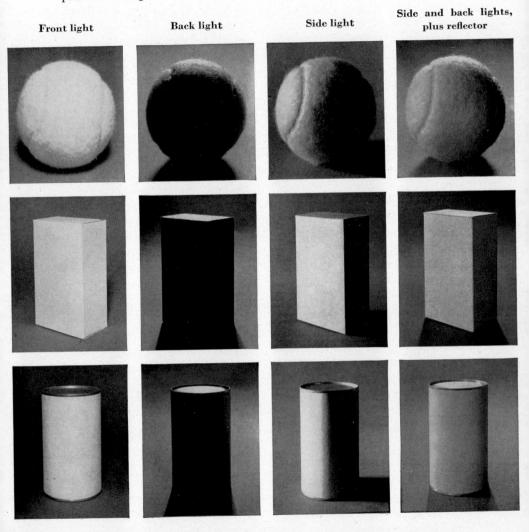

Now That They're Finished

MILLIONS of snapshots are stowed forlornly away in curling packs in desk and dresser drawers. Hundreds of thousands of enlargements, mounted and unmounted, lie forgotten in dusty envelopes. And the negatives for all these prints are enduring the same or even a more dismal fate.

Like many another example of mass inertia, this situation affords a background against which any reasonably alert individual can rise and shine.

It is assumed that you are such a person. Very well, what do *you* do with *your* negatives and prints?

File Your Negatives

Prints can be replaced almost anytime; most negatives cannot. A system will make the location of negatives easy; obviously you will be more likely to get full benefit from your printing sessions if your negatives are readily and definitely at hand.

A file of some sort is indicated—a file in which negatives are (a) protected from dust and moisture and (b) arranged in some sort of useful classification. There is a variety of ready-made negative file systems on the market. Kodak Negative Albums are made in several sizes and afford excellent protection as well as easy accessibility. If you prefer to make a file of your own, you'll discover few difficulties—beyond the temptation to make it too elaborate.

Negatives should be filed individually in paper envelopes, on which pertinent data are recorded. Some photographers paste a contact print on the outside of the envelope to identify the negative within; such a system, while explicit, increases the bulk of the file considerably.

The classifying of the negatives will vary with the kind of photographic work you do. Anyone specializing in portraits, for example, will classify his negatives according to the names of his subjects; a traveler will use

place names as the basis for his file; others, with diverse subjects to classify, will make some such alphabetical arrangement as this:

Animals	Gardens	Scenics
Architecture	Greeting Cards	School
Aviation	The House	Sports
Babies	Night Scenes	Table Toppery
Children	Portraits	Vacations (by year)

The important thing, of course, is not the filing system nor its details, but the fact that your negatives are all in one place, protected yet accessible.

If your file box is metal, so much the better; for films—like other valuables—deserve fire safety as well as protection from dust, excessive moisture, and handling. Given reasonable care, your negatives will last indefinitely.

Give Prints a Chance

And what about prints? There's no need for embarrassment even if all you do with a finished picture is to sit back and ponder it, comparing it with your memory of the original scene or with your hopes for the ultimate result. If this calm consideration is even faintly critical, it is well worth-while; for we can be our own best teachers.

If the picture is reasonably satisfactory, what do you do with it? Tack it up on the darkroom wall? Take it upstairs to show to the family? Enter it in a contest or exhibition? Send it to Uncle Bertram? Or what?

Undoubtedly the simplest, and one of the best means of getting enduring pleasure from a picture is by incorporating it in an album. Remember the stuffy, old-style album—the bulky, unattractive, pointless affair, with its clumsily mounted prints and its scratchy white ink captions? If so, forget it.

The modern photograph album has as much relation to the old-timers as the latest issue of a modern illustrated weekly has to a 1915 mail order catalog. The new album definitely is not a catch-all—or a "miscellaneous department."

In place of bigness, the new album emphasizes compactness. Instead of one or two big, bulky books, the modern picture collector maintains a number of smaller volumes, uniform in size and appearance but with relatively few pages. Each book is devoted to a specific subject—such as

cheerful, such as, "Well, well, Bill must have worked nights for a month to produce this."

You may find that existing negatives will work out well for your greeting. Possibly some shots you made last Christmas of the house in its holiday dress, of the Christmas tree, or of the kids about the fireplace will work out nicely. Or you may want to create something brand new, especially appropriate for this year. Once you have the basic idea, it's up to you to decide how it is to be presented—as a straight photograph, with or without special "props," as a silhouette, as a table-top creation, as a multiple exposure, as a combination of photography and line copy, or in any other manner that appeals to you. But the total effect must be appropriate. In a sense, your greeting card must be like a good advertisement. It must "sell" your message, neatly and convincingly.

3. If yours is a family greeting, enlist the help of the family in producing it, not merely in making the original pictures, but in printing and finishing the cards. Once you have the darkroom procedure established, with correct exposure and development times, set up a production line so that your total output of cards can be printed quickly and well. One person is at the printer, another does the developing, another takes care of the rinsing and fixing, while still another supervises the final washing and drying. Some such organization will not only produce results but, more importantly, it will give the entire family a sense of participation in the finished products.

Later on, if you feel inspired to make photographic book plates or any other specialty involving considerable quantities, you will be able to count on a "gang" procedure that will be effective as well as fun.

256

Two examples of photographic greeting cards

Through the years the photographic magazines have been telling and re-telling the story of how to make all sorts of photographic novelties. In most cases, you'll need no help, but there's no harm in seeing how others have proceeded; hence it is suggested that you keep in touch with what others are doing through one or more of the photographic journals.

Enlargements at Work

A "wasted" enlargement is a waste indeed; the time, money, skill, and hope involved certainly justify some use beyond the confines of the dark-room.

The most obvious of uses, of course, is as a framed picture for the wall of some room. Very fine indeed—but be careful. There's an art to the matting, mounting, and framing of a picture; if it is well done, the picture benefits; but if it is done clumsily or without regard for the decorative style of the room where it is to be hung—well, it might better not be done at all.

The 5X and 8X Kodachrome Prints, made from miniature Kodachrome transparencies, mounted and framed will add infinitely to the decoration of your home; too, they add a personal touch that is attractive and sat-isfying. Pictorial shots of your hobby or your family interests again fill the bill. Hunting, fishing, sailing, gardening, skiing—these and many others provide magnificent opportunities for color photographs which can ultimately mean much to your home's decoration.

There is, obviously, a limit to the number of walls on which one is free to hang enlargements. But enlargements have multiple uses. Their use in books has already been mentioned; here are a few other possibilities:

| Lamp shades | Screens | Backgrounds for |
| Book covers | Cut-out statuettes | table-top pictures |

And, of course, if you go in for enlarging in a really big way, there's the specialized enlargement known as the photomural. Because of its size and because of the necessity of harmonizing it with existing decorative schemes, there are few amateurs who are tempted to play with murals.

There is, however, one very practical variation of the photomural theme. It consists of a band of adjoining photographs, perhaps 20 inches high, running in series. Suppose, for example, you have a recreation room to be so decorated, and you'd like to use the candid pictures you've taken of your best friends over a period of years.

Photomurals don't need to be big and costly. A panel of enlargements can achieve a true mural effect

Enlarge all your negatives to the same size, in this case 20 inches high and 16 inches wide. Dry mount them on heavy cardboard or Masonite and trim uniformly. The pressed wood board is best, for it won't buckle or curl with normal changes in temperature and humidity. Frame the entire series as a unit, using strips of molding appropriate to your room, and there's your "mural."

Series of pictures of a hobby, such as model airplane building, skeet shooting, hunting, or any sport, will be ideal for your recreation room, while pictorial series are better suited for mural type decoration in your living room or front hallway.

Enlargements make excellent gifts too, but they can be embarrassing. Consider the sad case of the astonished gentleman to whom a friend sent two dozen 11 x 14 enlargements mounted on 16 x 20 cards. Beyond building a special gallery wherein to exhibit them, there was nothing whatever to do with them. Be discreet about your giving. A little is much better than too much.

An important use for enlargements is offered in the exhibits or salons of camera clubs. Competition is the life blood of photography to many; if you feel that you do your best work under the urge of competition, by all means join a camera club. Your association with others with similar interests is stimulating and certain to increase your photographic knowledge.

Mountings for Enlargements

Wherever or whenever enlargements are displayed, they should be suitably mounted. "Suitably" is, of course, another relative word; it is all things to all people. But, usually a simple mount serves best because it does not detract from the picture it bears. The simplest mount is a sheet of mounting board somewhat larger than the print, which is placed thereon so that top and side margins are equal and the lower margin a little greater. A neat black line is drawn around the print—and there you are. In general, the mount should be about half again as large as the print; thus an 8 x 10 print displays well on a 12 x 15 mount and an 11 x 14 looks right on a 16 x 20 board.

Variations on the simple mount include intermediate layers of black or toned paper between the print and the mount. These underlays show as bands around the print and tend to project the picture toward the observer. Another variant attains exactly the reverse effect, that of presenting the picture as seen through an opening or window. This is achieved through the use of a cut-out overlay.

THIS, THEN, IS PHOTOGRAPHY

If, perchance, you have been reading between the lines, you will have sensed the fact that the title of this book, despite its good intentions, is somewhat ambitious. No one book, no matter how inclusive and fact-laden, can hope to embrace all of photography.

For photography is one thing to you—and a totally different thing to your next door neighbor. It is a hobby, a science, a craft, an art, a tool, a casual pastime, or a basic interest—the sort of thing to which you respond, spontaneously, in some such gladsome terms as, "That's for me!"

As a career, photography is exactly like riveting, black-smithing, dancing, music, cost-accounting, preaching, or running a lathe. If you're good at it—really good—it is an ideal vocation. It is not an easy profession, nor does it often lead to great wealth. But a good photographer can carve out a reasonably happy, prosperous life.

What does it take? It depends, naturally, on whether you plan to run a commercial studio, a portrait studio, or an assignment job. But, fundamentally, the requirements are:

1. A sound, basic understanding of photography. Books such as this can help in gaining such an understanding, but actual practical training is

vital. Courses in photography are given in some schools; and intensive training is offered by specialized schools of photography. In photography, as in music or any other field of high skill, theory is important only if it is supplemented by lots of practice.

2. A background of artistic appreciation and, best of all, artistic achievement. A sculptor or painter is not automatically a good photographer, but a photographer who knows something of sculpture and painting has a real advantage.

3. An understanding of the simpler electrical hook-ups.

4. A handy-man's knack of improvising "props" or special studio equipment. There's a lot of Rube Goldberg carpentry back of some of the best pictures.

5. A willingness to get your hands dirty and to live on a slightly erratic schedule. If someone needs to get a picture to the engraver tomorrow morning, the photographer on the job must pass up dinner, the movies, bridge, or even sleep to get that picture out.

6. Adaptability to changing methods and styles in pictures. For photography is not static; it progresses—and progresses, sometimes, with bewildering speed.

7. Finally, a sound sense of business is handy. Competition is stiff and the photographer who expects to eat regularly must operate on a strictly business basis.

It All Depends On You

Photography may be, for you, only a casual pastime. Or it may be a hobby. Or it may be an important adjunct to your hobby. Or it may be the thing on which you focus your whole active life.

Whatever it may be, photography has in it the capacity to produce satisfactions far more deep and real than you may now suspect. But to discover and to realize those satisfactions, you have to do your part. You have to know what you want to do, and how to do it. For satisfaction is never an accident.

Back of every good picture is an idea; and back of every picture idea is an eye that sees and understands. So here we are, back where we started, with our theme song—you are the most important part of any camera you will ever own.